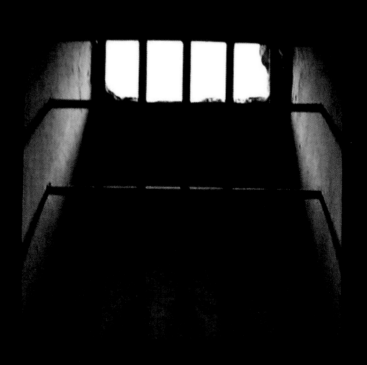

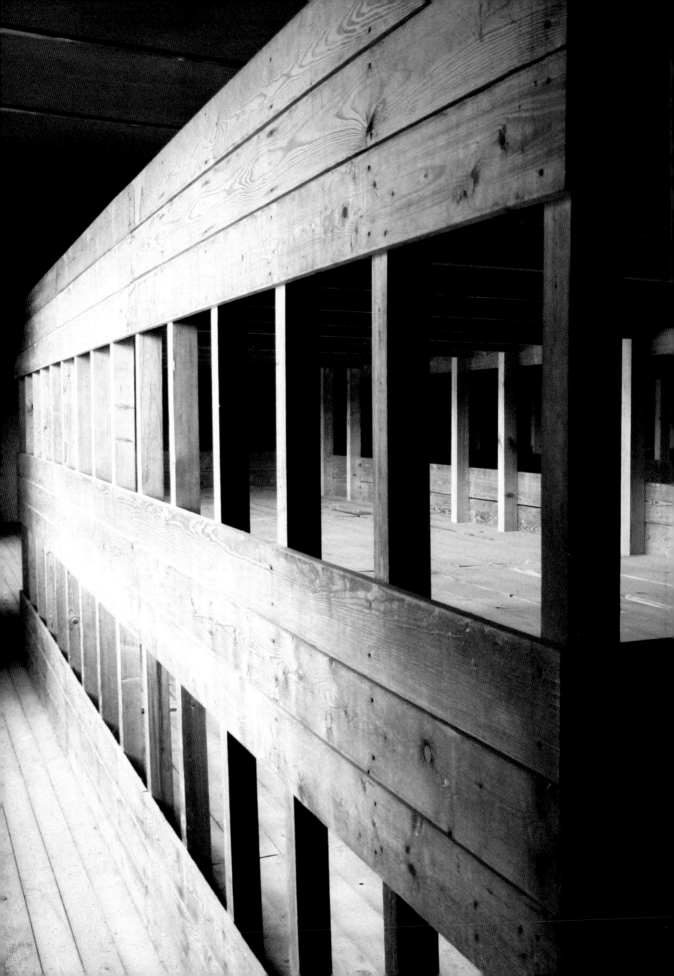

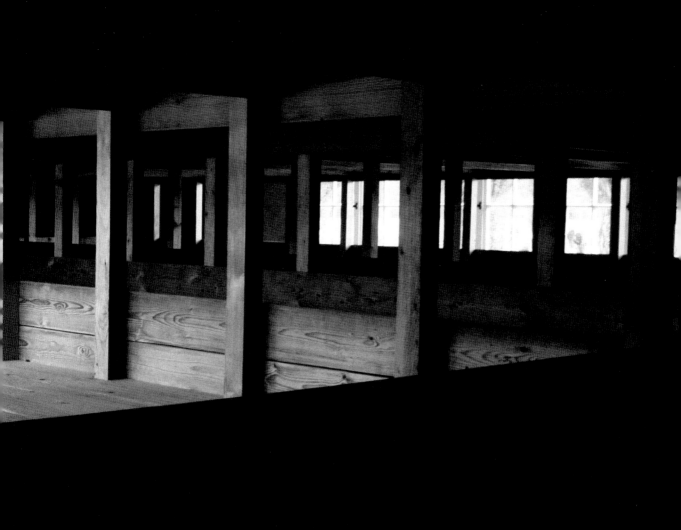

Arturo Benvenuti

Imprisoned

Drawings from Nazi Concentration Camps

Foreword by Primo Levi

Afterword by Roberto Costella

Translation by Jamie Richards

Skyhorse Publishing

The further that time distances us from it, and although the decades that have followed have not spared us violences or horrors, the story of Hitler's concentration camps is increasingly considered to be *a unicum*, an exemplary episode in the negative: **Man, you, were capable of doing this, the civilization of which you boast is a gloss, a garment, and when a false prophet comes and tears it off you, naked, you are a monster, the cruelest of animals.**

Since then, National Socialism (except for the few raving voices that justify, deny, or even celebrate its crimes) has been a reference point, a knot to be avoided. Countless works of testimony and analysis have appeared, but until now a book like this one has been missing in Italy. I think that, beyond pure remembrance, it has its own specific merit. In describing these horrors, words prove insufficient. The images reproduced here are not equivalents or surrogates: they replace the word, but with an advantage—they say what the word is not able to. Some have the immediate power of art; all have the raw power of the eye that has seen and that transmits its indignation.

For this collection—as Benvenuti too has seen—works produced after the fact, cold, in a studio, would have struck a false note, just as, even when written with the purest of intentions, the books where the camps have been fictionalized sound wrong. Here, save a few exceptions, the works come from there, from the hands of those who saw and experienced, and the exceptions are mostly from those who entered the camps as liberators and captured their final, convulsive images.

The editor is not a survivor of the concentration camps. He is an observant and devout man, sensitive to the past and the present; he is a poet-painter to whom, especially for this singular book he composed with such care, we all owe a little something.

Primo Levi
October 27, 1981

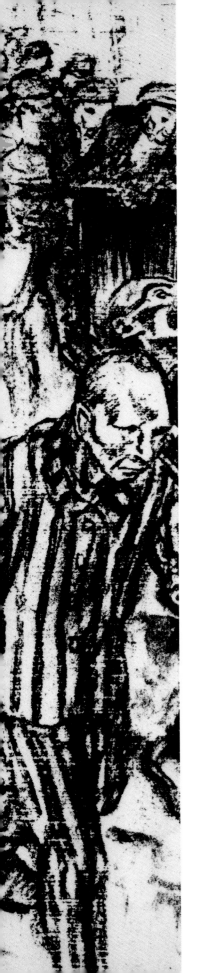

Without Words

The idea for this book is not from today. Today, it has come into being for a variety of reasons that I need not enumerate here. Everyone, generations old and new, is familiar with the accounts of human life from at least the last twenty years. There is plenty, if I'm not mistaken.

We all know how and where "freedom" and the "sacrosanct rights" of humanity ended up.

No doubts remain.

They told us: no more wars, no more oppression, persecution, genocide. Words. Nothing but words. And a sea of rhetoric. Exhausted, hypocritical rhetoric.

Humanity continues to kill, to massacre, to persecute, with increased ruthlessness. Before eyes that are increasingly indifferent, passive. When not complicit. There's no pity for the elderly, for women, for children. There's no pity for anyone anymore. Man is wolf to man, today as much as—and more than—yesterday.

The older generations seem to have learned very little; the new ones don't seem to want to learn any more. Wars continue to sow slaughter. Behind the barbed wire of new concentration camps, it has gone on; humanity has gone on being suppressed.

Most of all, this book aims to be—attempts to be—a contribution to the just "revolt" on behalf of those who feel like they can't, in spite of everything, resign themselves to a monstrous, terrifying reality. Those who believe they must still and always "resist." Without empty words. Without rhetoric. Just as without words or rhetoric resisted the authors of these images, awful "testimonies" of an immense tragedy. Acts of accusation, but also unequivocal messages from yesterday for today. Without useless speeches. There's really no need.

Arturo Benvenuti

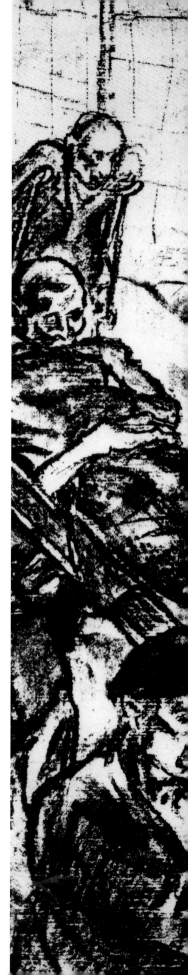

Editor's Note

I confess that, for me, organizing this project wasn't without its perplexities, especially concerning the methods of gathering and selecting this particular form of "testimony" given by art—almost always created in prohibitive material and spiritual conditions and at the risk of death—from the Nazi-Fascist concentration and extermination camps.

A book of art or of testimony, then? Testimony, however valid, does not always possess the necessary aesthetic criteria to support rigorous analysis. However, is it possible—or legitimate, I would say—to maintain the rigidity of the stern judge, the cold aesthete, with a project like this one?

This is why I decided to reconcile, within the limits of possibility, both of these demands, without losing sight of the fact that my primary intention had been to focus on "testimonies"—testimonies made by people of the most diverse nationalities, because there were few countries spared from experiencing and suffering the horrors of the immense tragedy.

I came to the conclusion that they could only be testimonies from people who, for one reason or another, had had a personal relationship, direct experience, with the concentration and extermination camps. It seemed right, then, and logical, to principally direct my attention to those made during that tragic time, or at most, immediately thereafter. Furthermore, I set out to explore *graphic* production (understanding the term "graphic" here in its larger sense, to include drawing, various engraving techniques, and watercolor), except for oil painting, which was done in the "camps" to a far lesser extent and in completely specific situations, and therefore of less interest for my project.

So then which of the many, many testimonies (there are thousands, for the victims number millions) should be privileged? What are the criteria for selection?

Not only the aesthetic, as I have said. This is why, alongside so many exceptional "folios," the work of professional artists, you also find others done by bonafide "naifs." So not infrequently we have drawings of a disarming "candor," often illustrations, which certainly have the flaw of excessively descriptive disposition, but are nonetheless no less valid in view of representing "events" and "moments" that humanity would have been better off if not called upon—for another time, and alas, not the last. And how should we deal with the children's drawings, especially from Terezín?

The reproductions of these works were not always entirely satisfactory, but this is usually attributable to their state of conservation, because the majority of them were drawn, understandably, in secret, with chance materials, and safeguarded in fortunate occurrences. Furthermore, it was not always possible to obtain careful photographic reproductions from their various owners (in public and private collections).

I have tried to locate the basic data for every author; i.e., first and last name, date, and place of birth. If at any point one of these elements is missing, it means that it is also unknown to the possessor of the work, and that additional attempts to investigate have proven futile. I would thus be grateful to anyone who can inform me of the numerous defects that I have undoubtedly incurred, thereby providing me with the means to remedy them.

Thank you.

A.B.

TO THE INNOCENT VICTIMS OF BARBARISM IN ALL TIMES.

The drawings are arranged in alphabetical order according to the artists' last names.

This book is a photographic reproduction of these works for the purpose of documentation and discussion.

Sources are listed at the end of the volume.

Bernhard Alherbert, b. France
Ready for the Crematorium, 1945
Gusen Concentration Camp, Austria

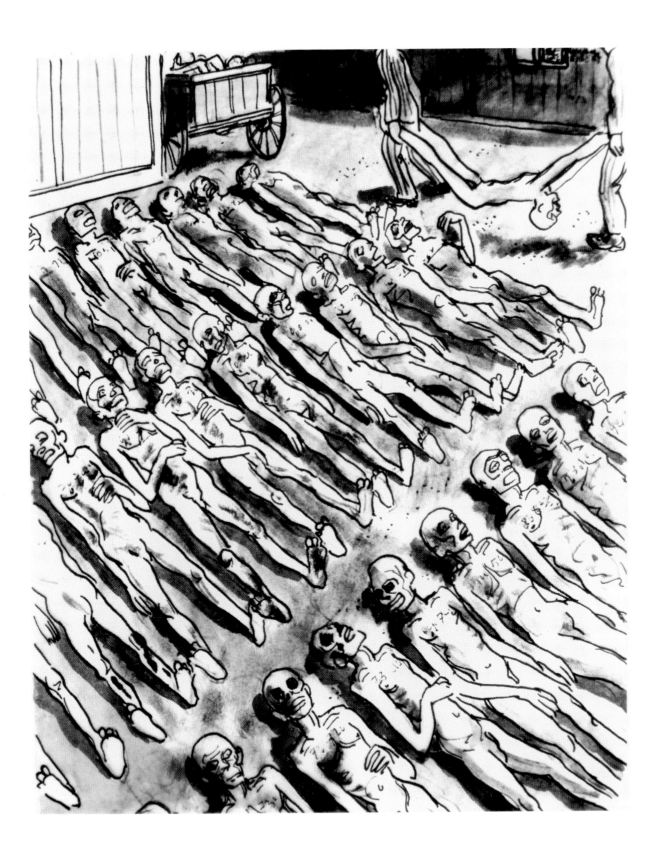

15

Bernhard Alherbert, b. France
Jewish Boys Drain the Black Well, 1945
Gusen II Concentration Camp, Austria

Bernhard Alherbert, b. France
Block 16, 1945
Gusen II Concentration Camp, Austria

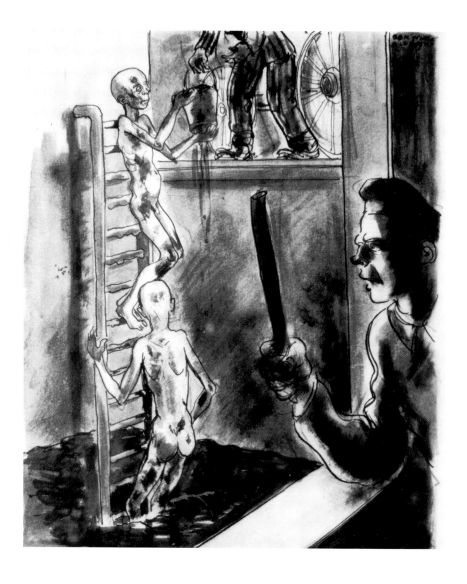

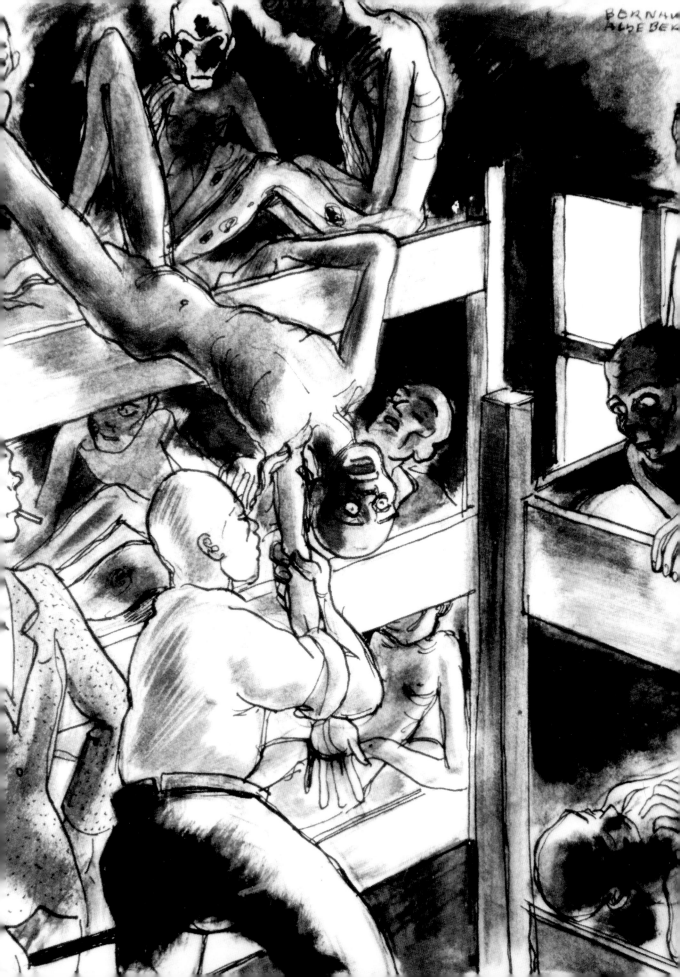

Irène Awret, b. Germany
Boy with Cap, 1943
Mechelen Transit Camp, Belgium

Yehuda Bacon, b. Czechoslovakia, 1929
Musulmano, 1945
Gusen II Concentration Camp, Austria

Yehuda Bacon, b. Czechoslovakia, 1929
Transporting the Dead, 1943–45
Oswiecim Concentration Camp, Poland

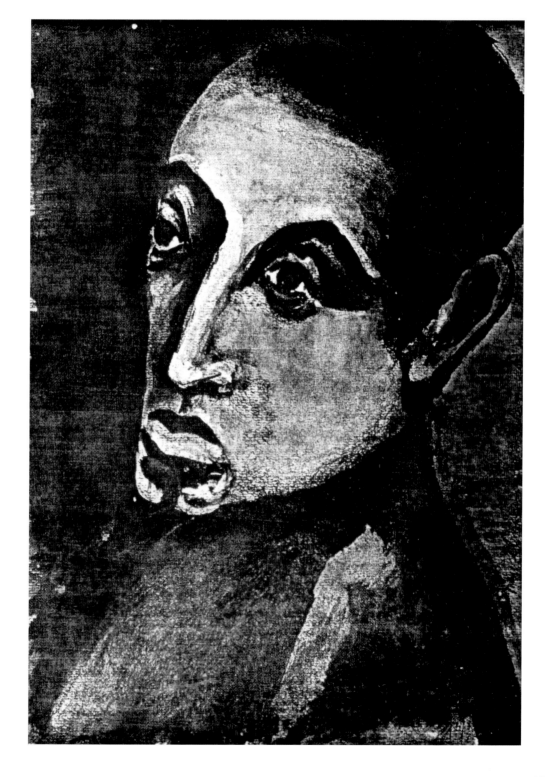

Agostino Barbieri, b. Italy, 1915
A Victim of the Quarry, 1945

Agostino Barbieri, b. Italy, 1915
Gas Chambers, 1945

Agostino Barbieri, b. Italy, 1915
Cremation Oven, 1945

Agostino Barbieri, b. Italy, 1915
Work is Freedom, 1945

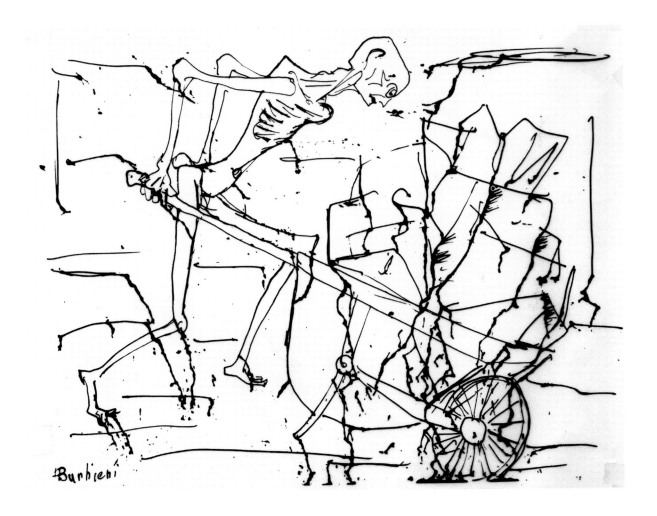

BIM, b. Poland
Commandant Seidler During an Interrogation, 1944
Gusen Concentration Camp, Austria

Renato Birolli, b. Italy, 1906
Deportation

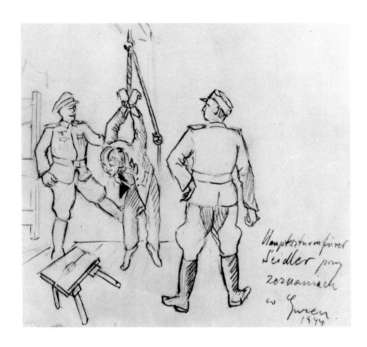

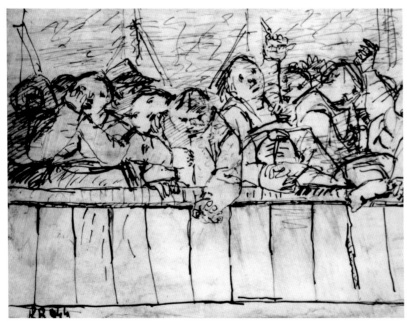

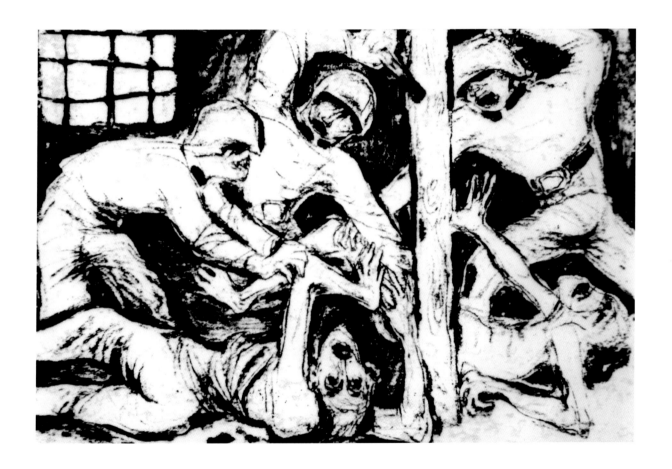

Ferdinand Bloch, b. 1898
Arrival of a Transport, 1942
Terezín Concentration Camp, Czechoslovakia

Ferdinand Bloch, b. 1898
Prayer Room, 1943
Terezín Concentration Camp,
Czechoslovakia

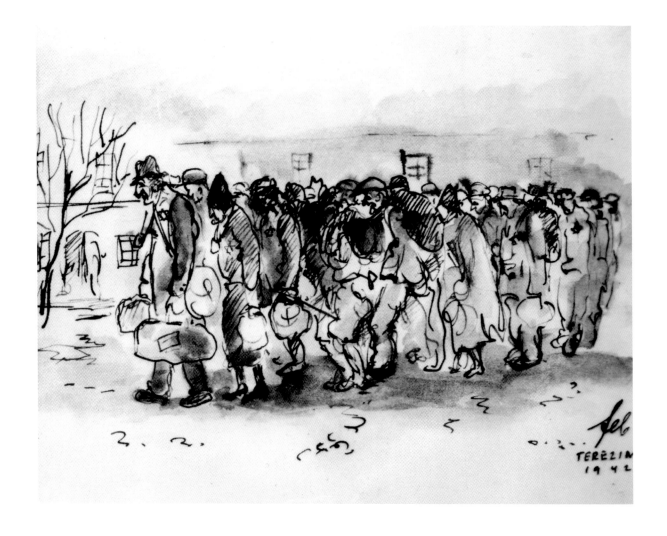

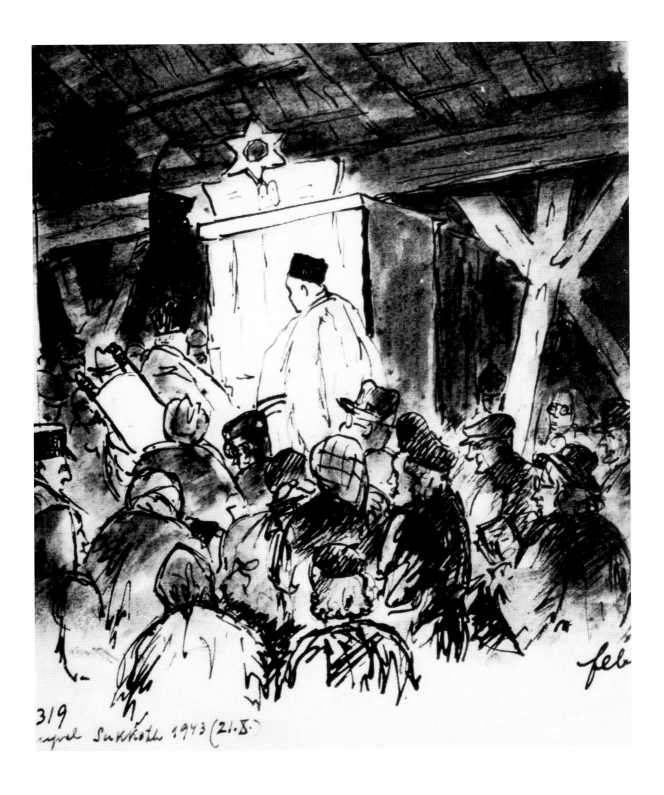

319
Synagoge Sukkoth 1943 (21.X.)

feb

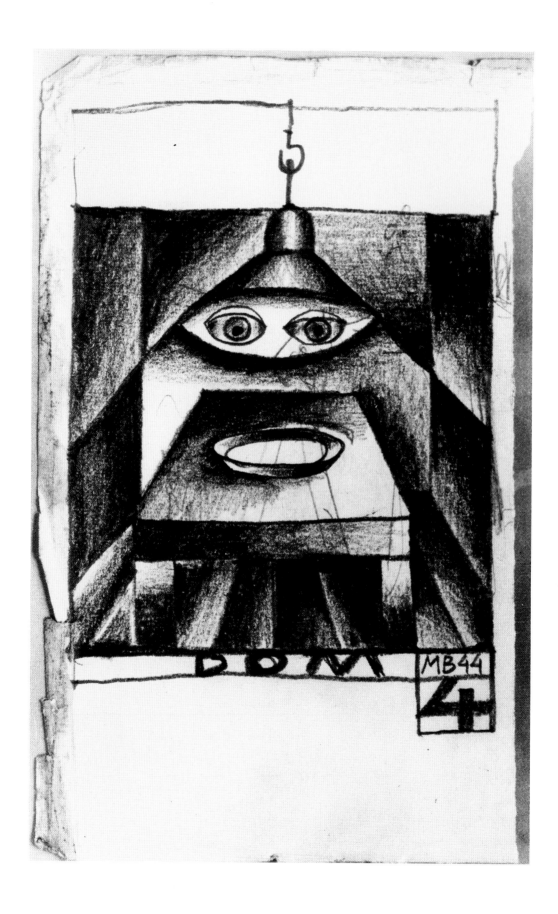

Marian Bogusz, b. Poland, 1920
The Stoker's Eyes I, 1944
Mauthausen Concentration Camp, Austria

Marian Bogusz, b. Poland, 1920
The Stoker's Eyes II, 1944
Mauthausen Concentration Camp, Austria

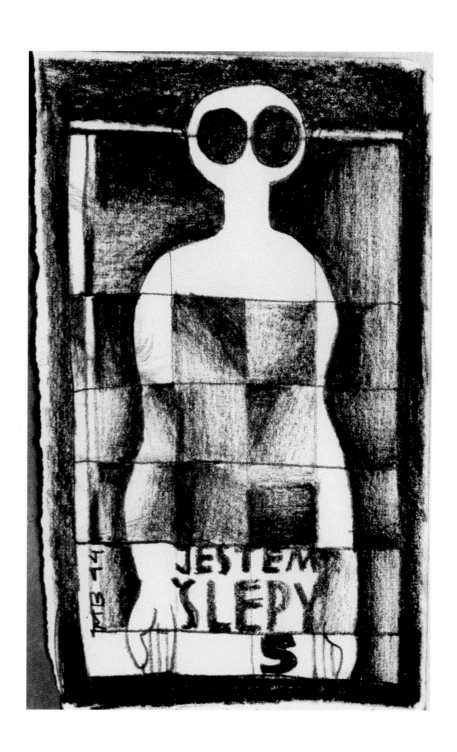

Marian Bogusz, b. Poland, 1920
The Stoker's Eyes III, 1944
Mauthausen Concentration Camp, Austria

The Cremation Oven

In the palms of their hands
they grasped
the little dust, the null
left by life, the trace
furtively dispersed
over the waters of the murky
pond.
The toothless slot
mustered a dull sneer.

Arturo Benvenuti
Oswiecim-Birkenau, June 1980

Jerzy Adam Brandhuber, b. Poland, 1897
Patients in the Hospital, 1946
Oswiecim Concentration Camp, Poland

Jerzy Adam Brandhuber, b. Poland, 1897
Execution, 1946
Oswiecim Concentration Camp, Poland

Jerzy Adam Brandhuber, b. Poland, 1897
Against the Wire, 1946
Oswiecim Concentration Camp, Poland

Jerzy Adam Brandhuber, b. Poland, 1897
Roll Call - June 1943, 1946
Oswiecim Concentration Camp, Poland

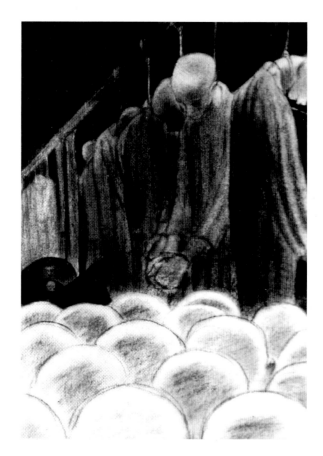

Jerzy Adam Brandhuber, b. Poland, 1897
Muselmann, 1946
Oswiecim Concentration Camp, Poland

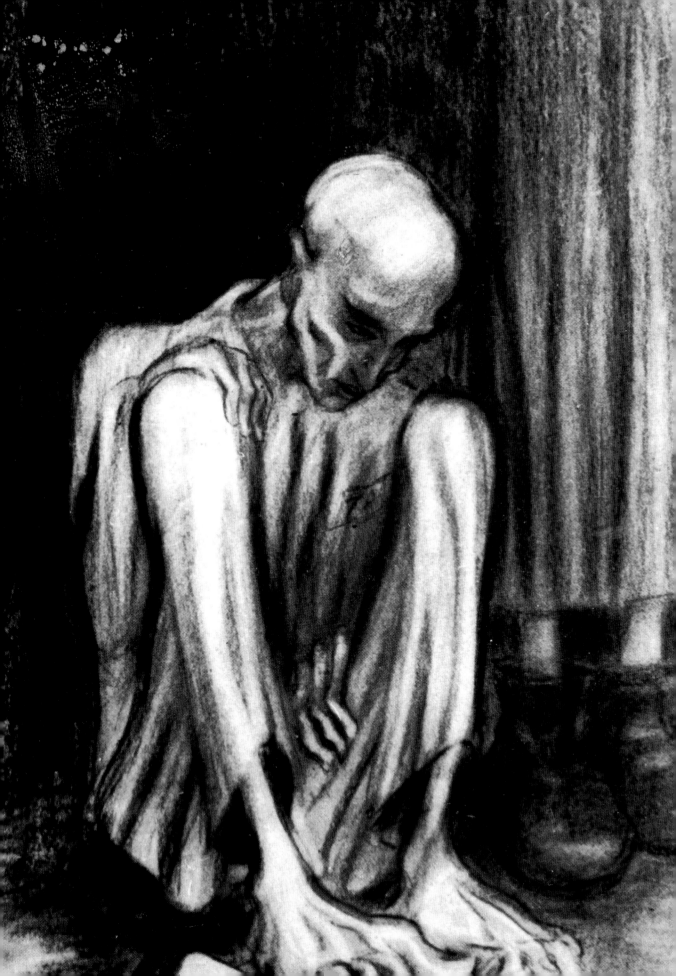

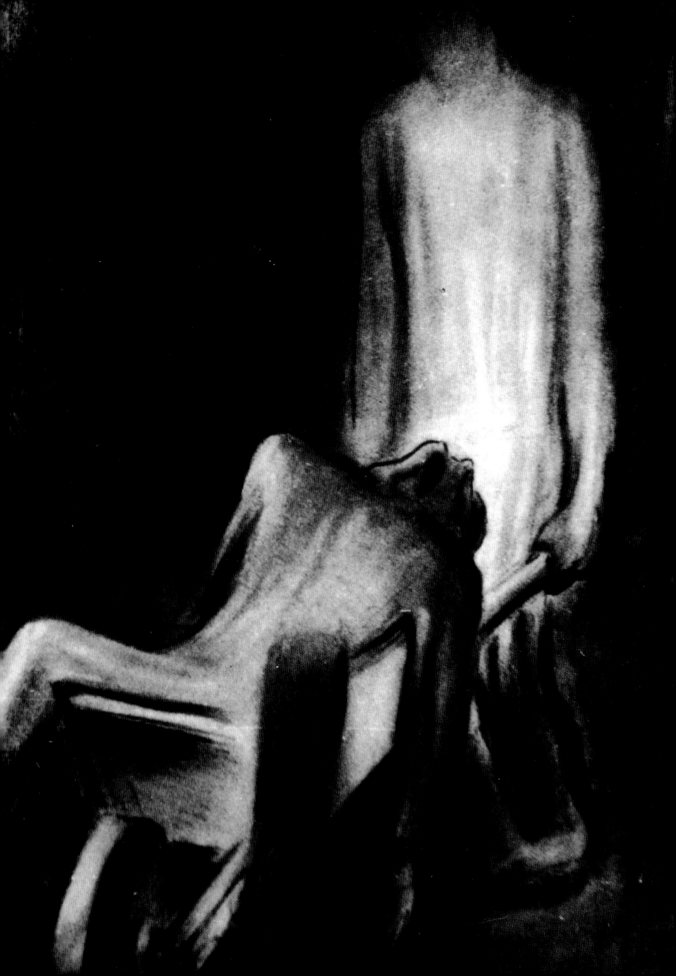

Jerzy Adam Brandhuber, b. Poland, 1897
Transport, 1946
Oswiecim Concentration Camp, Poland

Jerzy Adam Brandhuber, b. Poland, 1897
This Is How the Road was Built, 1946
Oswiecim Concentration Camp, Poland

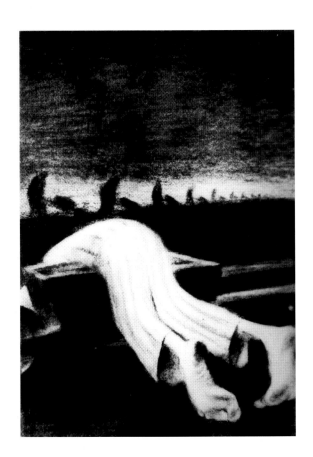

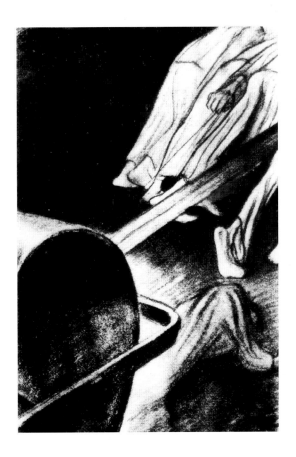

Jerzy Adam Brandhuber, b. Poland, 1897
Return from Work, 1946
Oswiecim Concentration Camp, Poland

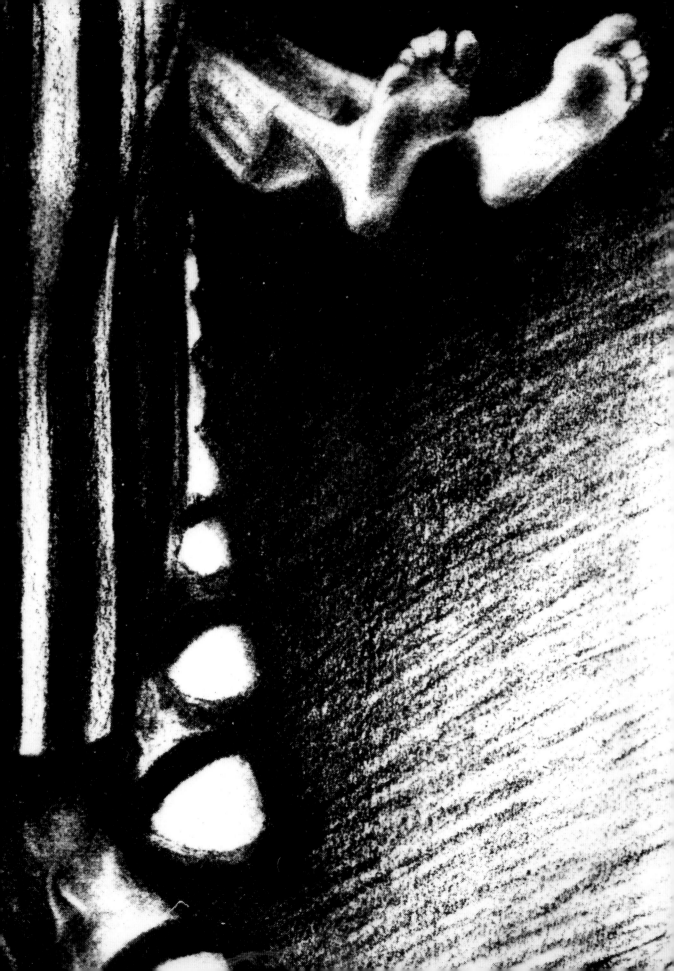

Jerzy Adam Brandhuber, b. Poland, 1897
Roll Call, 1946
Oswiecim Concentration Camp, Poland

Jerzy Adam Brandhuber, b. Poland, 1897
Song, 1946
Oswiecim Concentration Camp, Poland

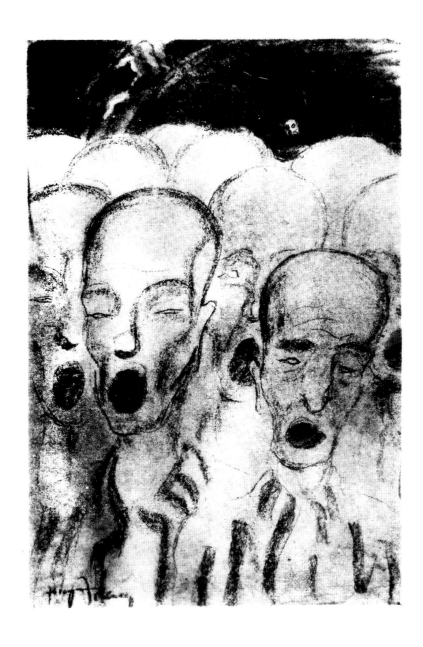

Jerzy Adam Brandhuber, b. Poland, 1897
Against the Wire, 1946
Oswiecim Concentration Camp, Poland

Jerzy Adam Brandhuber, b. Poland, 1897
Arbeit macht frei, 1946
Oswiecim Concentration Camp, Poland

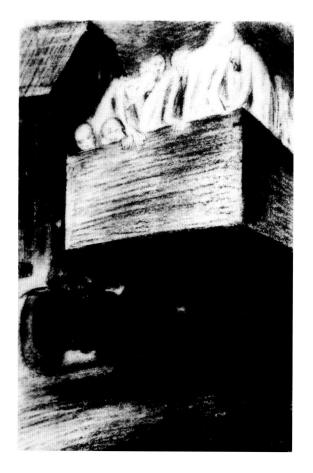

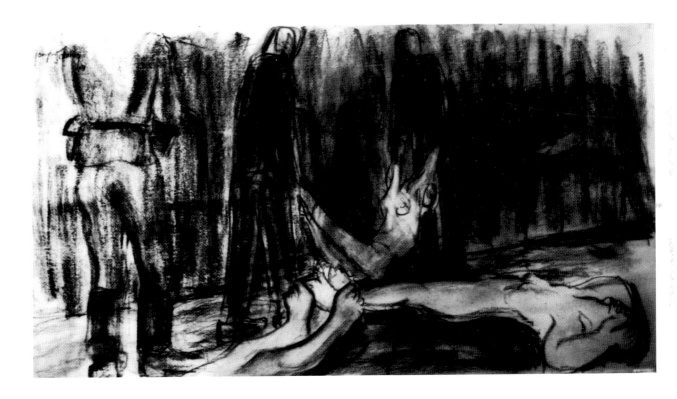

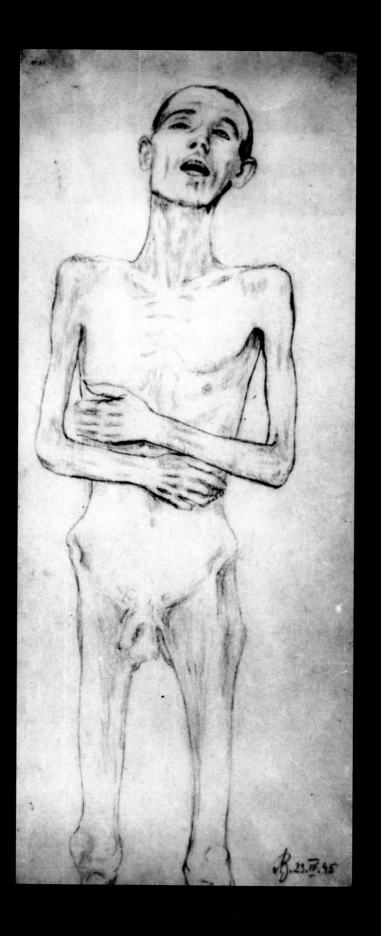

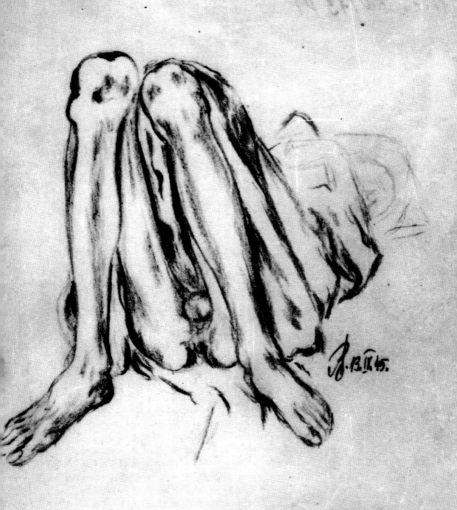

Charlotte Buresova, b. Czechoslovakia, 1904
Elderly People in Terezín, 1943

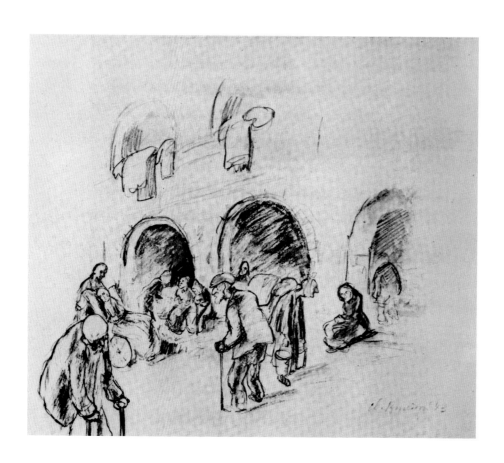

Corrado Cagli, b. Italy, 1910
Boy in the Camp, 1945
Buchenwald Concentration Camp, Germany

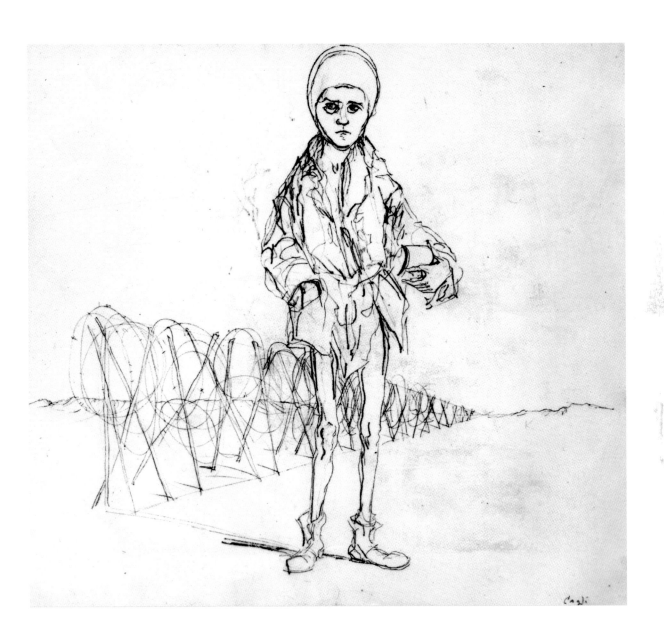

Corrado Cagli, b. Italy, 1910
Buchenwald I, 1945
Buchenwald Concentration Camp, Germany

Corrado Cagli, b. Italy, 1910
Buchenwald II, 1945
Buchenwald Concentration Camp, Germany

Corrado Cagli, b. Italy, 1910
Buchenwald III, 1945
Buchenwald Concentration Camp, Germany

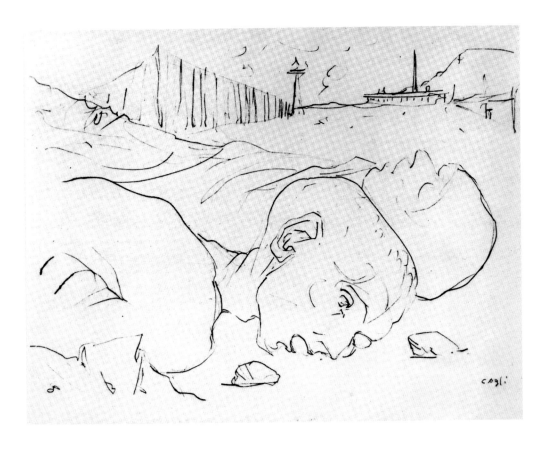

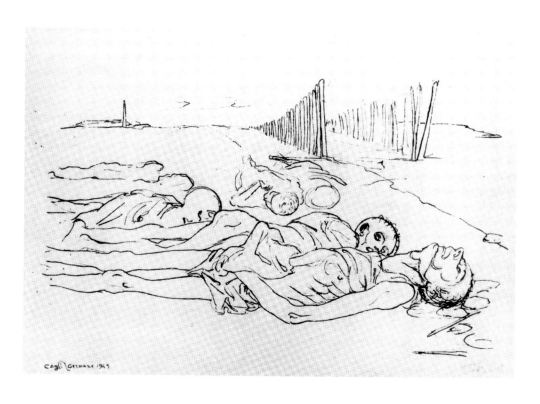

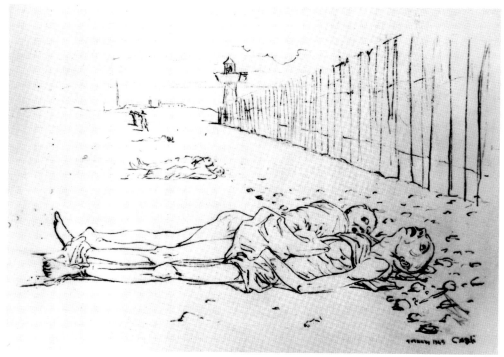

Aldo Carpi, b. Italy, 1886
Gusen Kommando, 1945
Gusen Concentration Camp, Austria

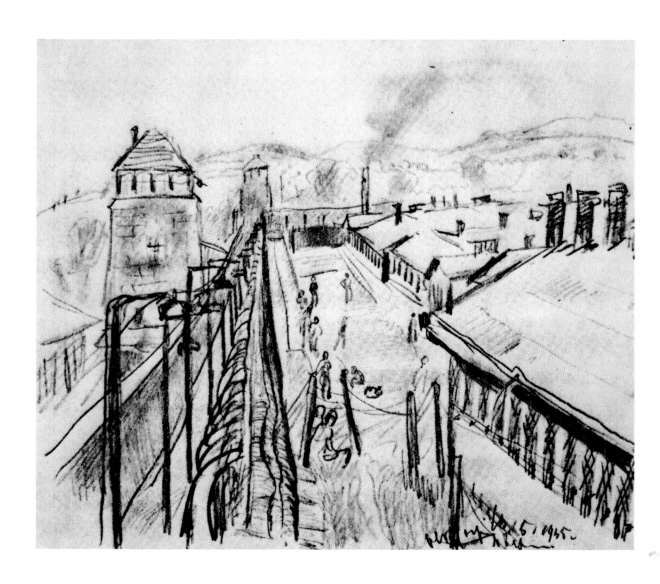

Aldo Carpi, b. Italy, 1886
Jews in Front of the Gusen Hospital, 1945
Gusen Concentration Camp, Austria

Aldo Carpi, b. Italy, 1886
Last Companion in the Gusen Cremation Oven, 1945
Gusen Concentration Camp, Austria

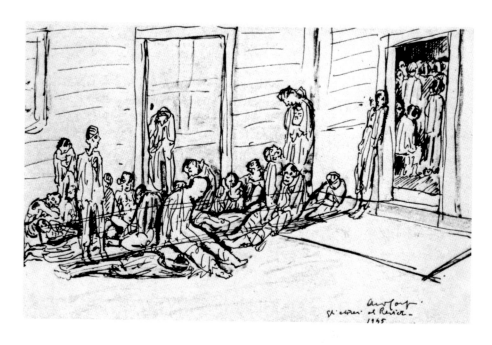

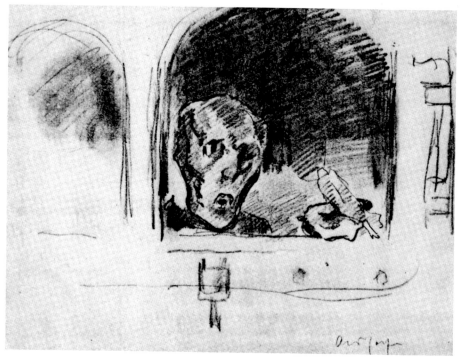

Aldo Carpi, b. Italy, 1886
Bodies in Front of the Crematorium I, 1945
Gusen Concentration Camp, Austria

Aldo Carpi, b. Italy, 1886
Bodies in Front of the Crematorium II, 1945
Gusen Concentration Camp, Austria

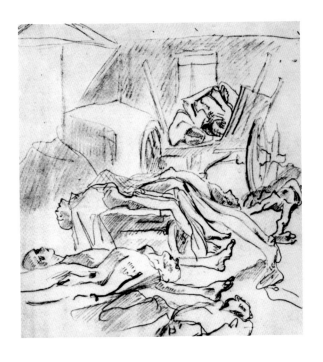

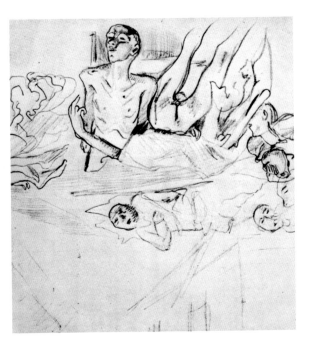

Aldo Carpi, b. Italy, 1886
Internees, 1945
Mauthausen-Gusen Concentration Camp, Austria

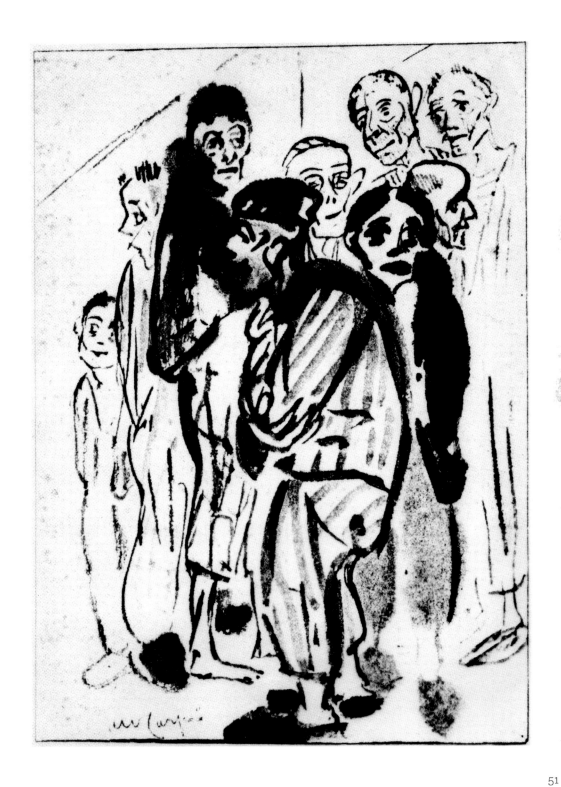

Gheorghe Ceglocoff, b. USSR, 1904
Roll Call, 1941
Targu Jiu Concentration Camp, Romania

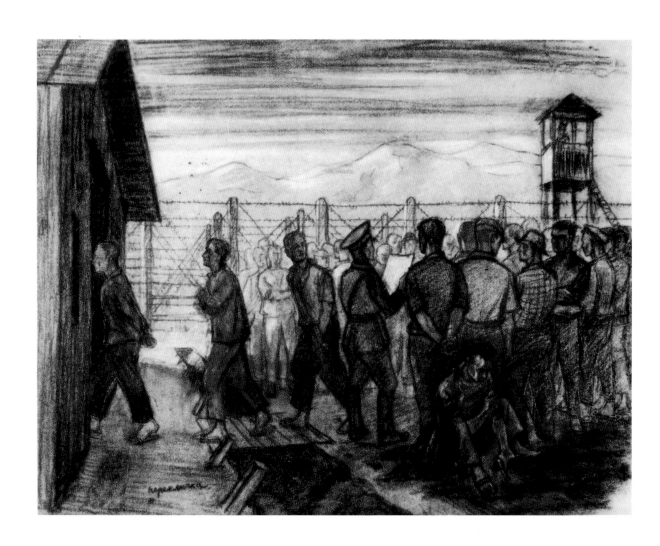

Gheorghe Ceglocoff, b. USSR, 1904
Liberated, 1941

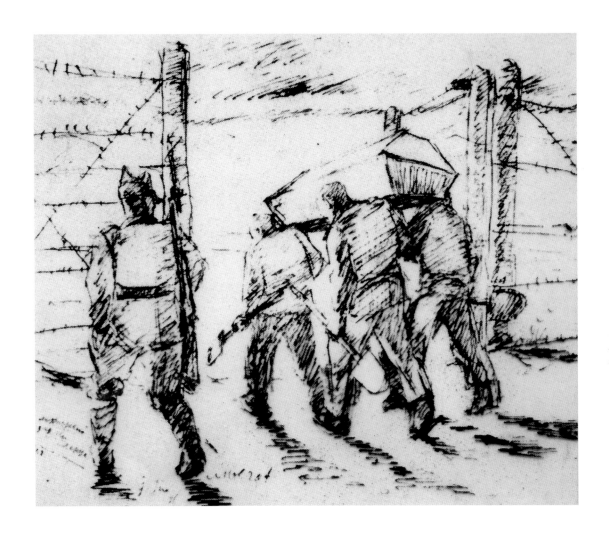

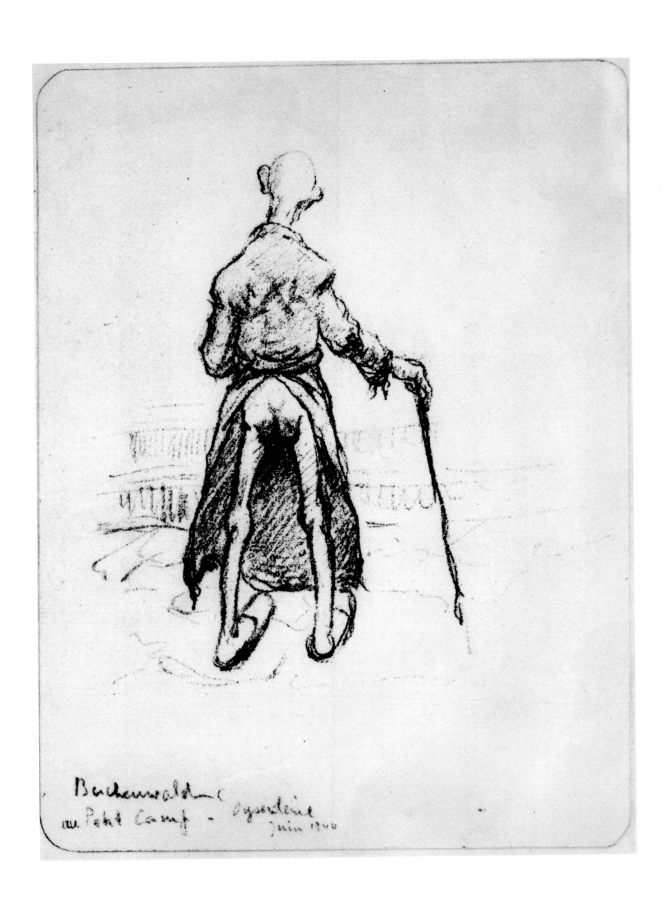

Buchenwald –
au Petit Camp – Agonteue
Juin 1944

54

Léon Delarbre, b. France, 1889
Dysentery, 1944
Buchenwald Concentration Camp, Germany

Léon Delarbre, b. France, 1889
The Day After Liberation: Too Late, 1945
Bergen-Belsen Concentration Camp, Germany

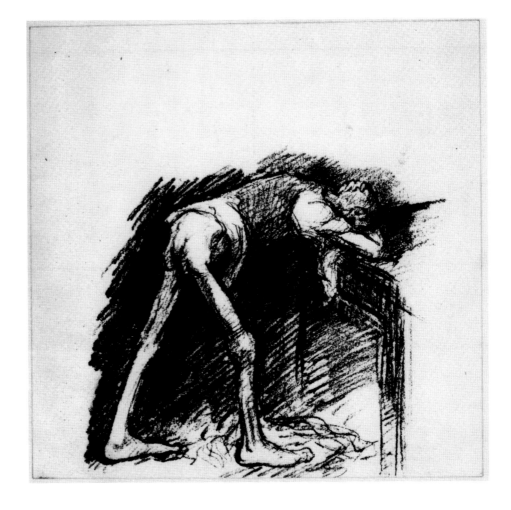

Léon Delarbre, b. France, 1889
Big Georg, Oberkapo of Werk II:
One of the Most Brutal in the Germans' Service, 1944
Dora Concentration Camp, Germany

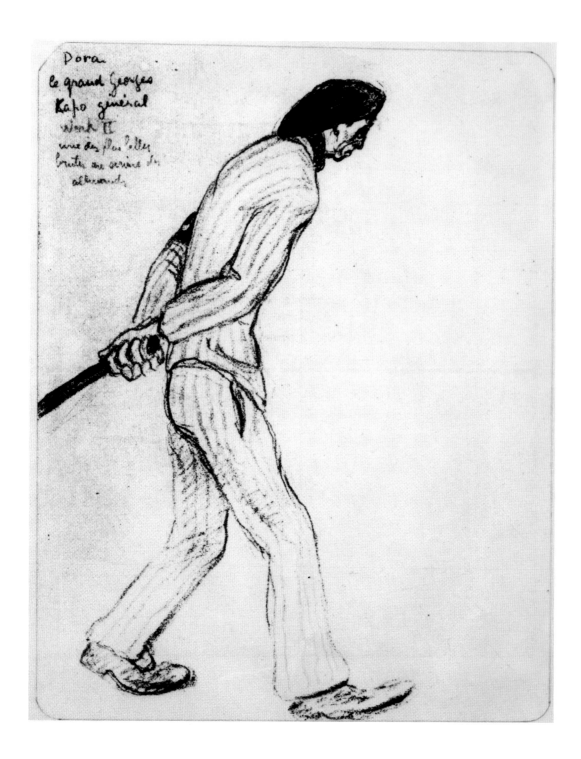

Léon Delarbre, b. France, 1889
One of the Madmen in the Little Camp, 1944
Buchenwald Concentration Camp, Germany

Léon Delarbre, b. France, 1889
The Hanged, 1945
Dora Concentration Camp, Germany

Léon Delarbre, b. France, 1889
Hanged Men, 1945
Dora Concentration Camp, Germany

Aleksandar Deroko, b. Yugoslavia, 1894
Hostages in the Banjica-Belgrade Camp, 1941
Banjica-Belgrade Concentration Camp, Yugoslavia

Rada Drakulić, b. Yugoslavia, 1825
Fellow Prisoners, 1943
Novi Sad Concentration Camp, Yugoslavia

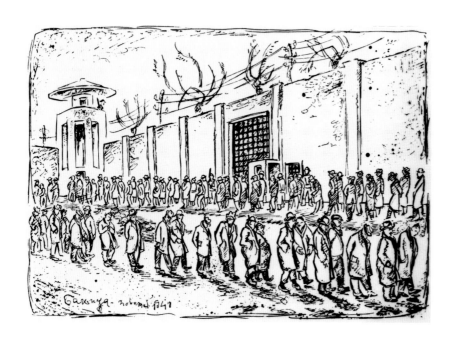

Xawery Dunikowski, b. Poland, 1875
Portrait of Jan Szymczak, 1940
Oswiecim Concentration Camp, Poland

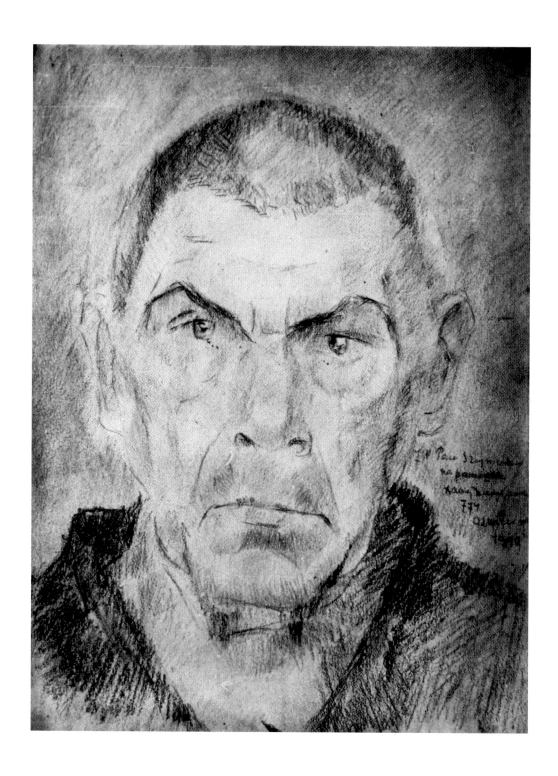

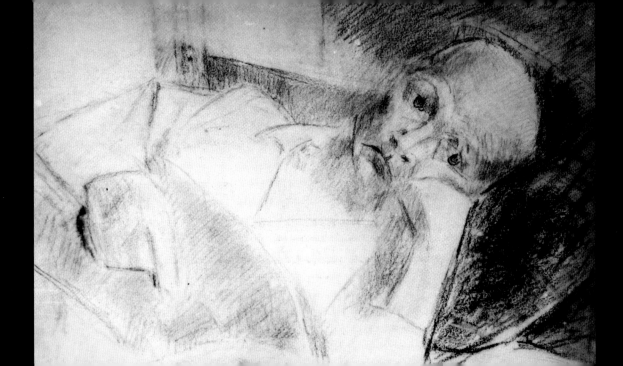

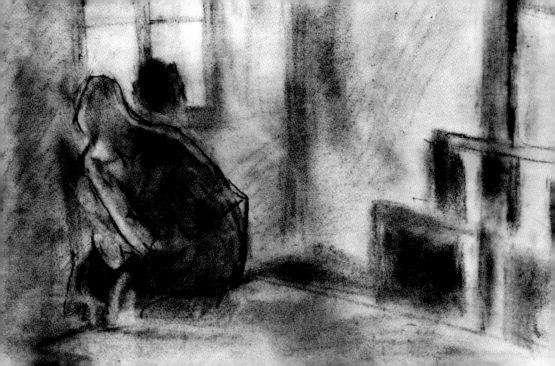

Xawery Dunikowski, b. Poland, 1875
Portrait of an Internee, 1943–44
Oswiecim Concentration Camp, Poland

Xawery Dunikowski, b. Poland, 1875
Portrait of an Internee
Oswiecim Concentration Camp, Poland

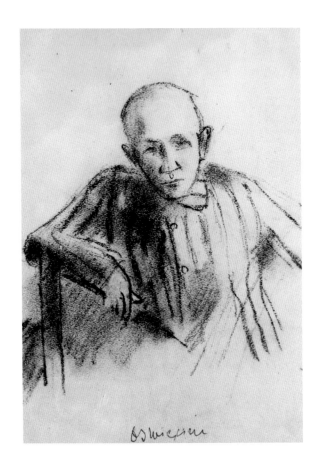 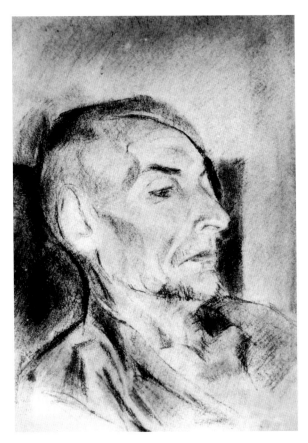

Xawery Dunikowski, b. Poland, 1875
Road to Freedom, 1943–44

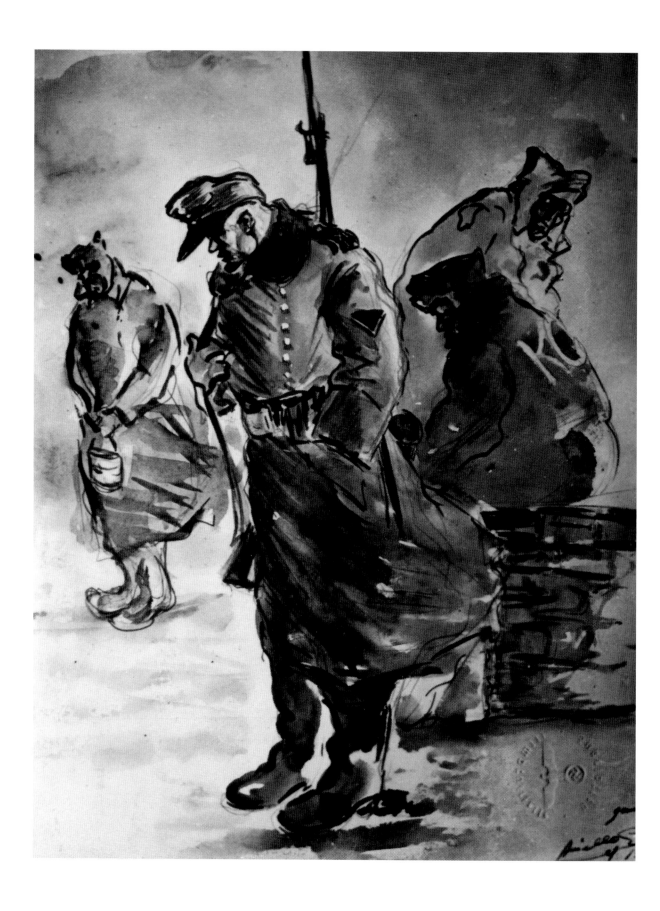

Aniello Eco, b. Italy, 1919
The Iron Curtain, 1944
Fallingbostel Camp, Germany

Aniello Eco, b. Italy, 1919
Christmas in the Camp, 1944
Fallingbostel Camp, Germany

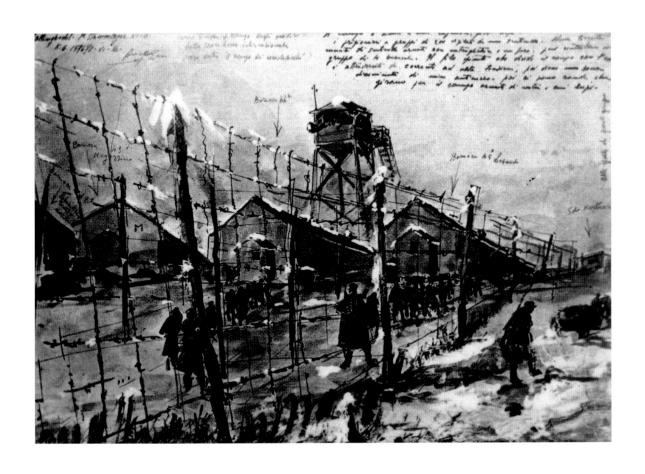

Karel Fleischmann, b. Czechoslovakia, 1896
Registration, 1943

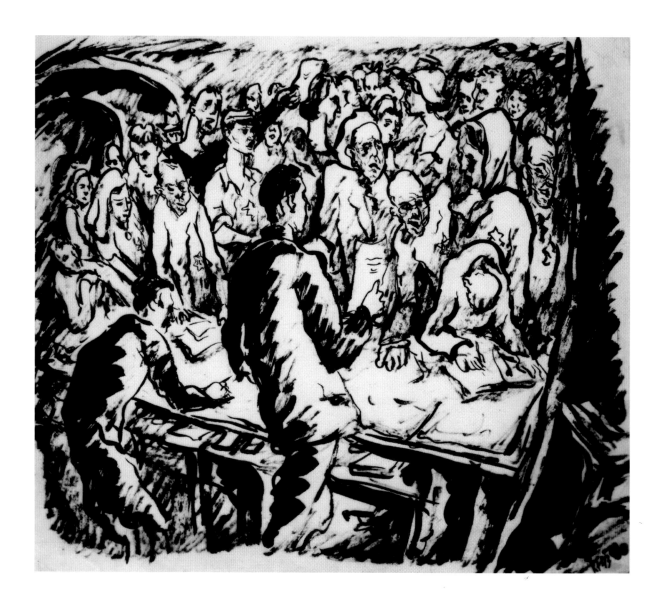

Karel Fleischmann, b. Czechoslovakia, 1896
Transport I, 1943

Karel Fleischmann, b. Czechoslovakia, 1896
Transport II, 1943

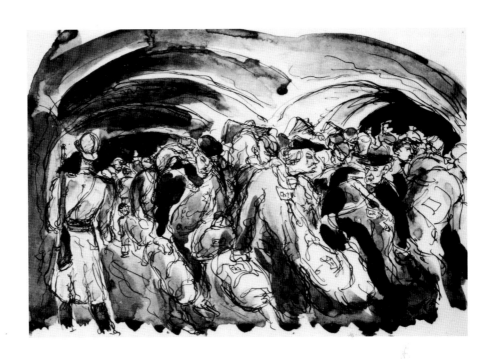

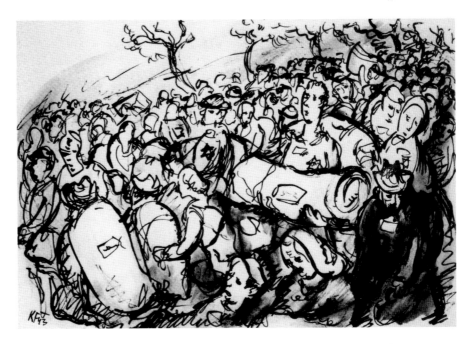

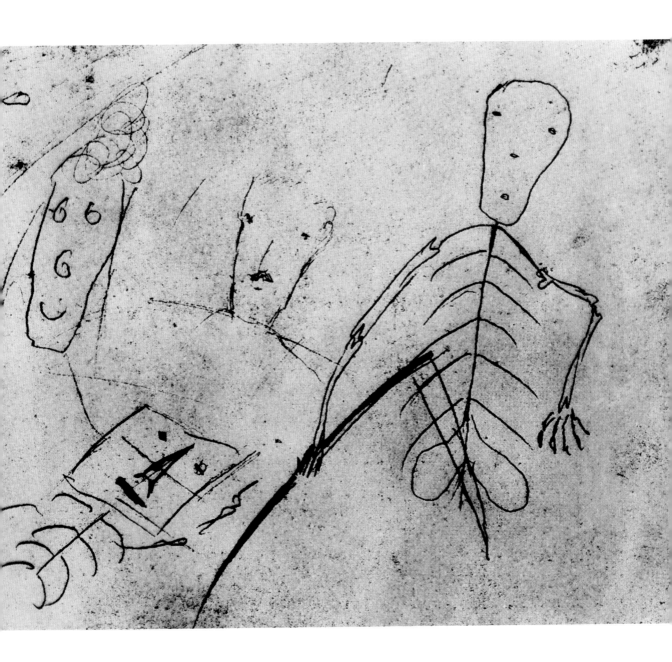

Wladimir Flusser, b. Poland, 1931
At Terezín
Terezín Concentration Camp, Czechloslovakia

The Tunnel

For a long time I cultivated
your loving memory.
On the stone
soaked in shadow
the wild shudder
the vortex of judgment
reverberates still
I give myself back to you
in the whirlpool of the freezing tunnel
with the worry of the anguished hours;
by secret paths
the tumult of the heart
spreads through the veins.
A little livid flesh
covered the bones.
If only the name
exiled in the chest
could have given you death without din.
Full will be our lives
when the right measure
of your lucid agony
will be able to grow inside us.

Arturo Benvenuti
Terezín, June 1980

[The tunnel is the passageway in Terezín that led to the gas chambers.]

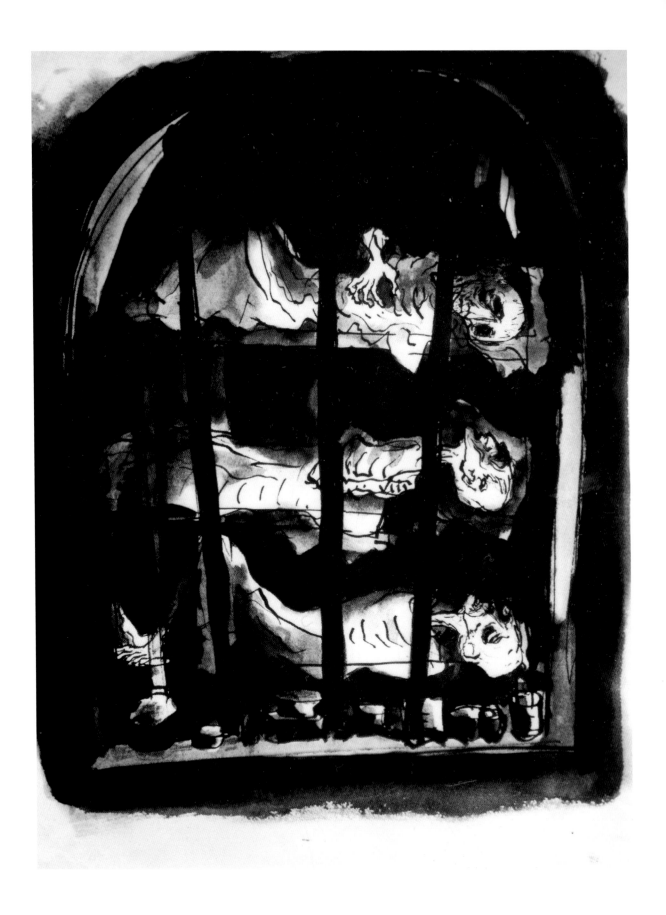

Bedrich Fritta, b. Czechoslovakia, 1906
Elderly Prisoners Lodging in the Kavalierkaserne

Bedrich Fritta, b. Czechoslovakia, 1906
Little Theater at Terezín, 1944
Terezín Concentration Camp, Czechloslovakia

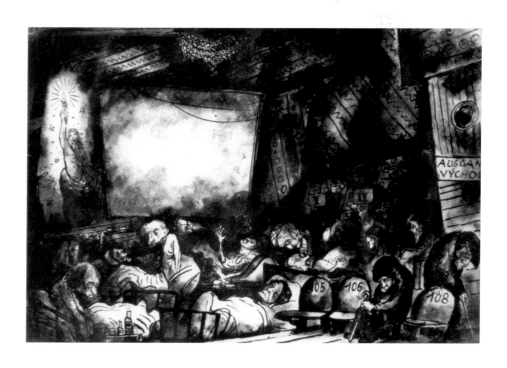

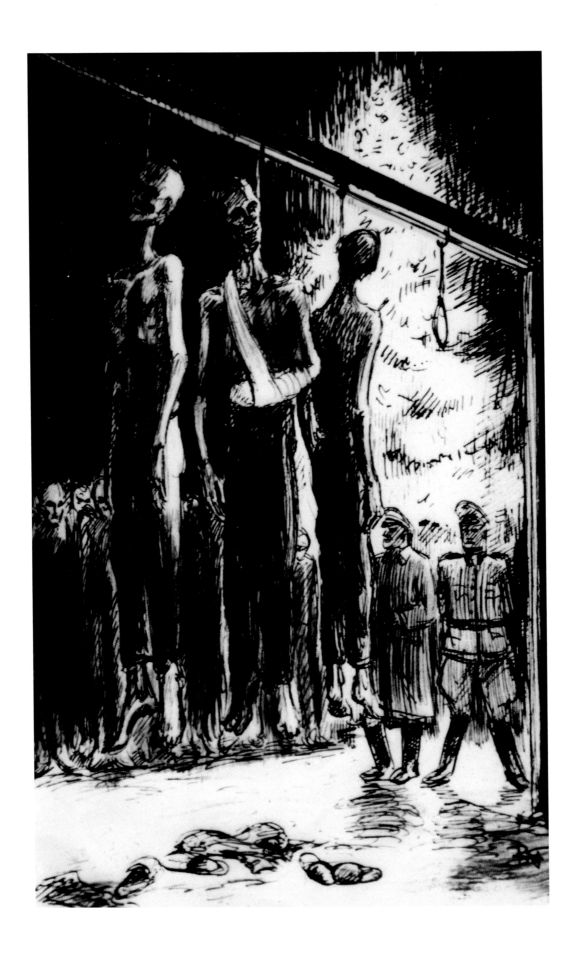

Bruno Furch, b. Austria, 1913
Night Execution
Flossenbürg Concentration Camp, Germany

Bruno Furch, b. Austria, 1913
Untitled

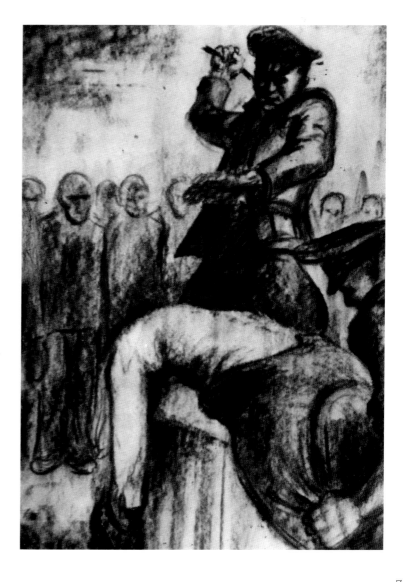

Bruno Furch, b. Austria, 1913
Untitled I

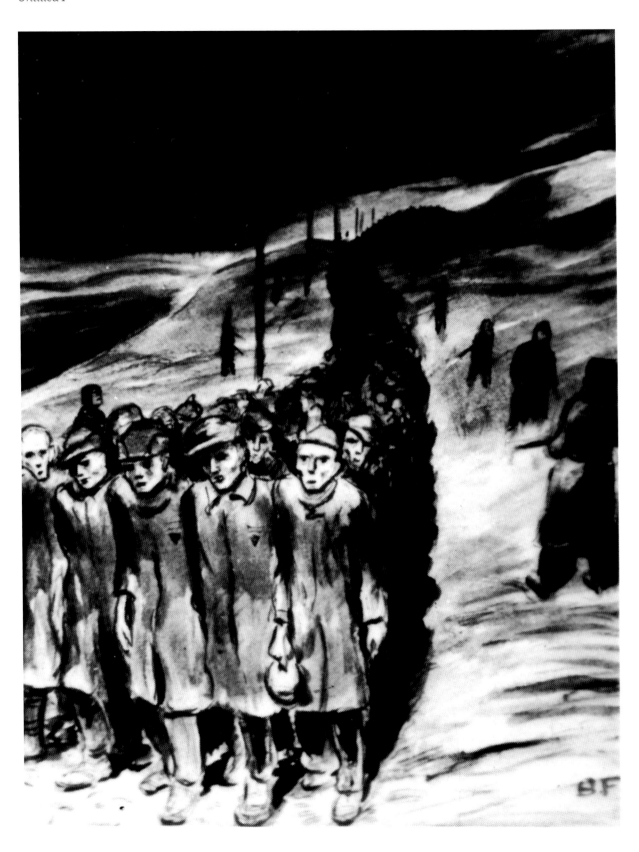

Leo Hass, b. Czechoslovakia, 1901
Blind Internees at Terezín, 1943
Terezín Concentration Camp, Czechoslovakia

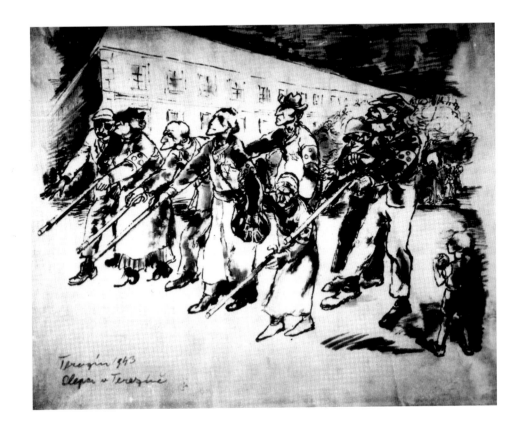

Leo Hass, b. Czechoslovakia, 1901
Waiting, 1947

Leo Hass, b. Czechoslovakia, 1901
Oswiecim, 1947

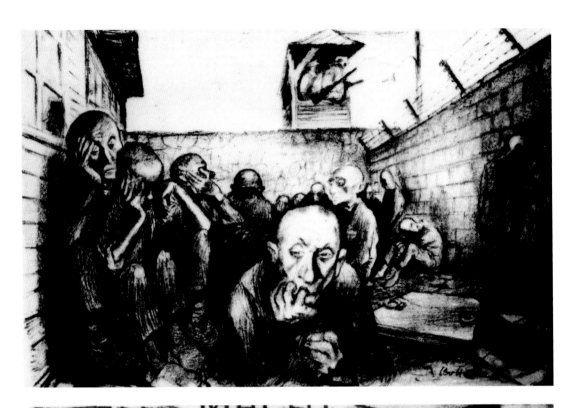

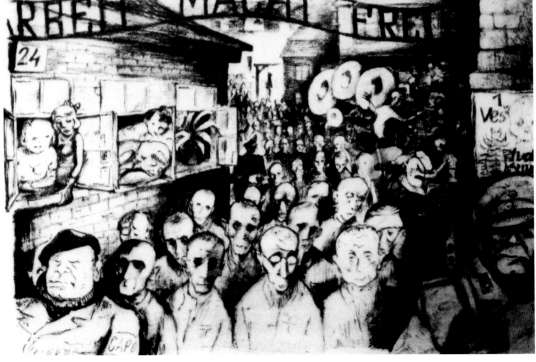

Leo Hass, b. Czechoslovakia, 1901
Call to Order, 1947

Leo Hass, b. Czechoslovakia, 1901
Hunger, 1947

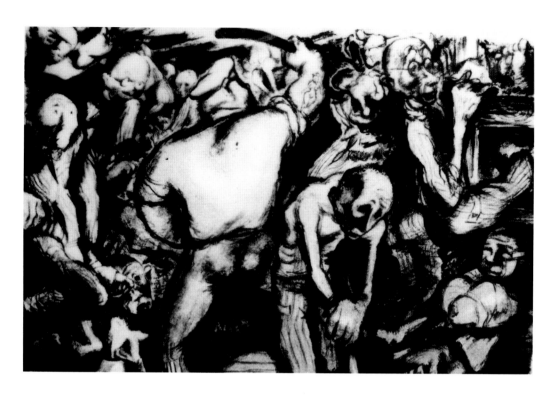

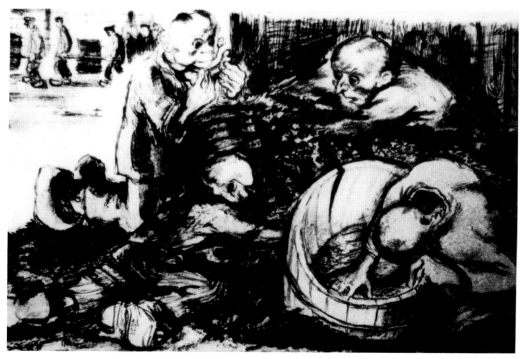

Leo Hass, b. Czechoslovakia, 1901
Appelplatz, 1947

Leo Hass, b. Czechoslovakia, 1901
Arbeit macht frei, 1947

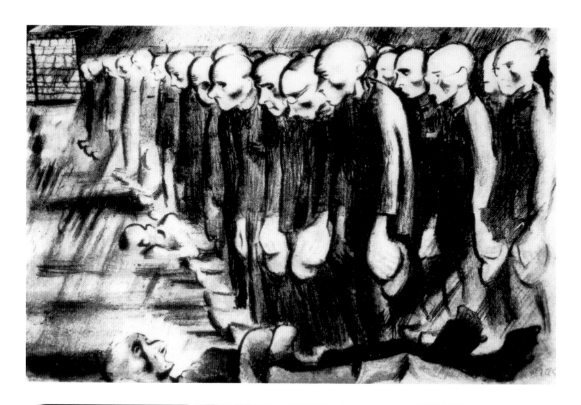

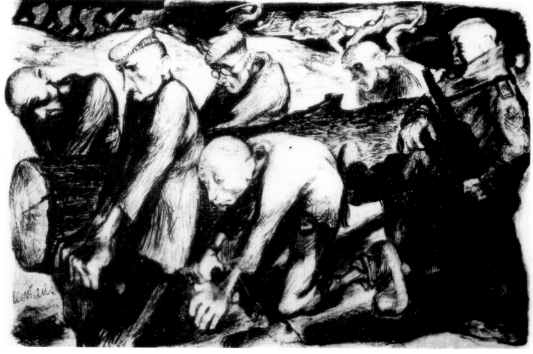

Leo Hass, b. Czechoslovakia, 1901
Mortuary, 1943
Terezín Concentration Camp, Czechoslovakia

Leo Hass, b. Czechoslovakia, 1901
In the Crematorium, 1947

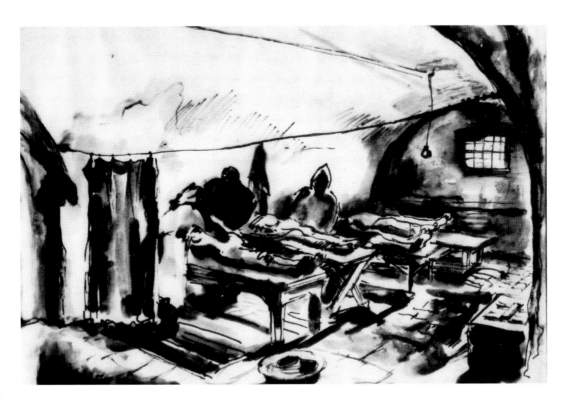

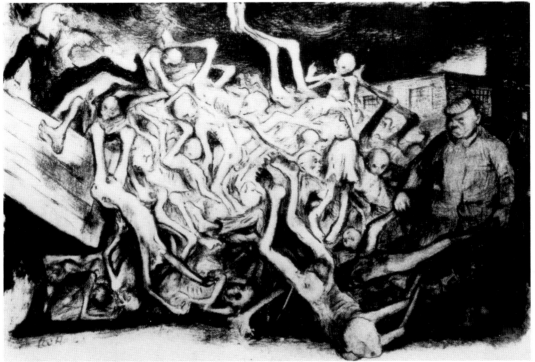

Maria Hiszpanska-Neumann, b. Poland, 1917
Hauling Stones, 1944
Ravensbrück Concentration Camp, Germany

Maria Hiszpanska-Neumann, b. Poland, 1917
Internee at Ravensbrück, 1944
Ravensbrück Concentration Camp, Germany

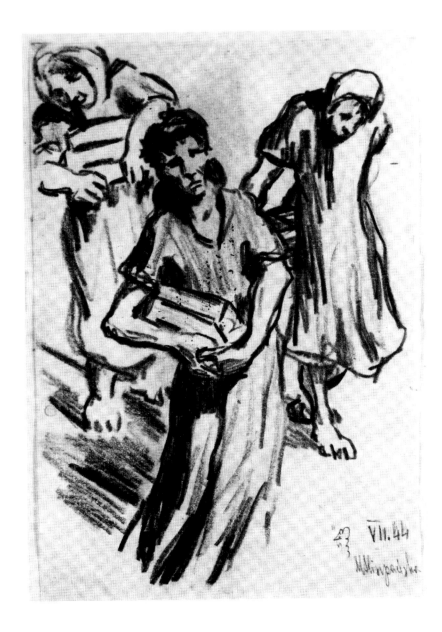

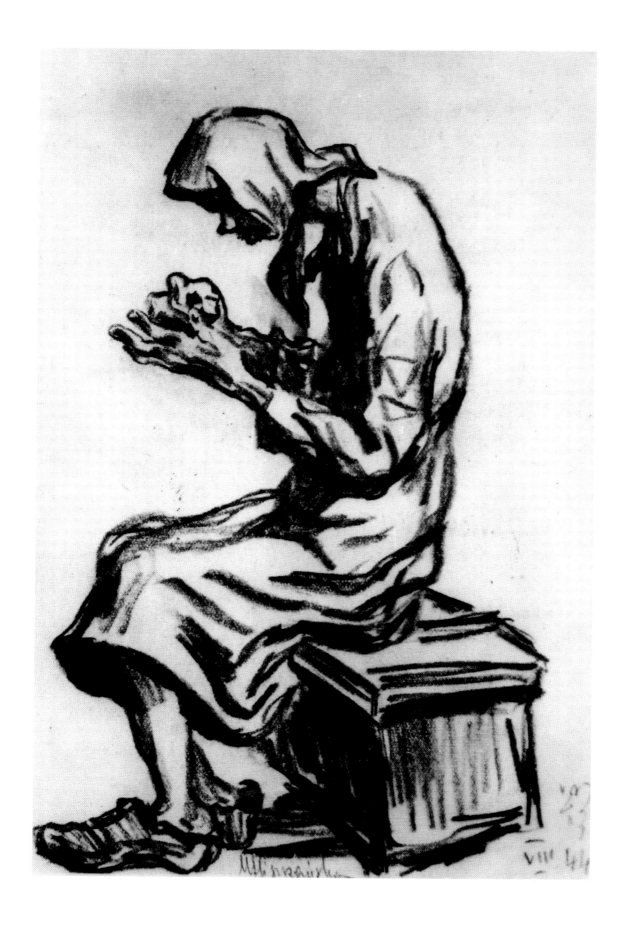

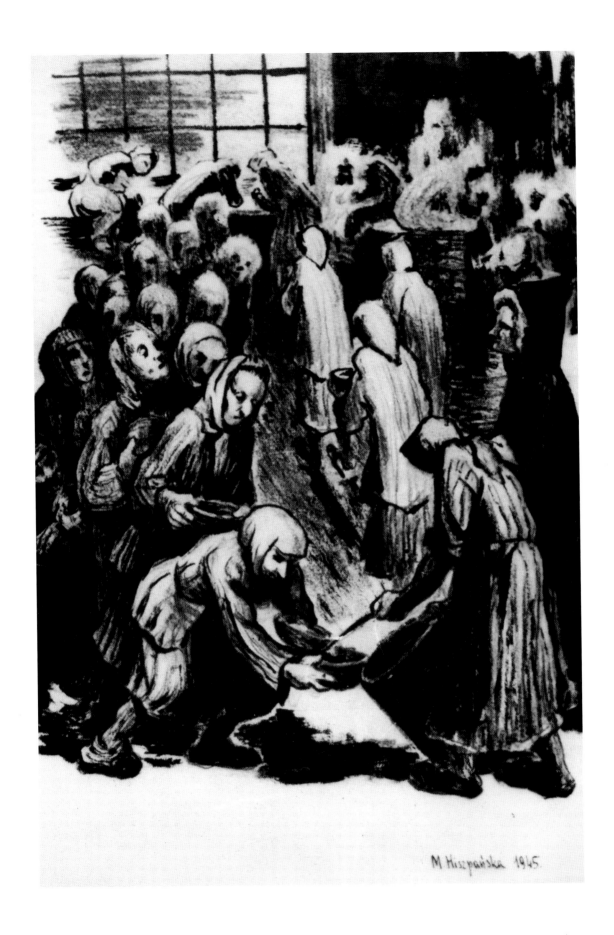

M Hiszpańska 1945.

Maria Hiszpanska-Neumann, b. Poland, 1917
Distribution of the Meal, 1945
Ravensbrück Concentration Camp, Germany

Maria Hiszpanska-Neumann, b. Poland, 1917
Forced Labor, 1948

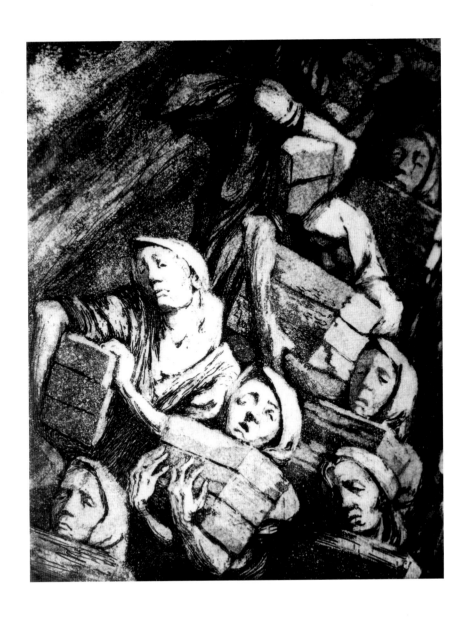

Maria Hiszpanska-Neumann, b. Poland, 1917
Removing Lice, 1944
Ravensbrück Concentration Camp, Germany

Maria Hiszpanska-Neumann, b. Poland, 1917
In the Barracks, 1945
Ravensbrück Concentration Camp, Germany

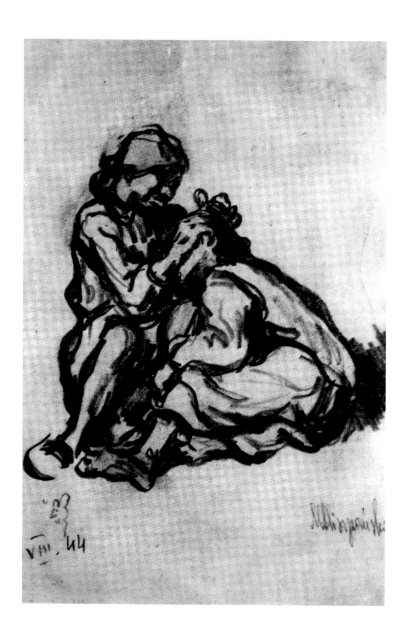

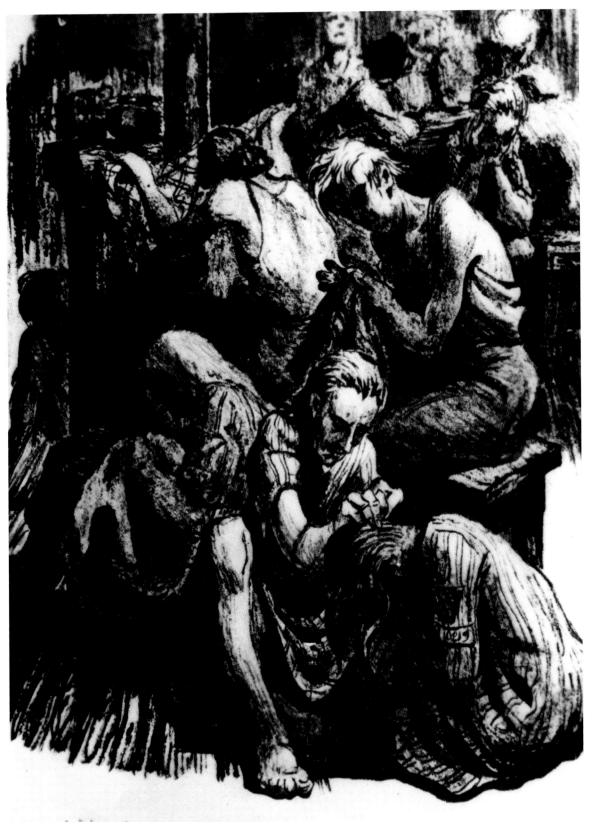

Ravensbrück – w baraku po pracy.

Maria Hiszpanska-Neumann, b. Poland, 1917
Digging, 1945
Ravensbrück Concentration Camp, Germany

Maria Hiszpanska-Neumann, b. Poland, 1917
At Work, 1945
Ravensbrück Concentration Camp, Germany

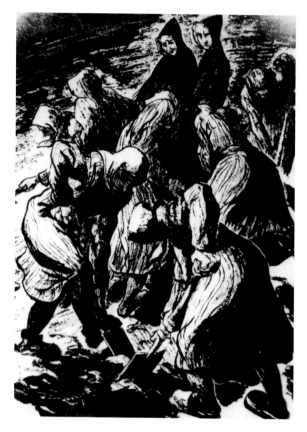

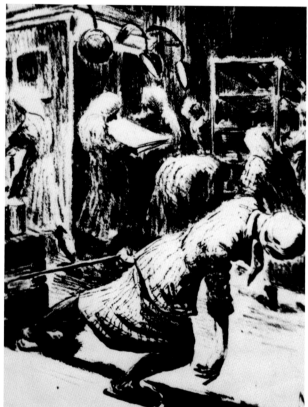

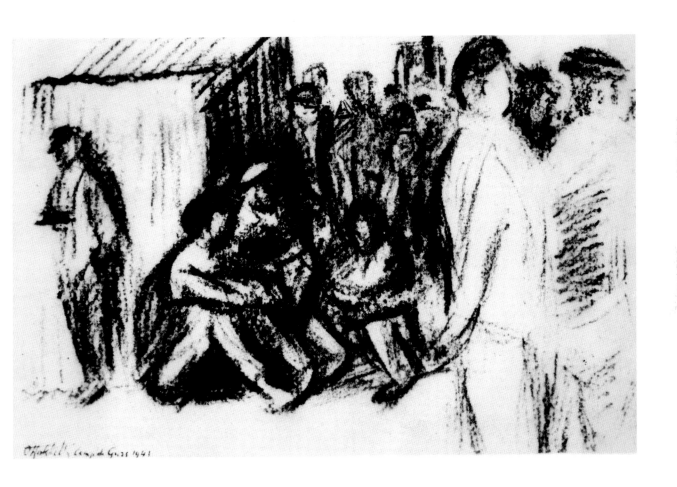

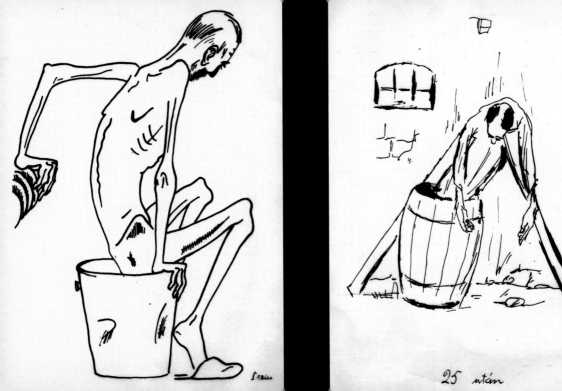

25 után

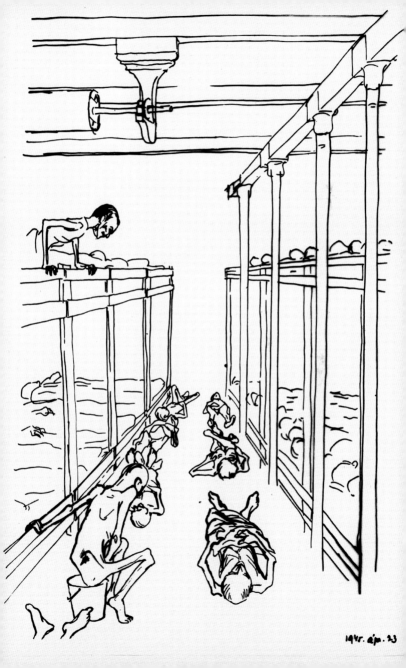

1945. ápr. 23

Imre Holló
Lice, 1944–45
Dörnhau Concentration Camp, Germany

Imre Holló
The Common Grave, 1944–45
Dörnhau Concentration Camp, Germany

Imre Holló
Late Help . . . , 1945
Dörnhau Concentration Camp, Germany

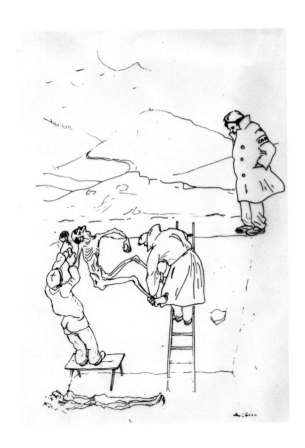

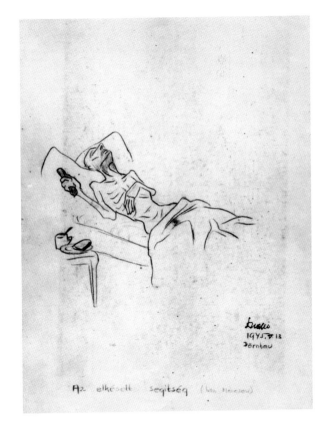

Imre Holló
Life Is Fading, 1944–45
Dörnhau Concentration Camp, Germany

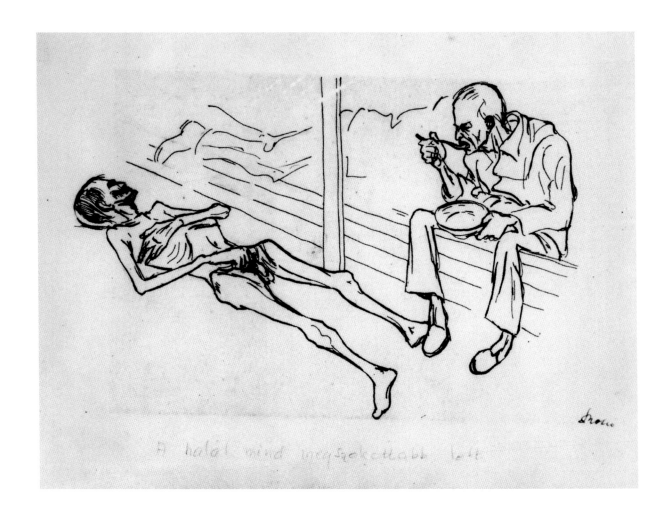

Imre Holló
Shower after Roll Call, 1944–45
Dörnhau Concentration Camp, Germany

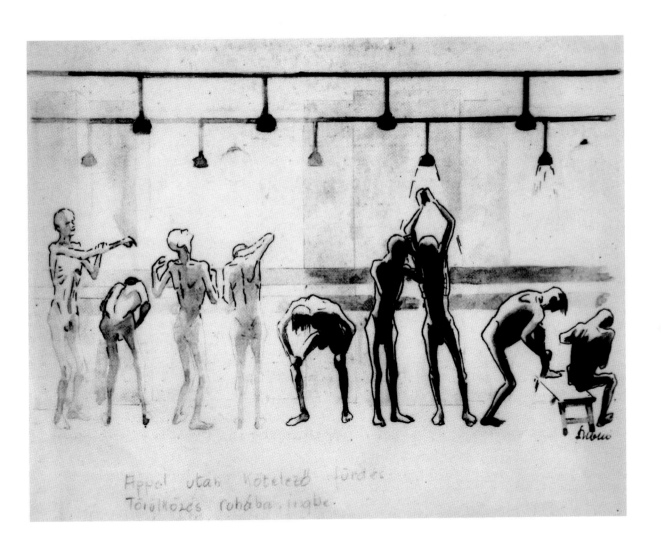

Franciszek Jaźwiecki, b. Poland, 1900
Portrait of Giovanni from Rzeszów, 1943
Oranienburg Concentration Camp, Germany

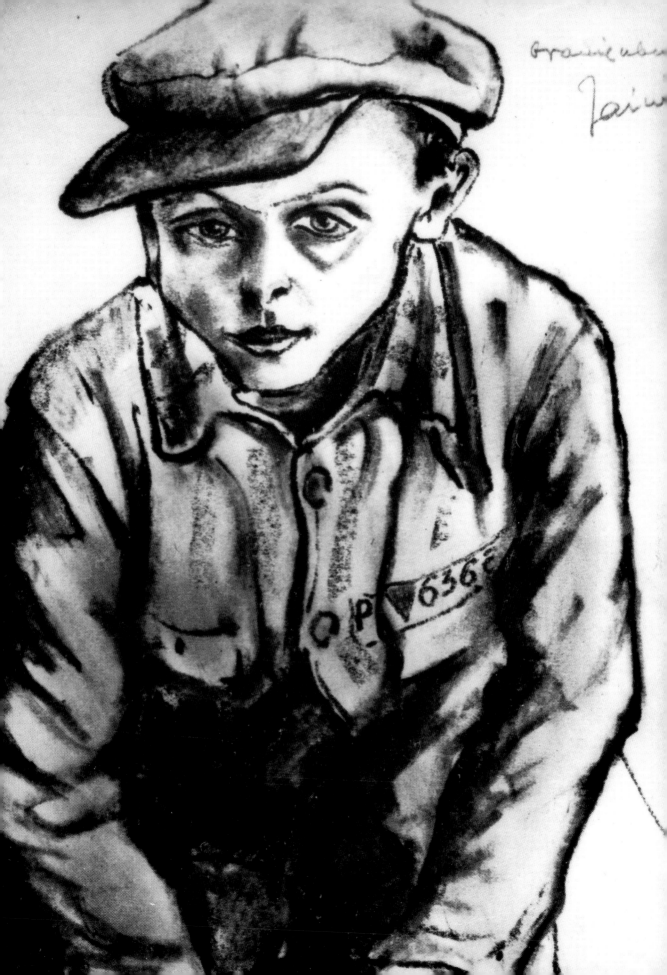

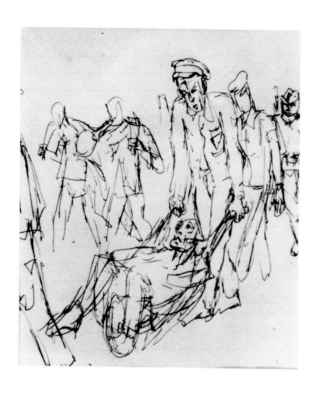

František Jiroudek, b. Czechoslovakia, 1914
Execution, 1943

Hans Kecker, b. Austria
Untitled, 1940

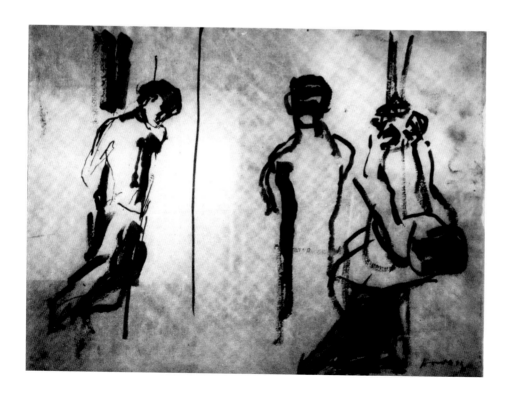

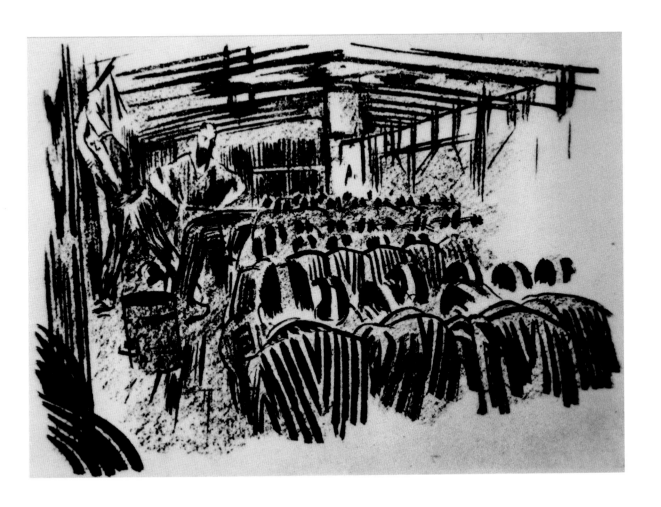

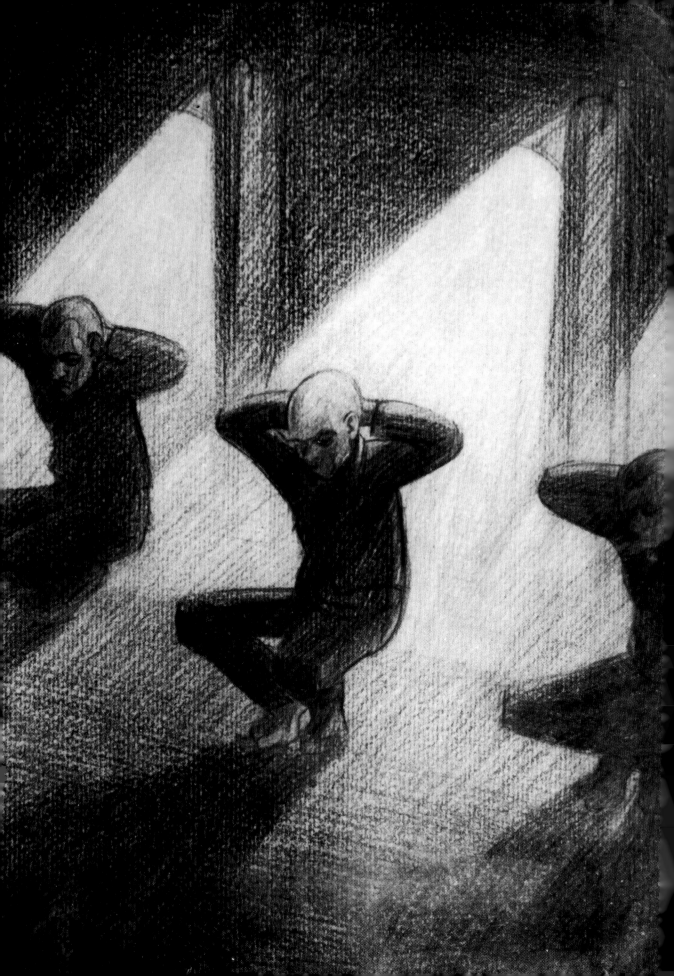

Marian Kolodziej, b. Poland, 1923
Punishment, c. 1950

Jan Komski, b. Romania, 1915
Hung by the Hands

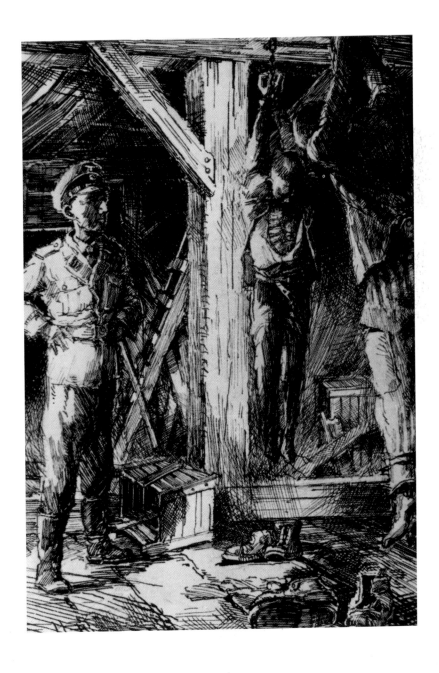

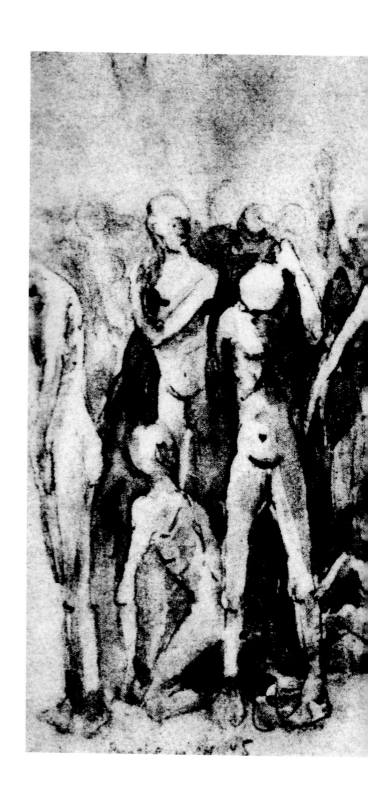

Karol Konieczny, b. Poland, 1919
First Bath, 1945
Buchenwald Concentration Camp, Germany

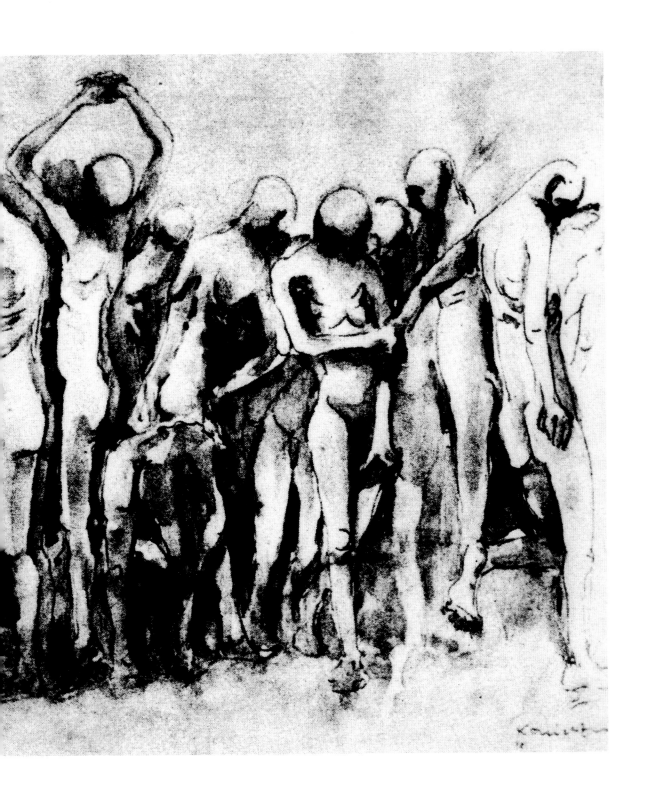

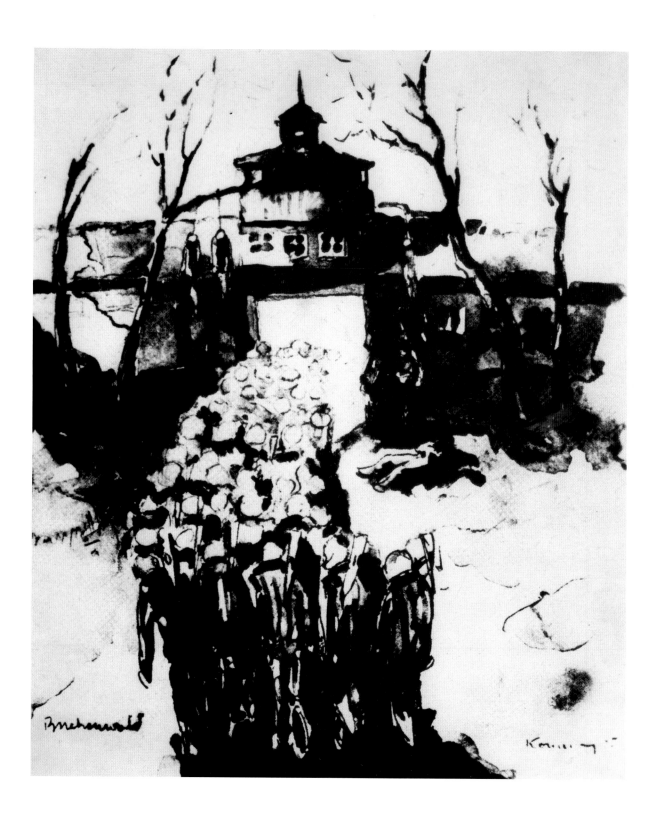

Buchenwald Kaurina

Karol Konieczny, b. Poland, 1919
Entering the Camp, 1945
Buchenwald Concentration Camp, Germany

Karol Konieczny, b. Poland, 1919
Punishment, 1945
Buchenwald Concentration Camp, Germany

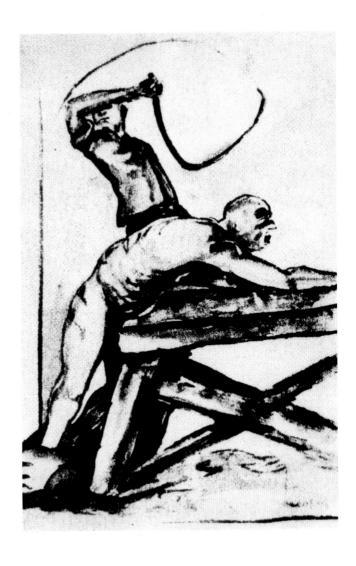

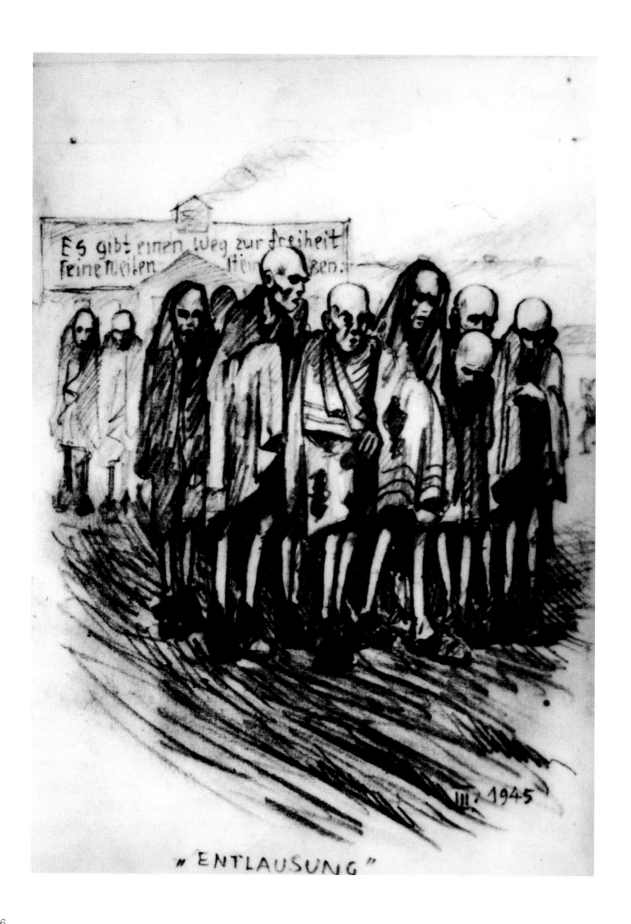

"ENTLAUSUNG"

Vlasto Kopač, b. Yugoslavia, 1913
Delousing, 1945

Vlasto Kopač, b. Yugoslavia, 1913
Bathroom at Dachau, 1945
Dachau Concentration Camp, Germany

Vlasto Kopač, b. Yugoslavia, 1913
Transport, 1945
Dachau Concentration Camp, Germany

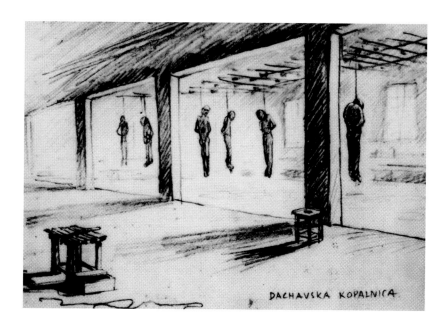

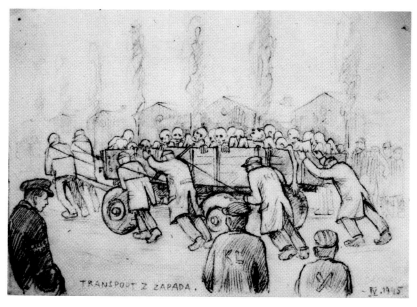

Mieczyslaw Koscielniak, b. Poland, 1912
Roll Call in Oswiecim, 1944
Oswiecim Concentration Camp, Poland

Mieczyslaw Koscielniak, b. Poland, 1912
Collegial Service, 1943
Oswiecim Concentration Camp, Poland

Mieczyslaw Koscielniak, b. Poland, 1912
The Return from Work, 1943
Oswiecim Concentration Camp, Poland

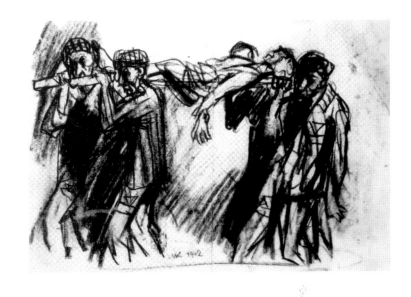

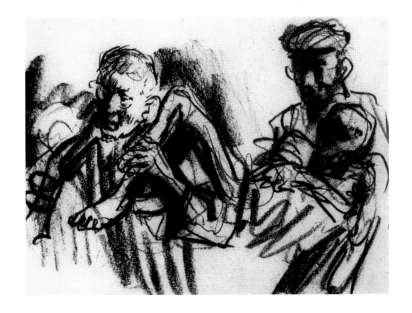

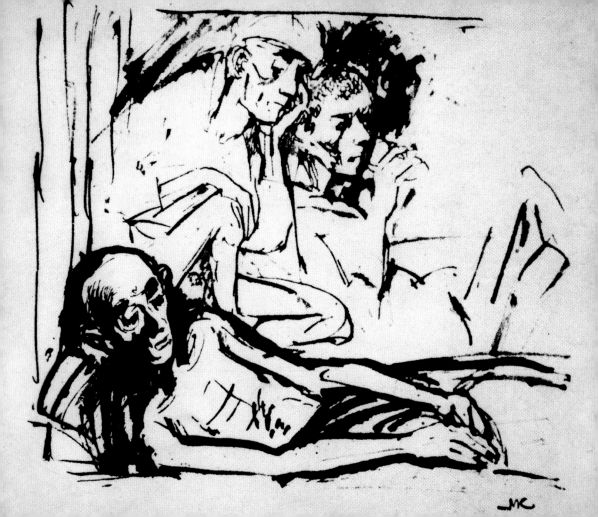

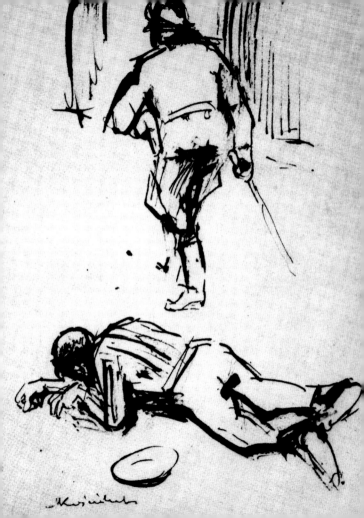

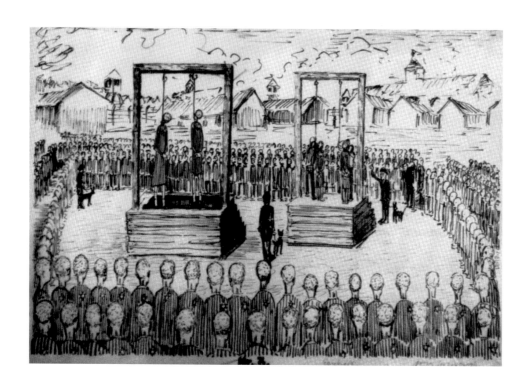

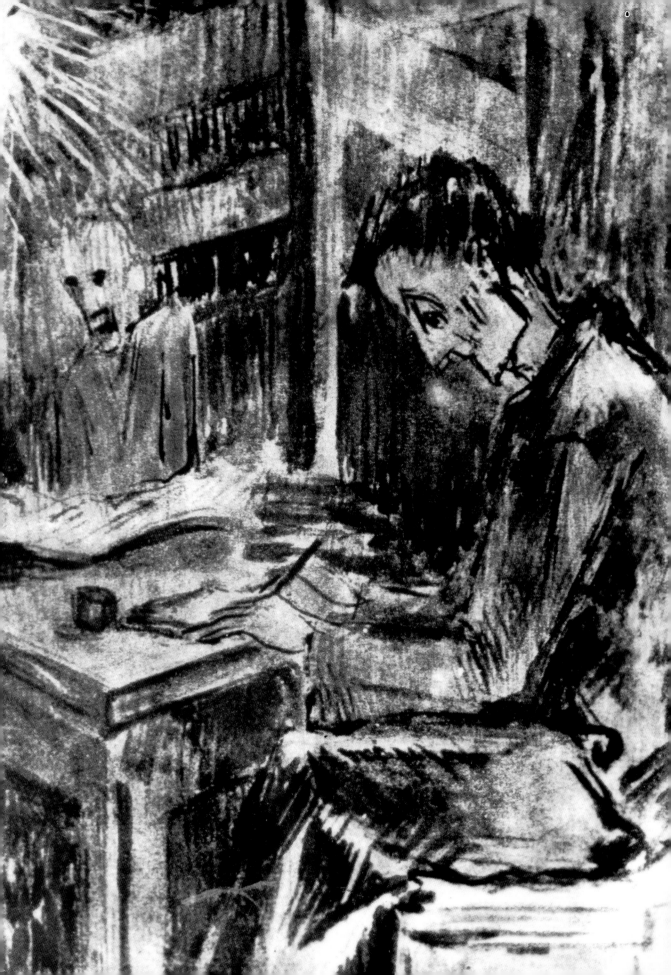

Stane Kumar, b. Italy, 1910
Dead Internee, 1943
Gonars Concentration Camp, Italy

Stane Kumar, b. Italy, 1910
Boy from Čabar, 1943
Gonars Concentration Camp, Italy

Stane Kumar, b. Italy, 1910
Internee, 1943
Gonars Concentration Camp, Italy

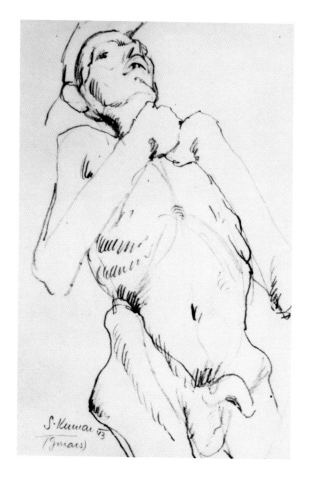

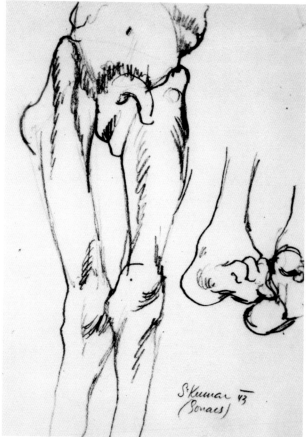

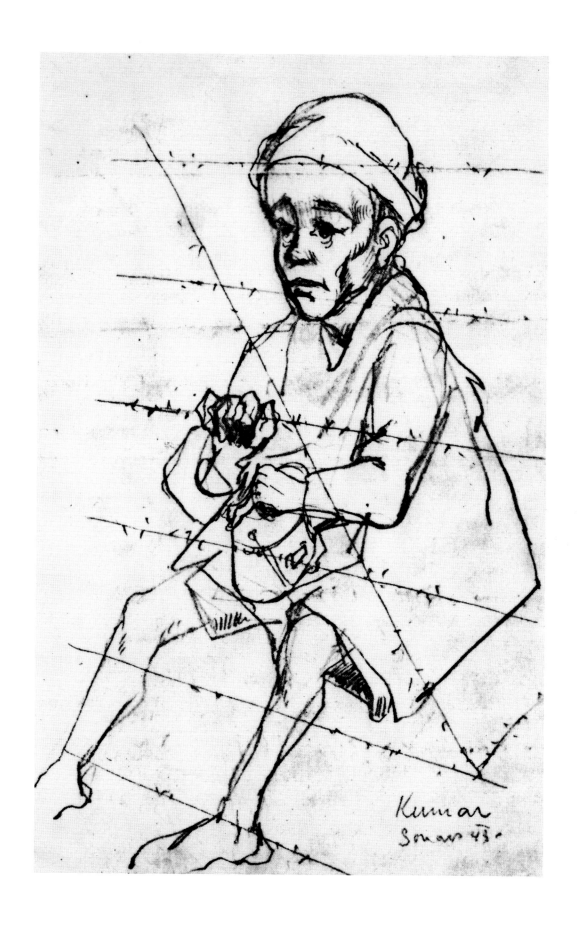

Aleksandar Laric, b. Yugoslavia, 1922
Cooking in the Camp, 1944

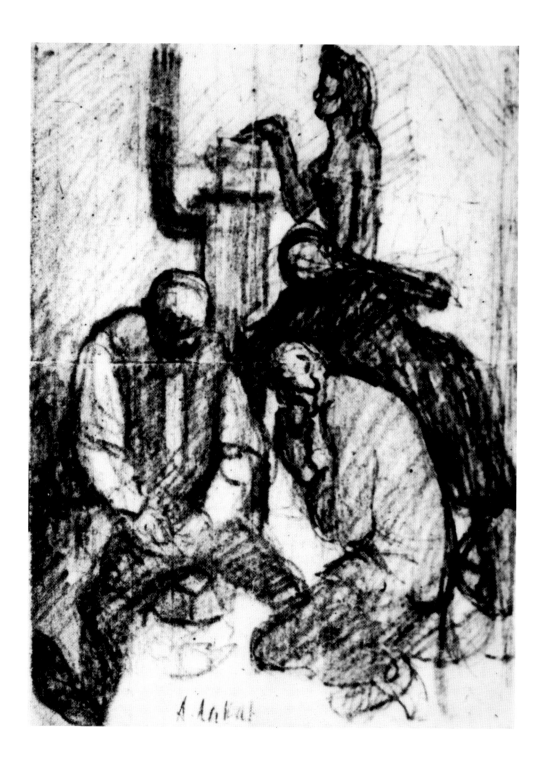

Aleksandar Laric, b. Yugoslavia, 1922
In the Camp I, 1944

Aleksandar Laric, b. Yugoslavia, 1922
In the Camp II, 1944

Aleksandar Laric, b. Yugoslavia, 1922
At the Banjica Concentration Camp
Banjica Concentration Camp, Yugoslavia

Aleksandar Laric, b. Yugoslavia, 1922
Portrait of a Prisoner, 1944

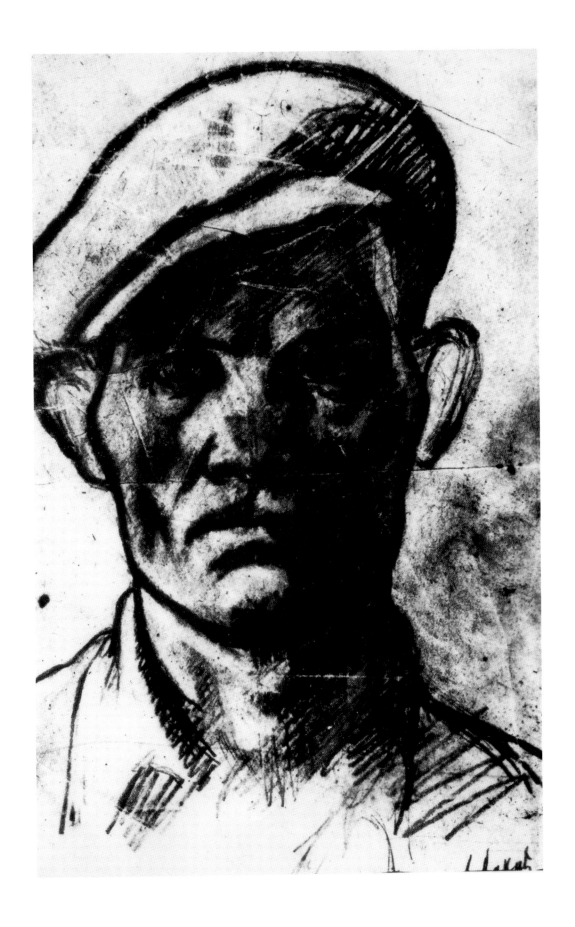

Vlado Lamut, b. Yugoslavia, 1915
The Camp, 1943
Monigo Concentration Camp, Italy

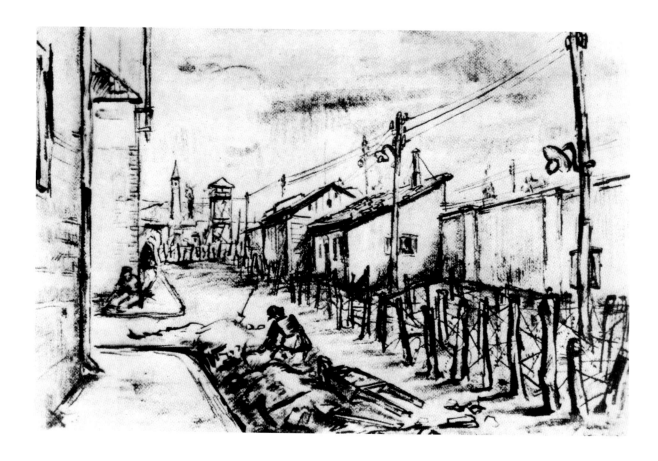

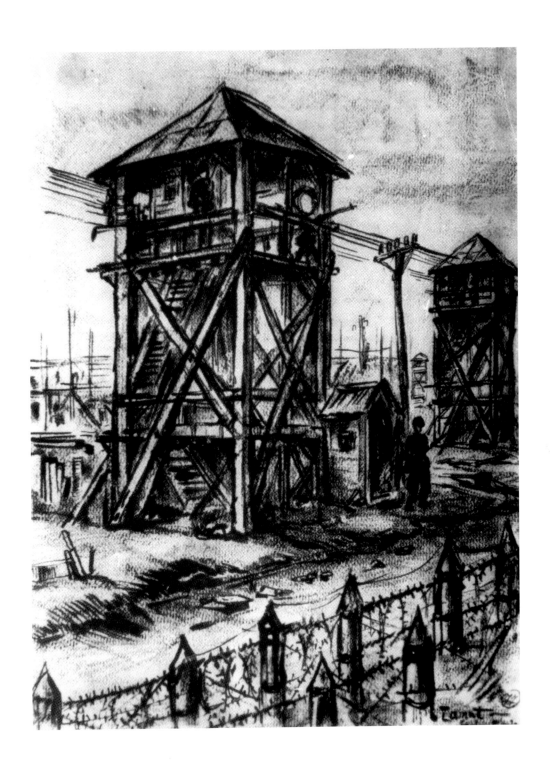

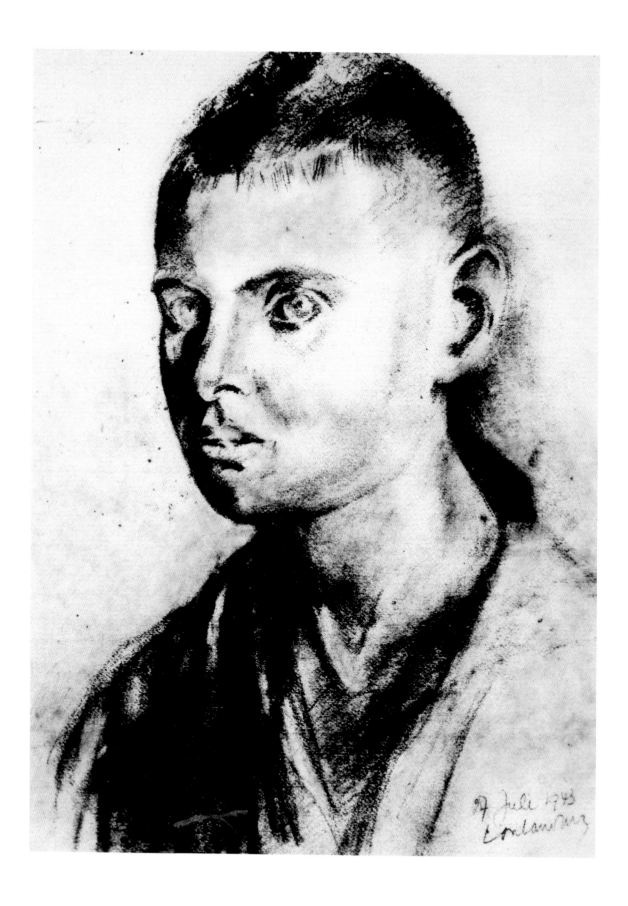

27 Juli 1943
Konstanz

Léon Landau
Portrait of a Young Man, 1943
Malines Transit Camp, Belgium

Mirko Lebez, b. Yugoslavia, 1912
Skeleton, 1943
Gonars Concentration Camp, Italy

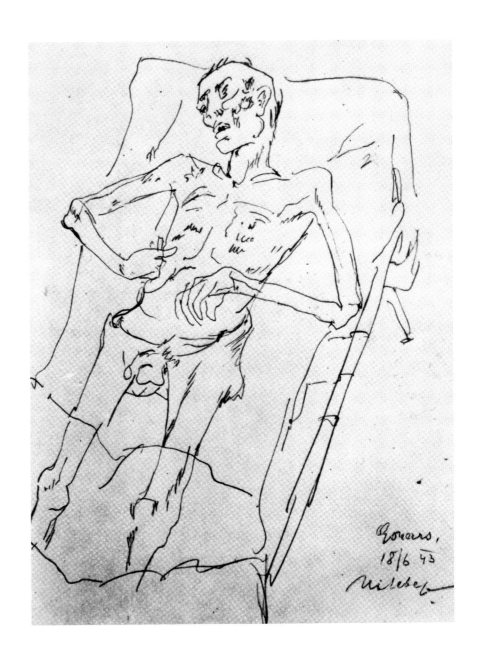

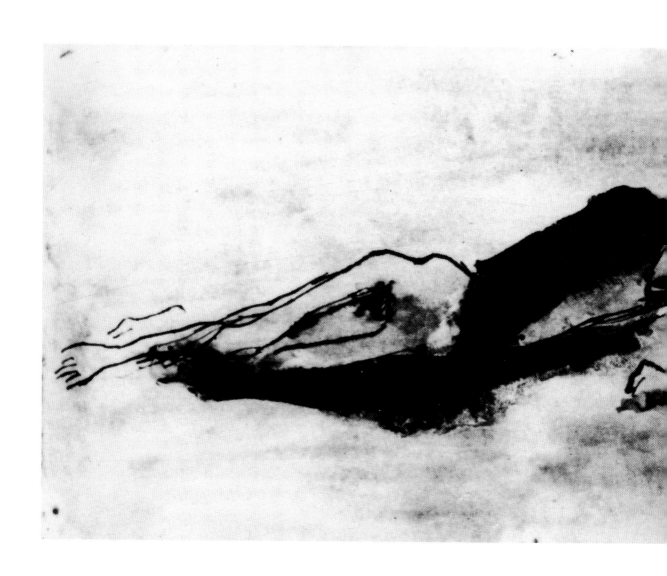

Bohumil Lonek, b. Czechoslovakia, 1903
Living Dead, 1945
Mauthausen Concentration Camp, Austria

Milan Lorbek, b. Yugoslavia
Transport of the Dead, 1945
Dachau Concentration Camp, Germany

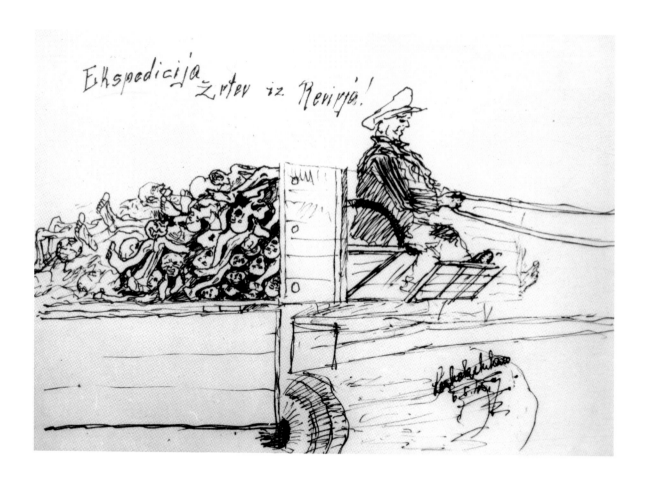

Milan Lorbek, b. Yugoslavia
Transporting the Victim, 1945
Dachau Concentration Camp, Germany

Milan Lorbek, b. Yugoslavia
Transport, 1945
Dachau Concentration Camp, Germany

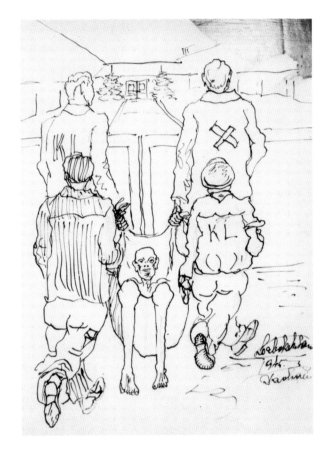

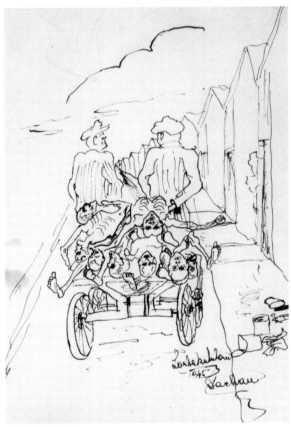

Petar Lubarda, b. Montenegro, 1907
Nazi-Fascist Concentration Camp, 1943

Ivan Lučev, b. Yugoslavia
In the Camp, 1942
Nürnberg Concentration Camp, Germany

Esther Lurie, b. Latvia, 1913
Ration of Soup, 1942
Kovno Ghetto, Lithuania

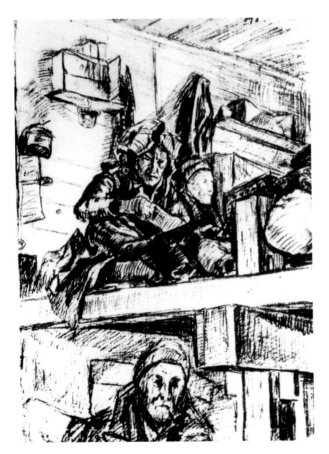

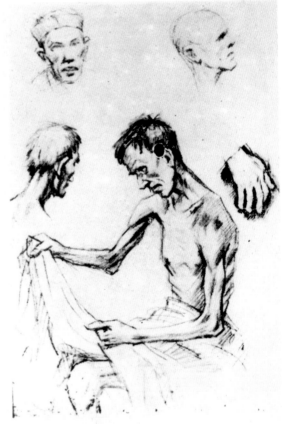

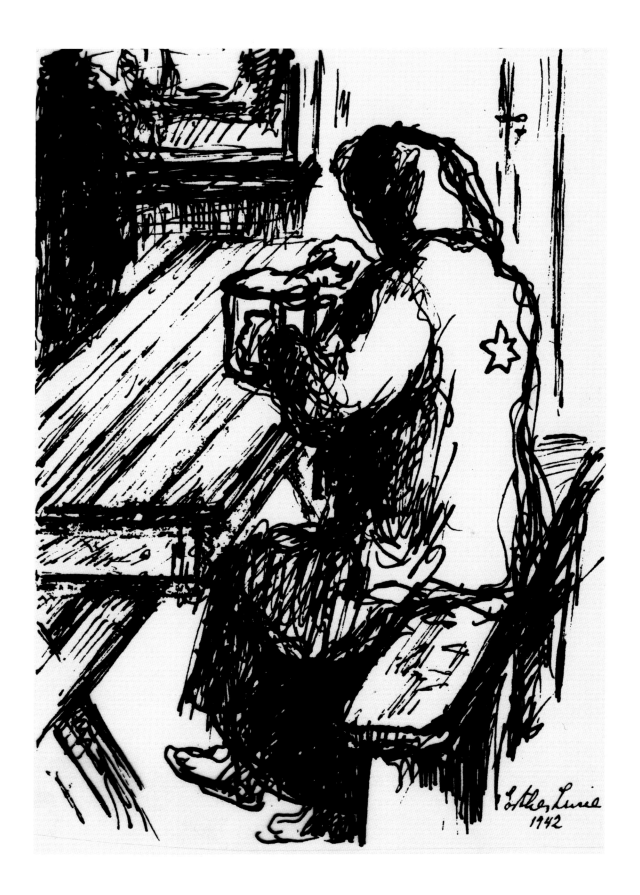

Pierre Mania, b. France
Arrival, 1943

Aurel Marculescu, b. Romania, 1900
Burial at Vapniarca Concentration Camp, 1944
Vapniarca Concentration Camp, Ukraine

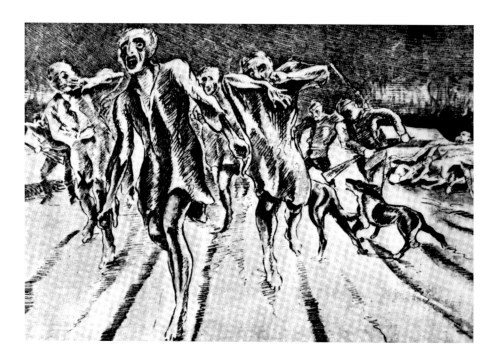

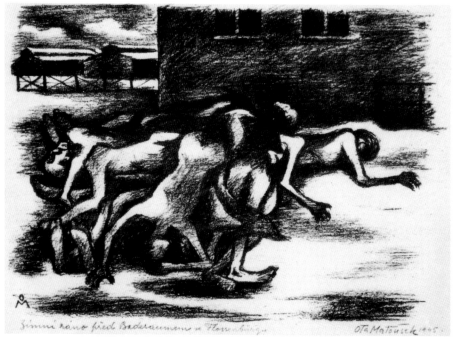

Ota Matoušek, b. Czechoslovakia, 1890
Winter Morning Outside the Bathroom, 1945
Flossenbürg Concentration Camp, Germany

Ota Matoušek, b. Czechoslovakia, 1890
At Work, 1943–45
Flossenbürg Concentration Camp, Germany

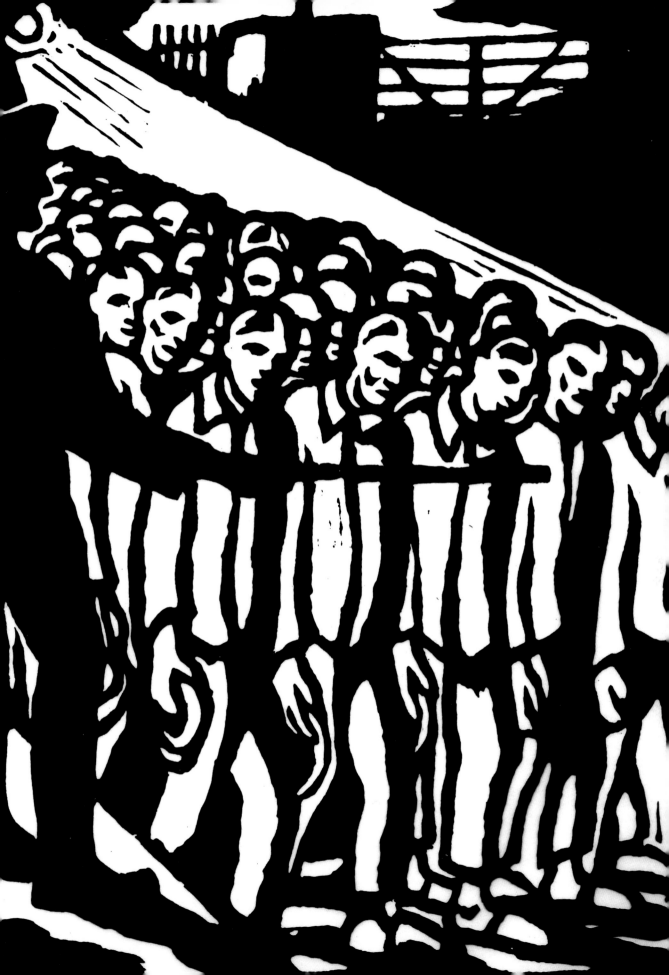

Anton Zoran Music, b. Italy, 1909
First Shower after Transport, 1945
Dachau Concentration Camp, Germany

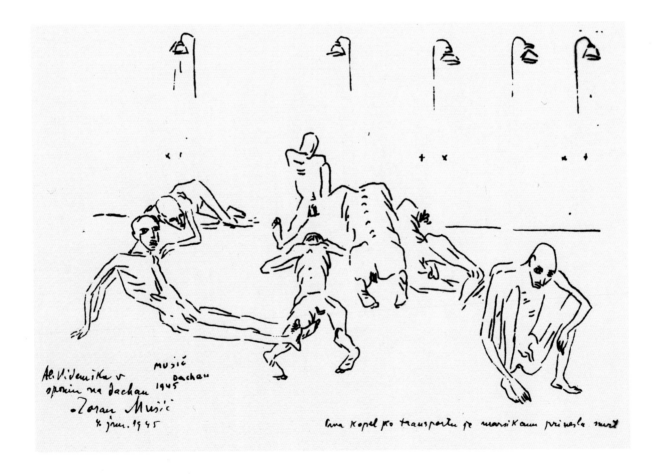

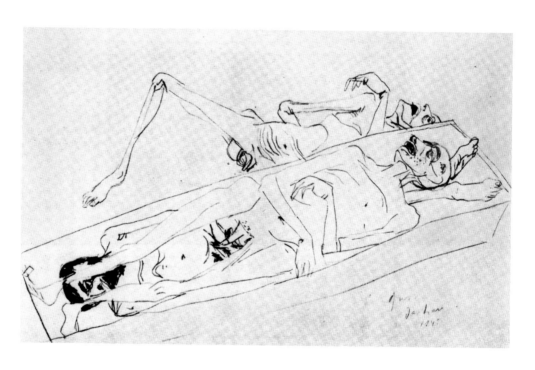

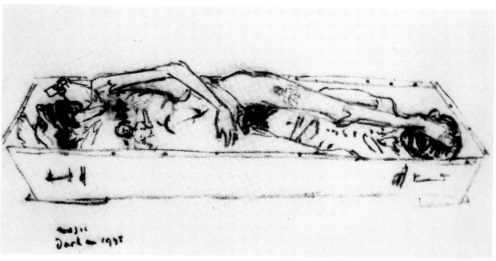

Anton Zoran Music, b. Italy, 1909
Dachau, 1945
Dachau Concentration Camp, Germany

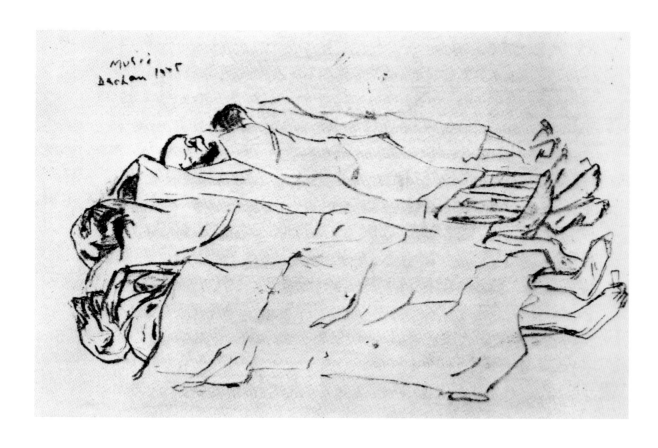

Anton Zoran Music, b. Italy, 1909
Dachau I, 1945
Dachau Concentration Camp, Germany

Anton Zoran Music, b. Italy, 1909
Dachau II, 1945
Dachau Concentration Camp, Germany

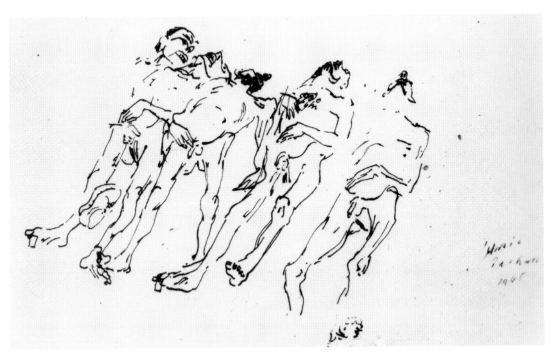

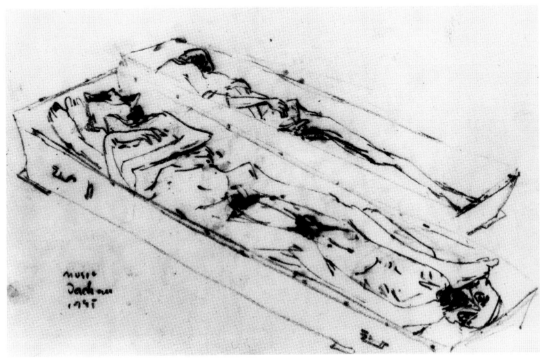

Anton Zoran Music, b. Italy, 1909
Dachau, 1945
Dachau Concentration Camp, Germany

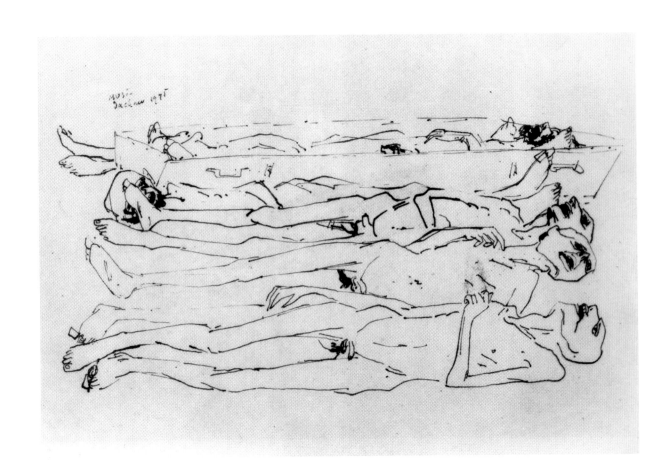

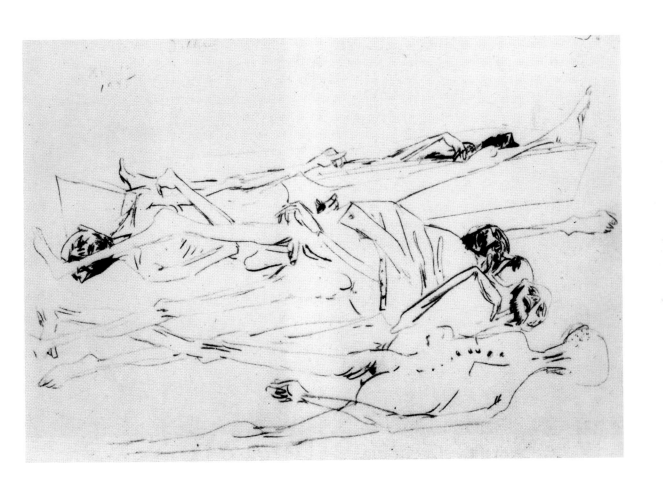

Milivoj Nikolajević, b. Yugoslavia, 1912
Persecuted in a Concentration Camp I, 1941
Sabac Concentration Camp, Yugoslavia

Milivoj Nikolajević, b. Yugoslavia, 1912
Persecuted in a Concentration Camp II, 1941
Sabac Concentration Camp, Yugoslavia

Giuseppe Novello, b. Italy, 1897
Out the Window, 1943

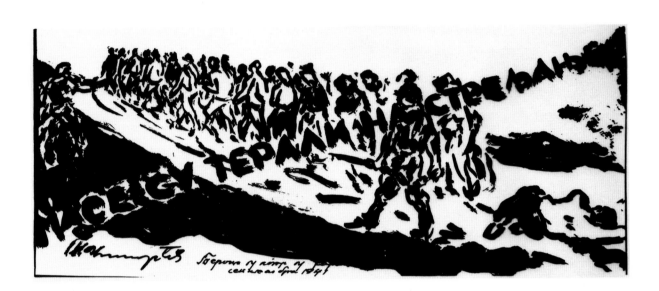

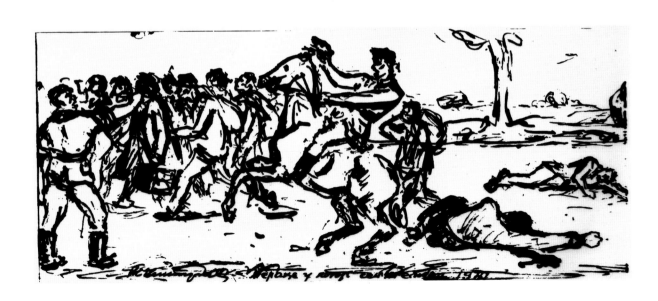

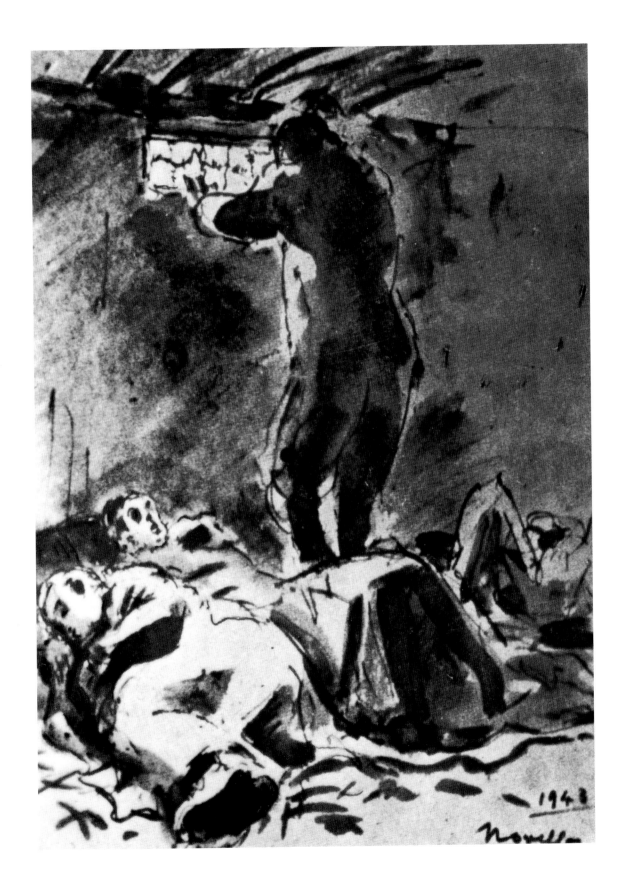

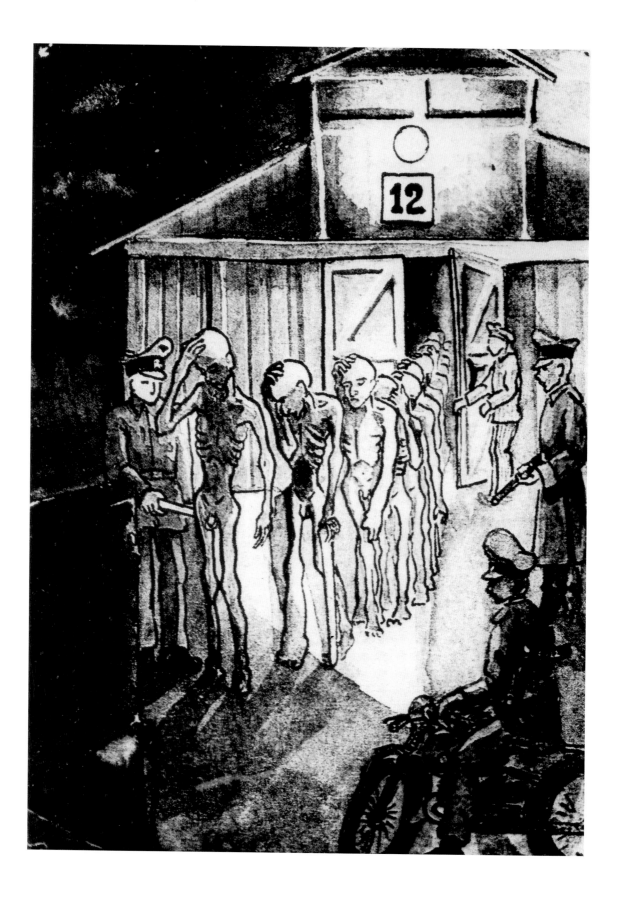

Waldemar Nowakowski, b. Ukraine, 1917
Selection of the Jews, 1943
Oswiecim Concentration Camp, Poland

David Olère, b. Poland, 1902
Crematorium, 1945
Oswiecim Concentration Camp, Poland

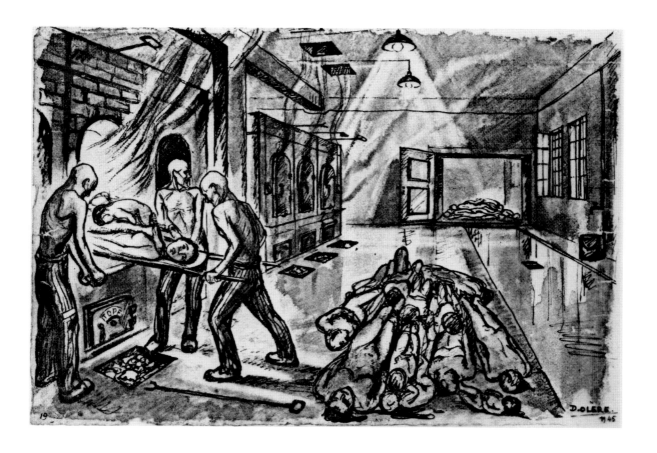

Halina Olomucka, b. Poland
Women in the Warsaw Ghetto, 1943

Halina Olomucka, b. Poland
In the Ghetto, 1943

Halina Olomucka, b. Poland
In the Warsaw Ghetto

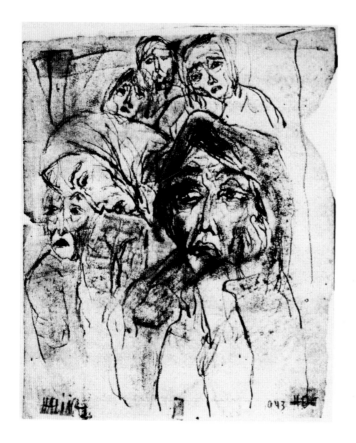

Nikolaj Omersa, b. Yugoslavia, 1911
Punishment, 1945

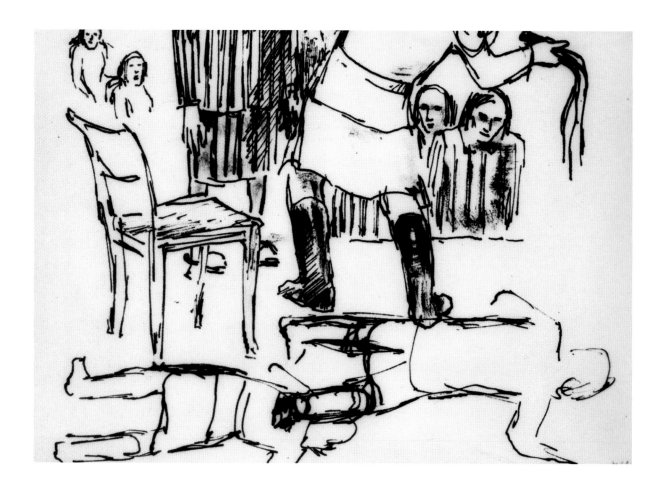

Daniel Ozmo, b. Yugoslavia, 1912
Internee in the Ustaše Camp, 1942
Jasenovac Concentration Camp, Croatia

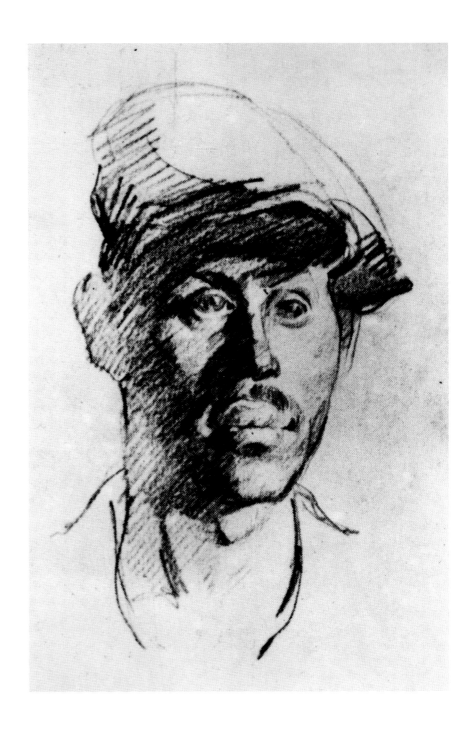

Božo Pengov, b. Yugoslavia, 1910
Death, 1945
Dachau Concentration Camp, Germany

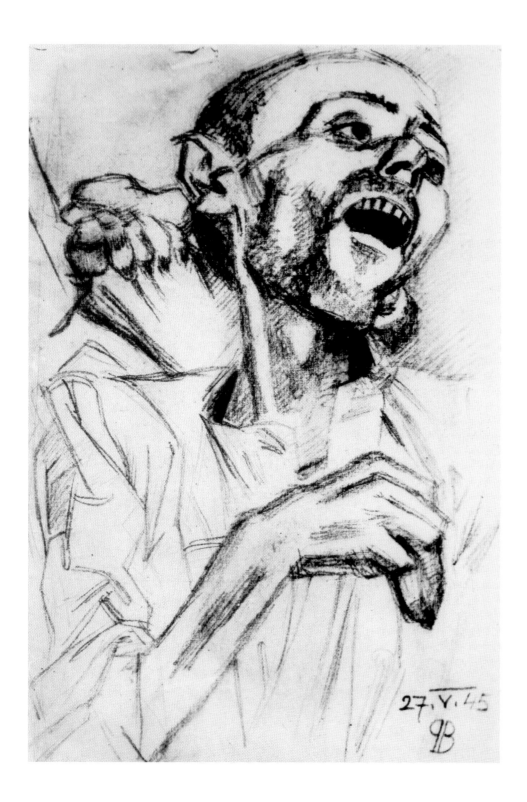

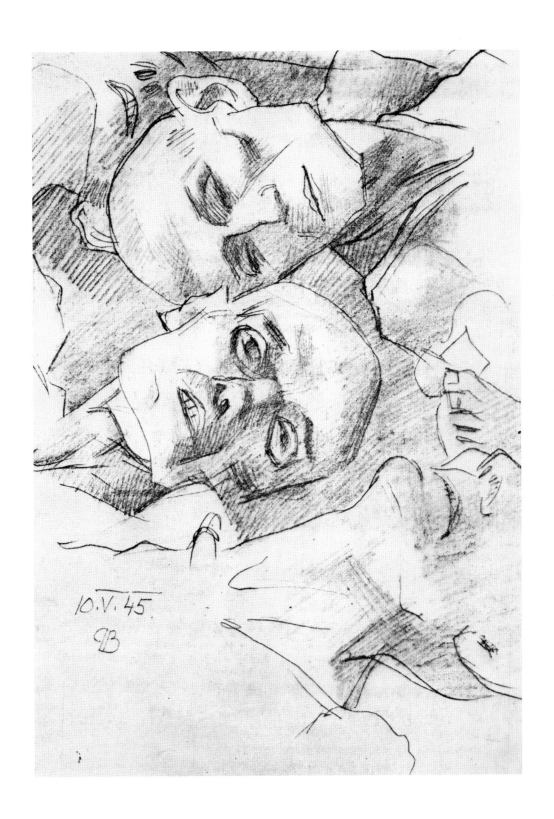

Božo Pengov, b. Yugoslavia, 1910
Dachau, 1945
Dachau Concentration Camp, Germany

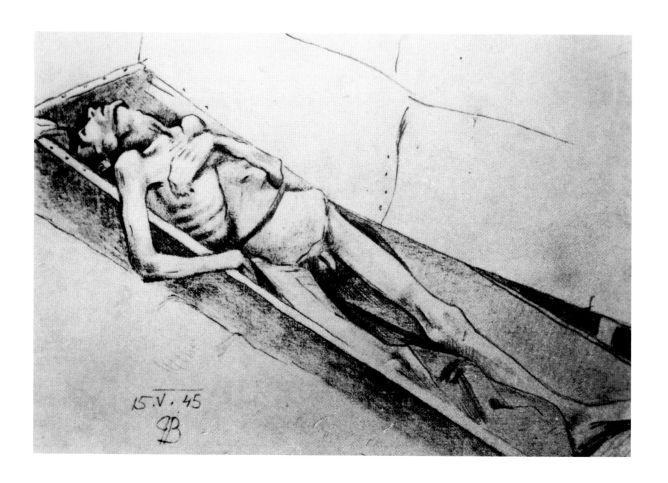

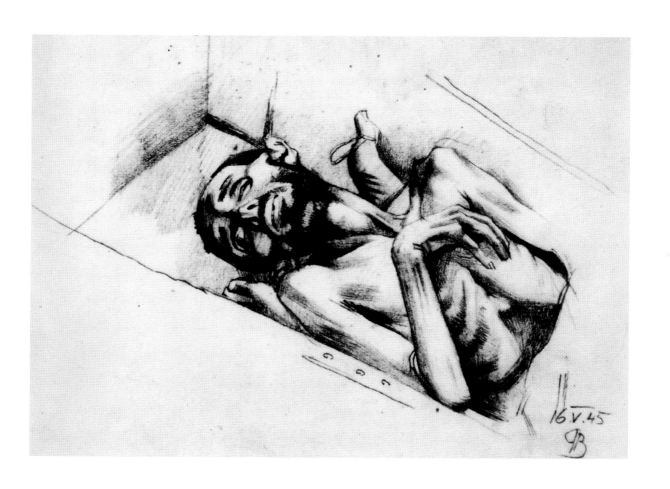

Božo Pengov, b. Yugoslavia, 1910
Dachau I, 1945
Dachau Concentration Camp, Germany

Božo Pengov, b. Yugoslavia, 1910
Dachau II, 1945
Dachau Concentration Camp, Germany

Božo Pengov, b. Yugoslavia, 1910
Dachau III, 1945
Dachau Concentration Camp, Germany

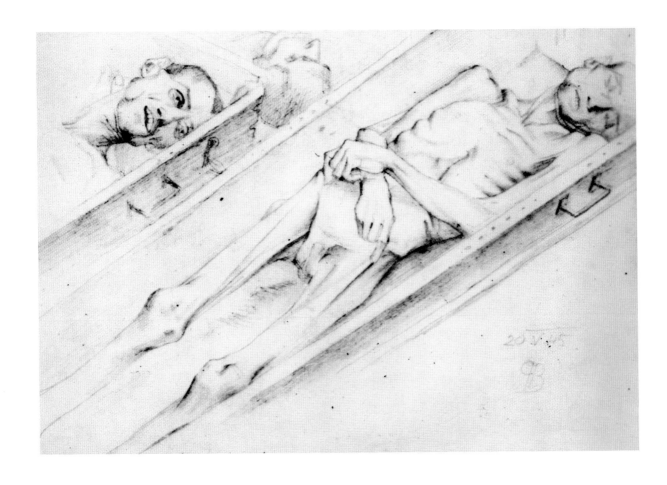

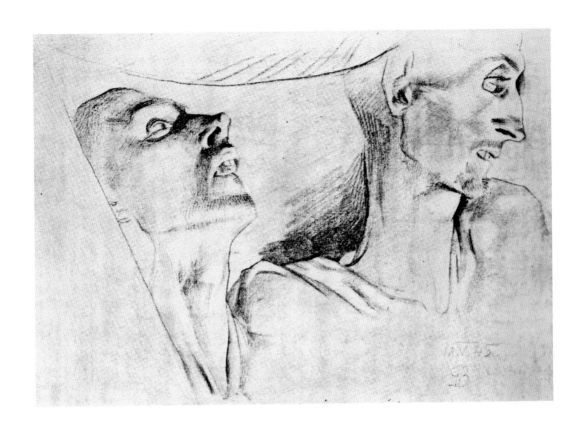

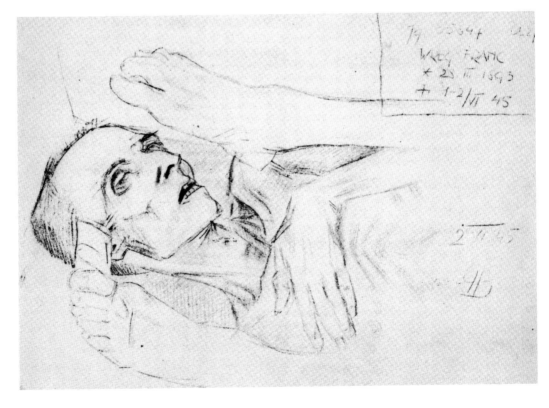

153

Bosko Petrović, b. Yugoslavia, 1922
Imprisonment, 1943
Novi Sad Concentration Camp, Yugoslavia

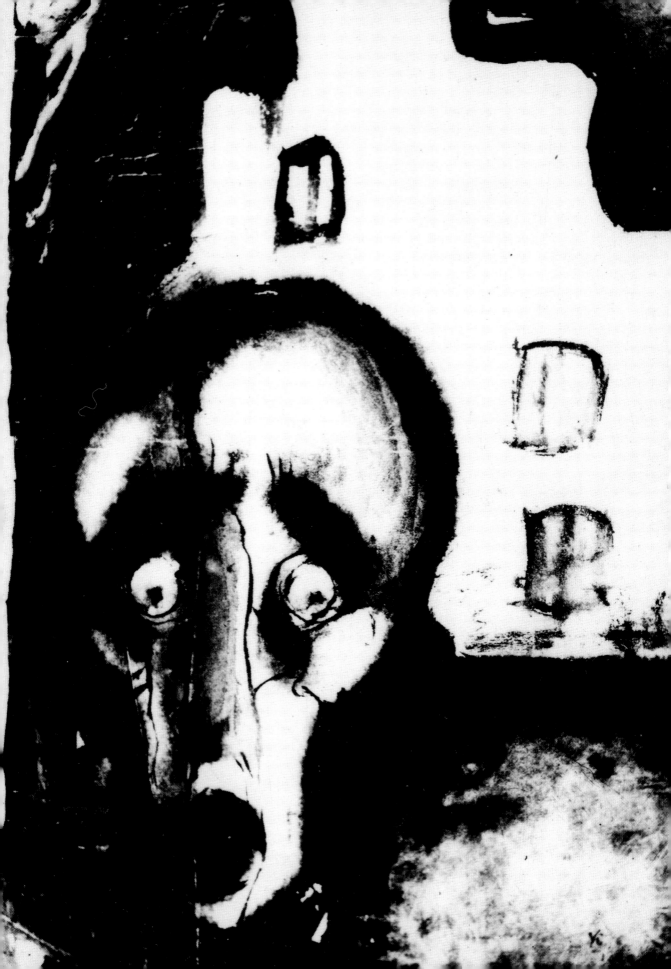

Henri Pieck, b. Holland
At the Hospital, 1945
Buchenwald Concentration Camp, Germany

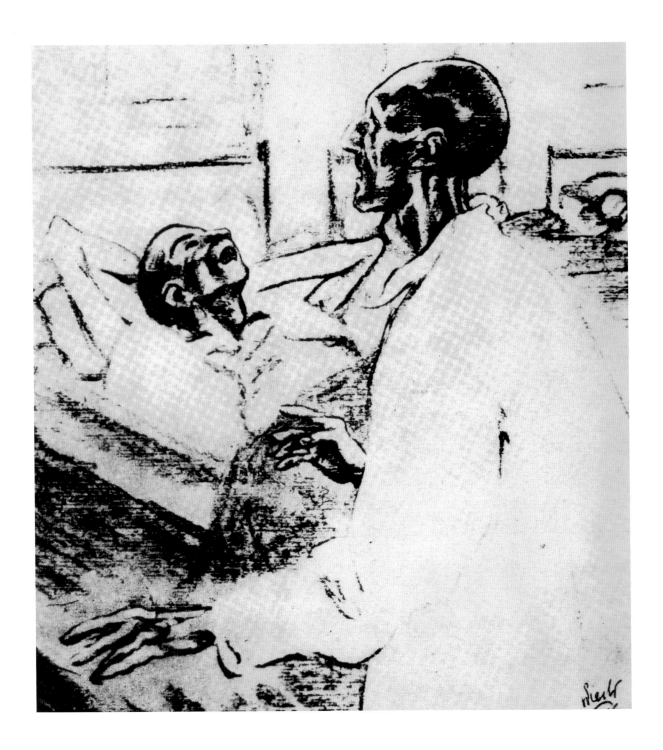

Henri Pieck, b. Holland
Albert Kayser Dying, 1944
Buchenwald Concentration Camp, Germany

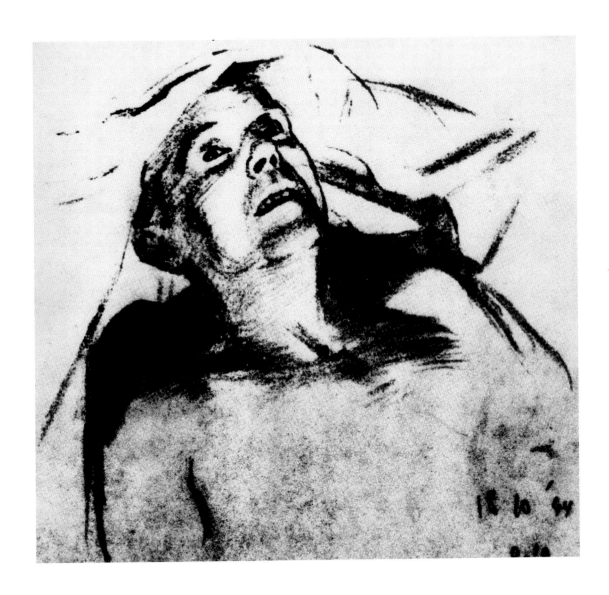

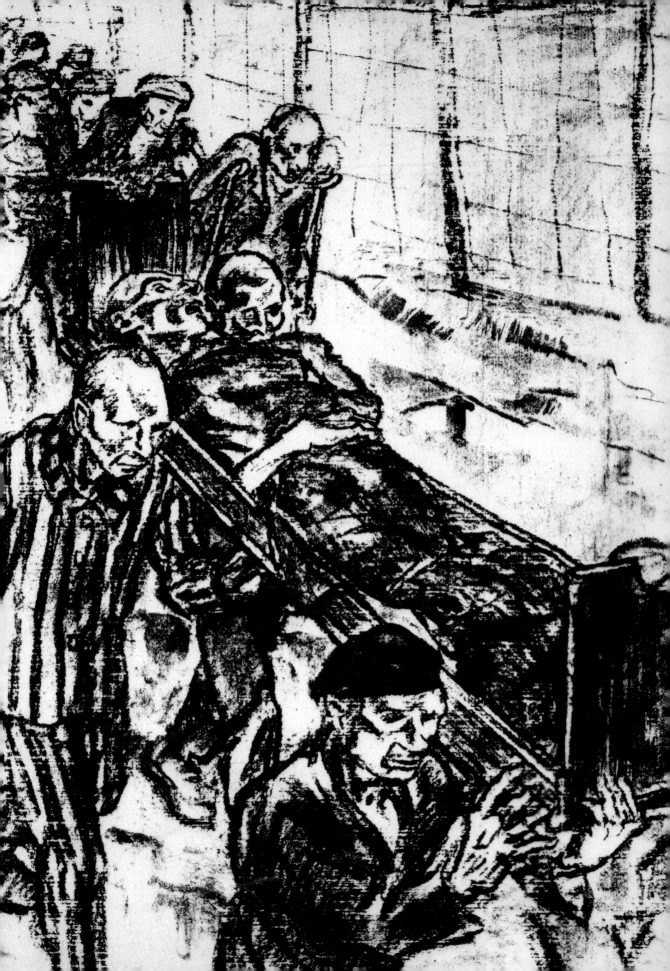

Henri Pieck, b. Holland
Transporting the Dead, 1945
Buchenwald Concentration Camp, Germany

Henri Pieck, b. Holland
Russian Internee, 1945
Buchenwald Concentration Camp, Germany

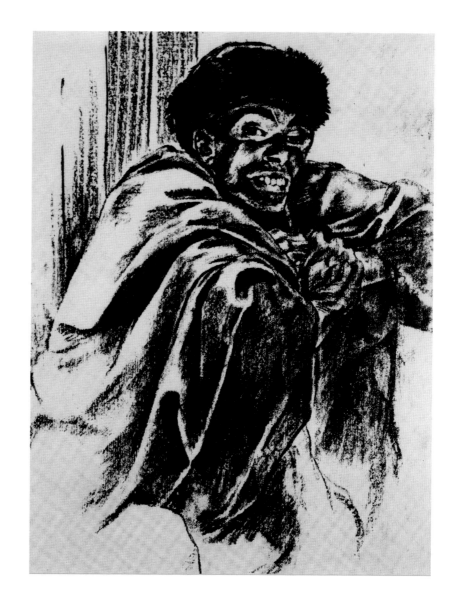

Walter Pinto
Toilet Facilities, 1943
Westerbork Concentration Camp, Holland

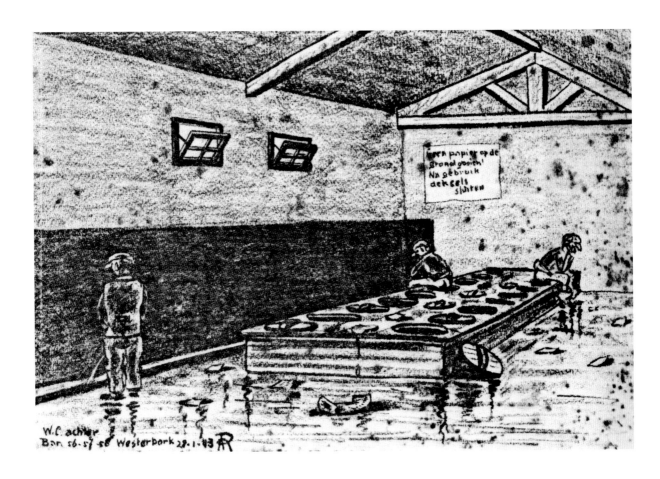

Nikolaj Pirnat, b. Yugoslavia, 1903
Arrival at the Camp, 1942
Gonars Concentration Camp, Italy

Nikolaj Pirnat, b. Yugoslavia, 1903
Examination, 1942
Gonars Concentration Camp, Italy

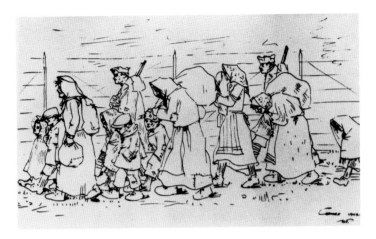

Nikolaj Pirnat, b. Yugoslavia, 1903
Breakdown, 1942
Gonars Concentration Camp, Italy

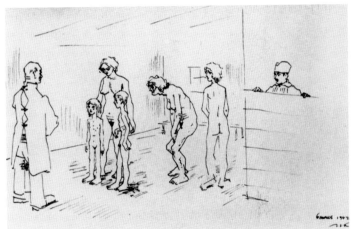

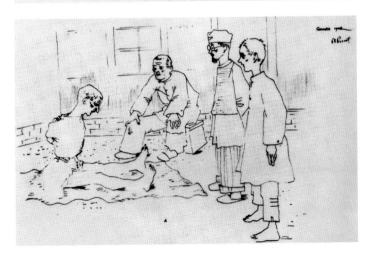

161

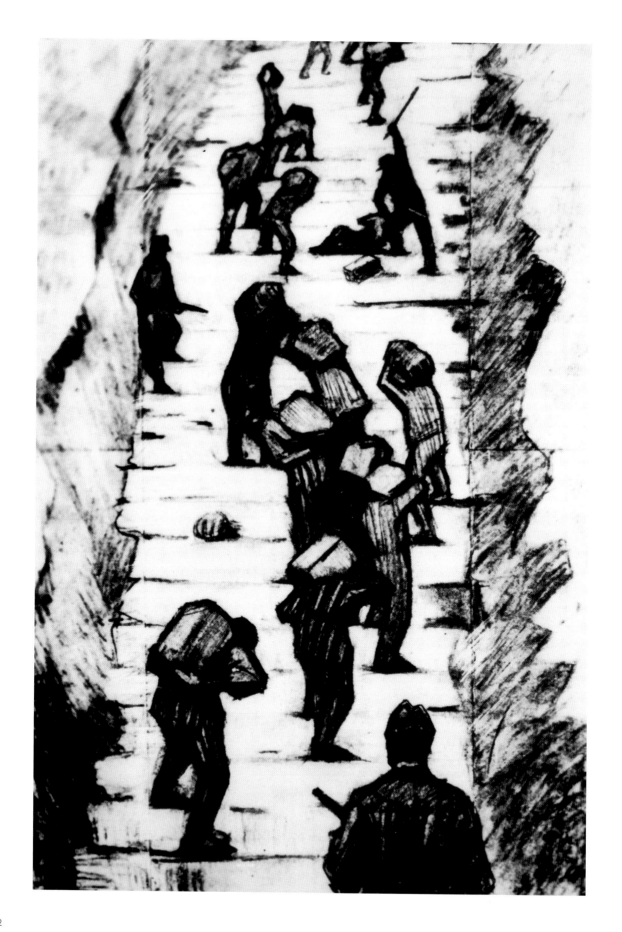

S. Podoroschnij, b. USSR
Work in the Rock Quarry
Mauthausen Concentration Camp, Austria

The Stone Stairs

The sky looks like
a mysterious spot
over the hole
that for the night's reign
the stone seals.
A pressing roar of memories;
the echoes hardened by pain
over the crags of the dark arena
loom.
The terrible demon stole
even the comfort of a friendly hand
on dying flesh.

By mad command
the stone steps
spent the laments
of the torturous chorus.

Arturo Benvenuti
Mauthausen, June 1980

[At Mauthausen, the path to the quarry led down the "Stairs of Death," carved out of the rock.]

Jože Polajnko, b. Yugoslavia, 1915
Elimination, 1945
Mauthausen Concentration Camp, Austria

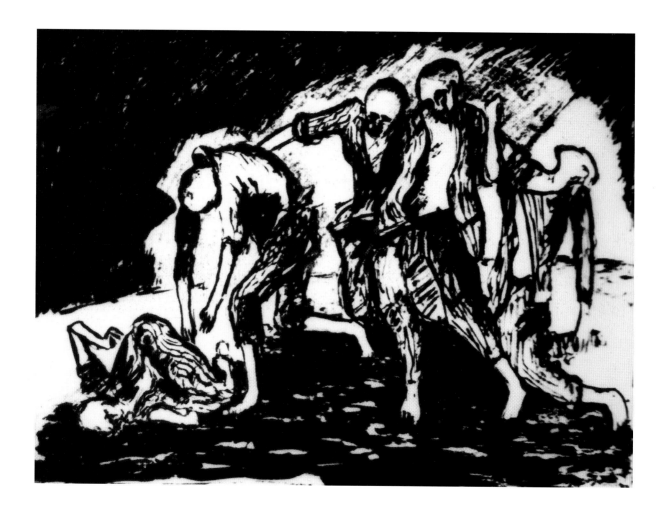

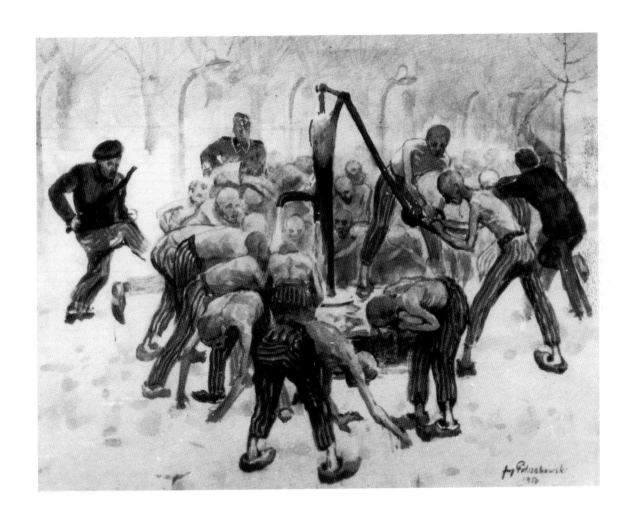

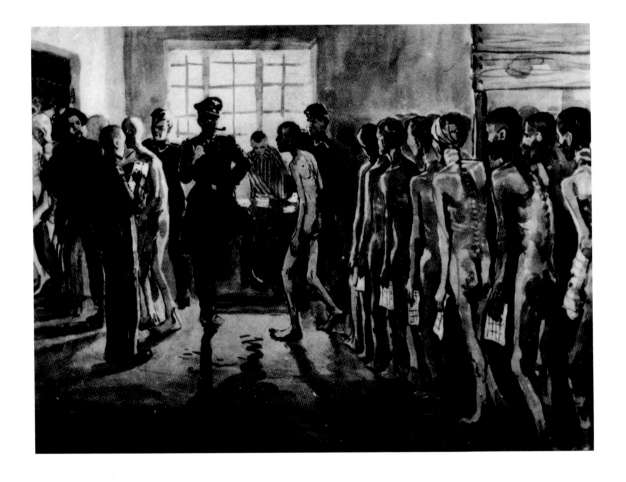

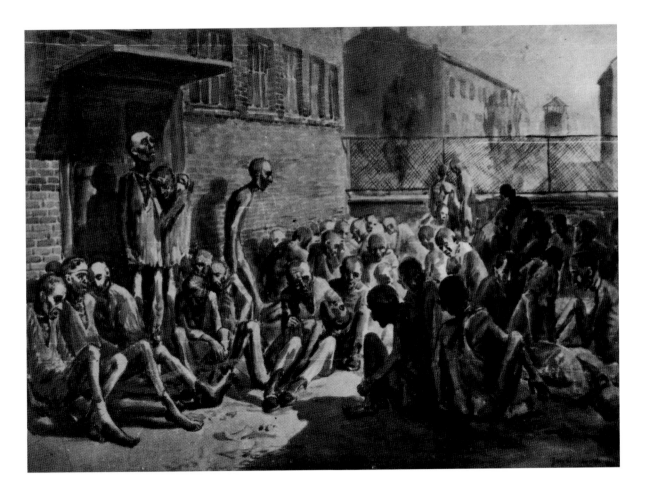

Marij Pregelj, b. Yugoslavia, 1913
Rest, 1941
Dössel-Warburg Concentration Camp, Germany

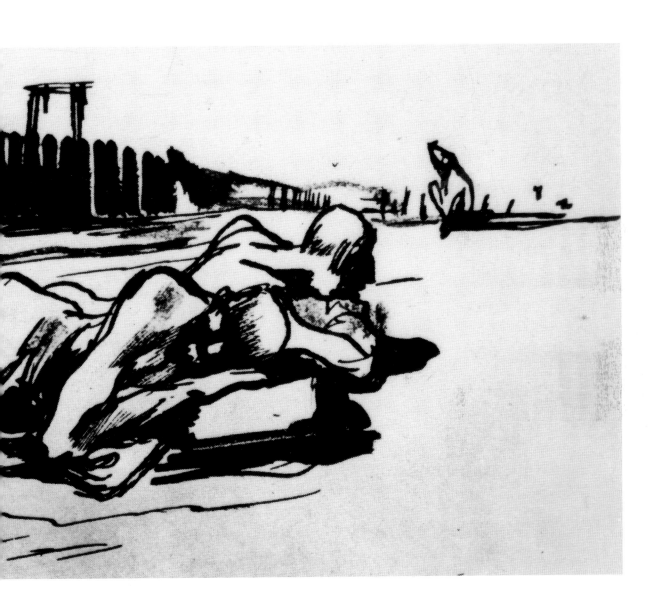

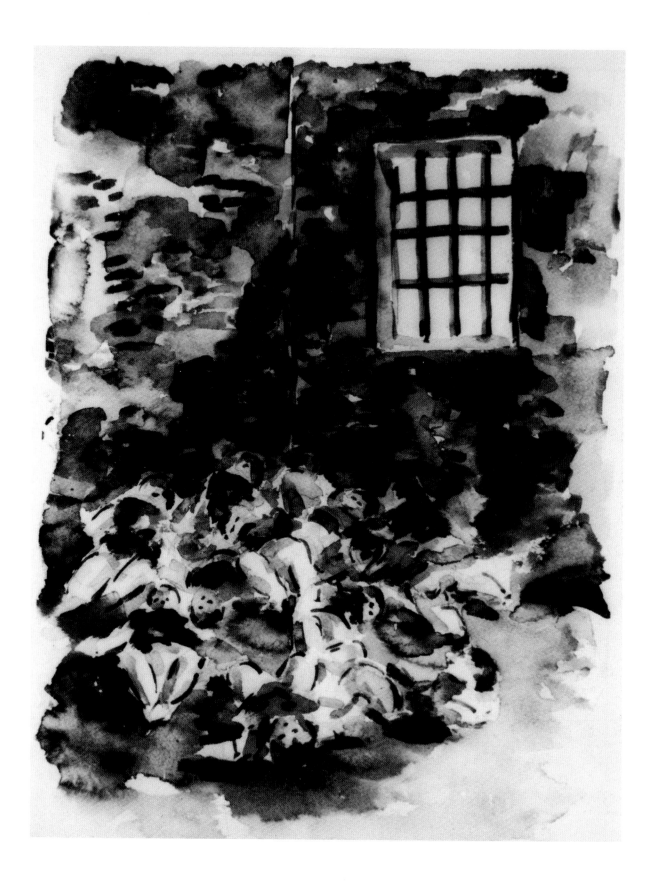

Vanja Radaus, b. Yugoslavia, 1913
Children's Prison, 1943–44

Joseph Richter
Grave for the Escapee about to Be Executed, 1943
Uhrusk, Poland

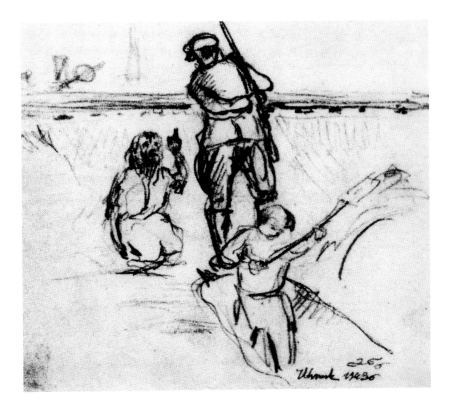

Joseph Richter
Begging for Water from the Train Window, 1943
Sobibór Concentration Camp, Poland

Joseph Richter
Transport to Uhrusk, 1943

Joseph Richter
On the Way to Majdanek, 1943

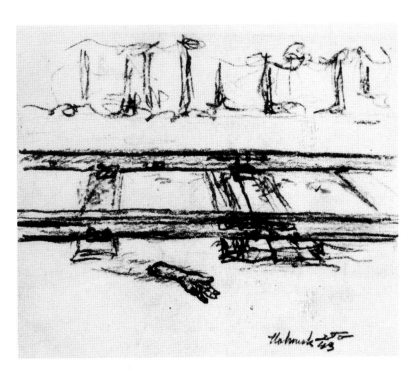

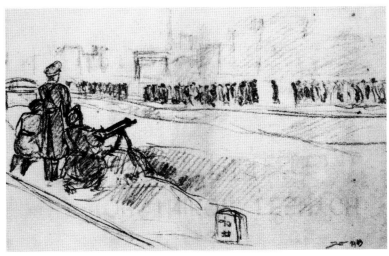

Karel Sattler, b. 1932
Terezín Camp, 1944
Terezín Concentration Camp, Czechoslovakia

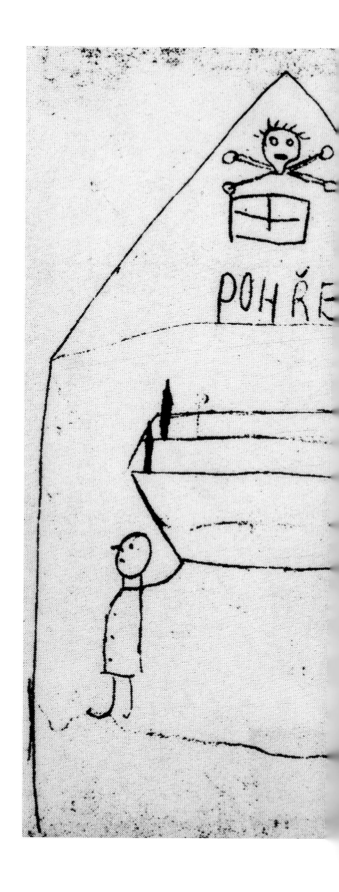

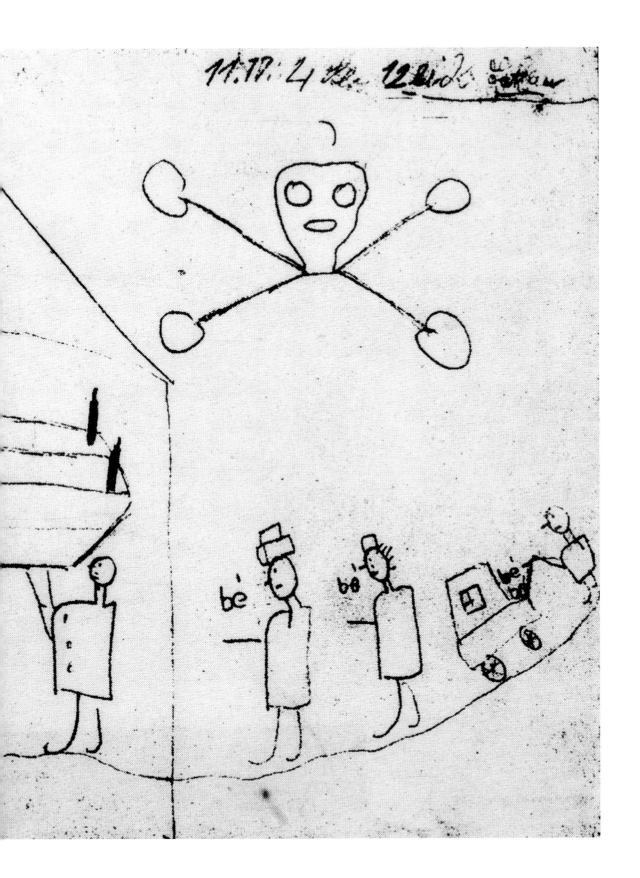

175

Ruth Schächter, b. 1930
Dormitory
Terezín Concentration Camp, Czechoslovakia

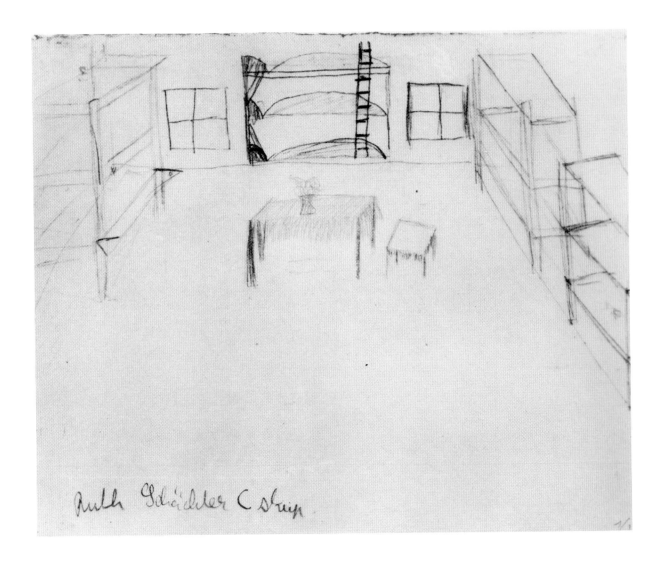

Eva Schulzová, b. 1931
Transporting a Sick Child
Oswiecim Concentration Camp, Poland

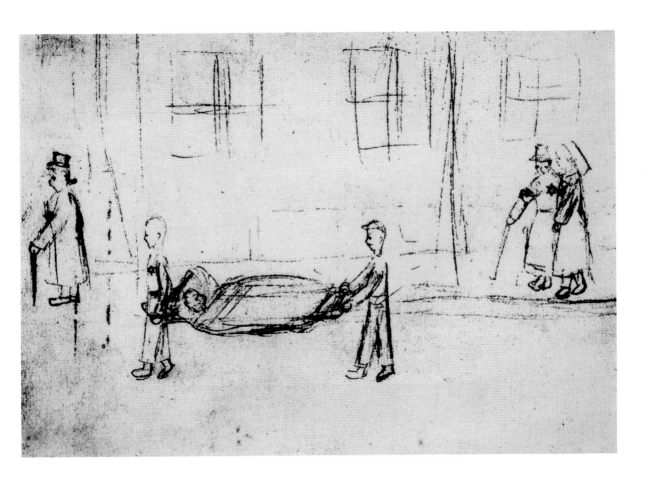

Karl Schwesig, b. Germany, 1898
Internees at the Infirmary, 1940
Saint Cyprien Internment Camp, France

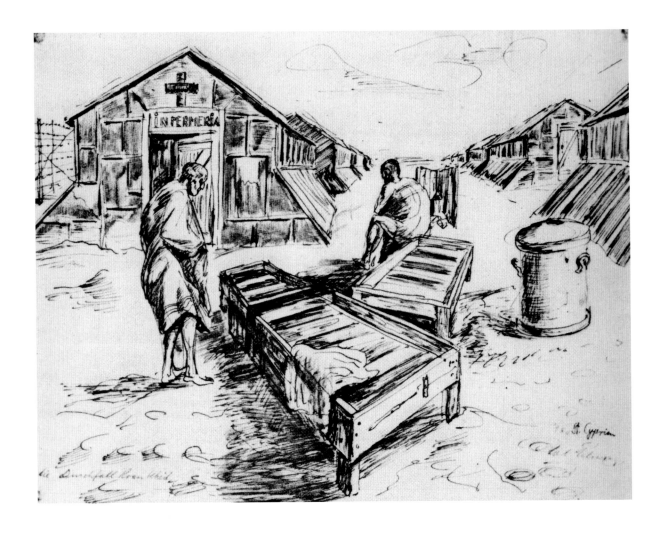

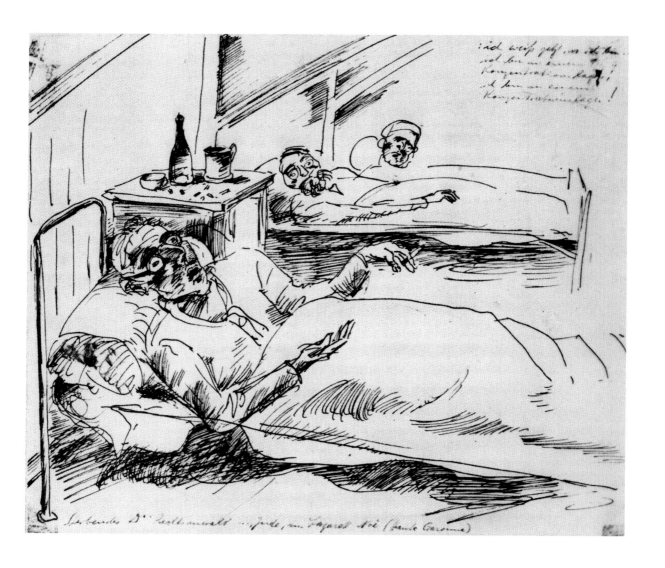

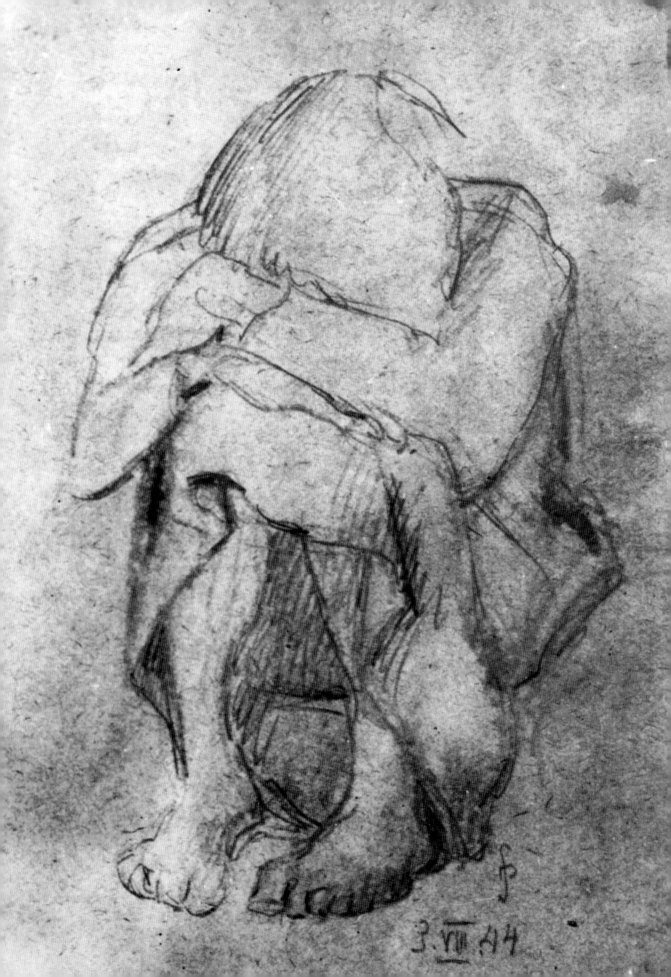

Jadwiga Simon-Pietkiewicz, b. Poland, 1906
Internee, 1944

Jadwiga Simon-Pietkiewicz, b. Poland, 1906
Interview, 1944

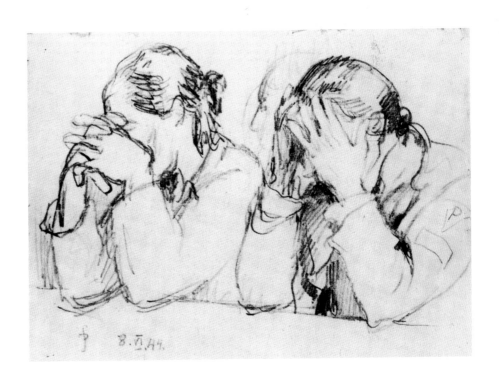

Jadwiga Simon-Pietkiewicz, b. Poland, 1906
Women Internees, 1944
Ravensbrück Concentration Camp, Germany

Jadwiga Simon-Pietkiewicz, b. Poland, 1906
Old Woman Knitting, 1943
Ravensbrück Concentration Camp, Germany

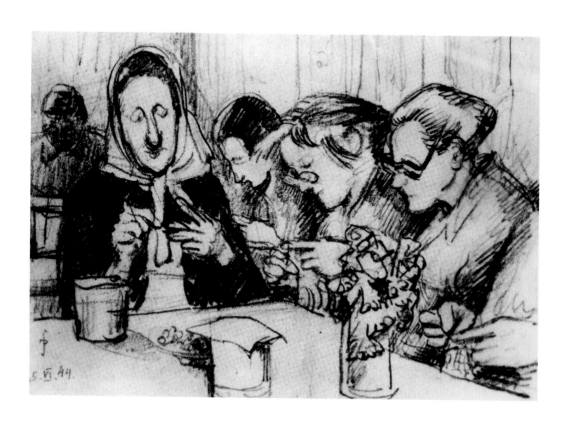

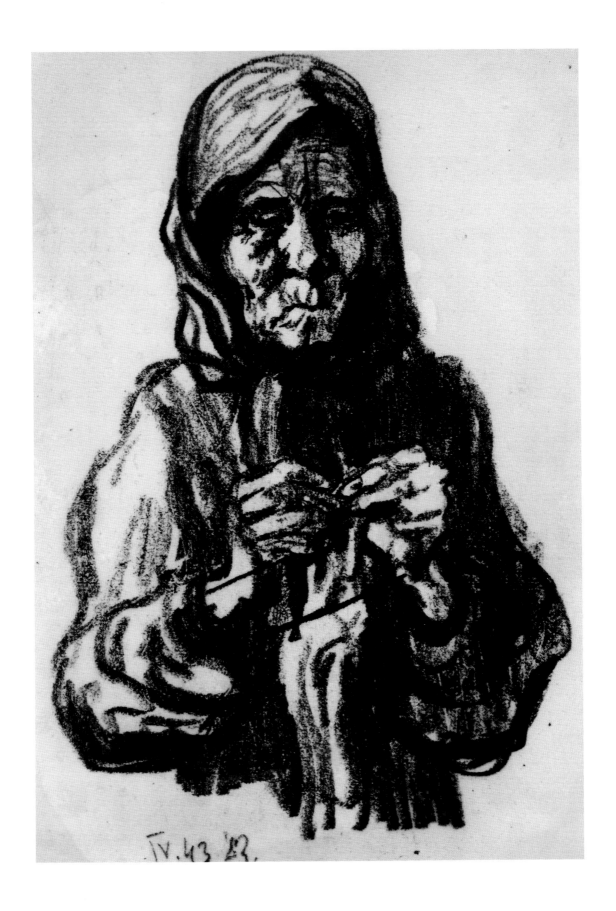

IV. 43 ×2.

Jadwiga Simon-Pietkiewicz, b. Poland, 1906
Portrait of an Internee, 1945
Ravensbrück Concentration Camp, Germany

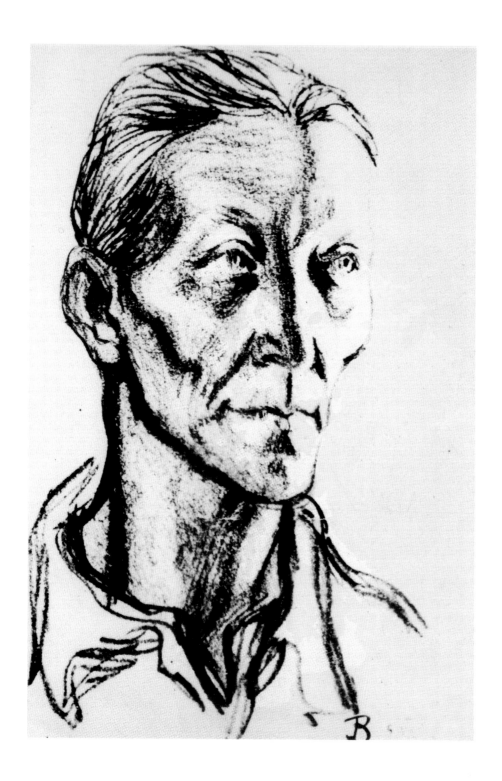

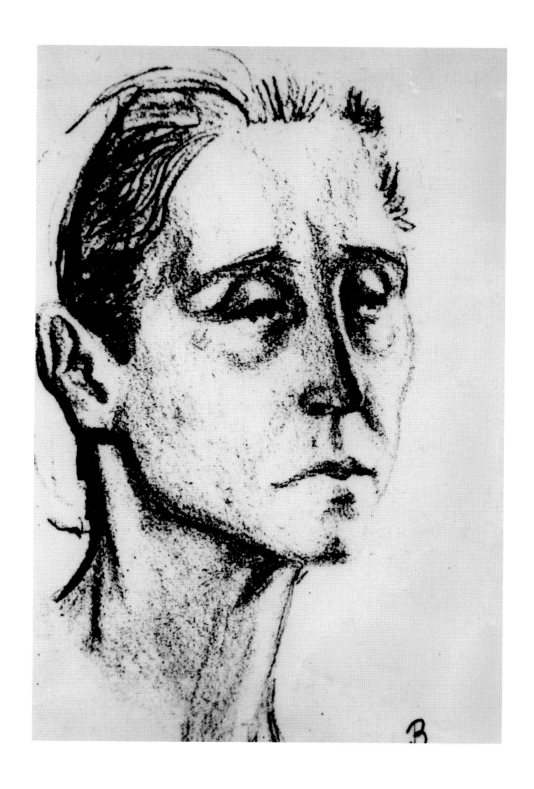

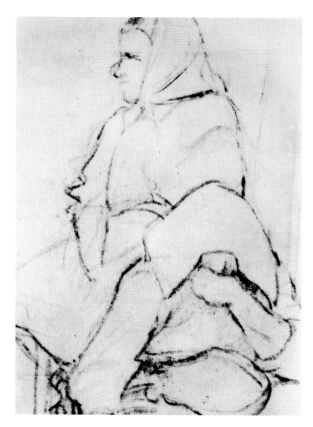

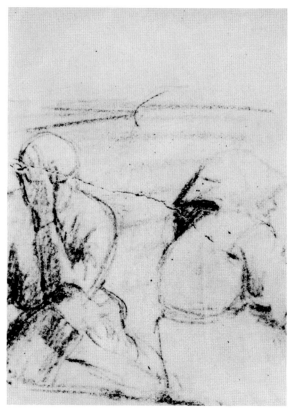

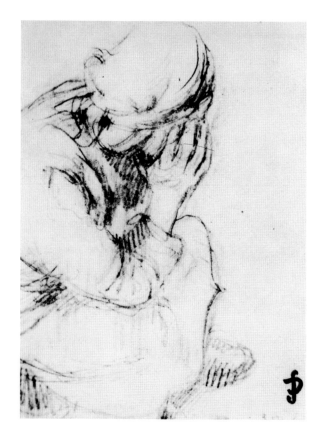

Jadwiga Simon-Pietkiewicz, b. Poland, 1906
Two Internees Sitting, 1945
Ravensbrück Concentration Camp, Germany

Jadwiga Simon-Pietkiewicz, b. Poland, 1906
Two Internees, 1945
Ravensbrück Concentration Camp, Germany

Jadwiga Simon-Pietkiewicz, b. Poland, 1906
Desolation, 1944
Ravensbrück Concentration Camp, Germany

Wladyslaw Siwek, b. Poland, 1907
Selection of Women at Birkenau, 1950
Birkenau Concentration Camp, Poland

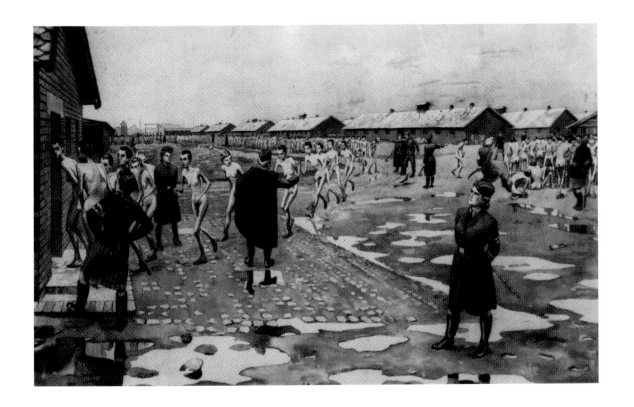

Carlo Slama, b. Italy, 1921
Transport, 1945
Oswiecim Concentration Camp, Poland

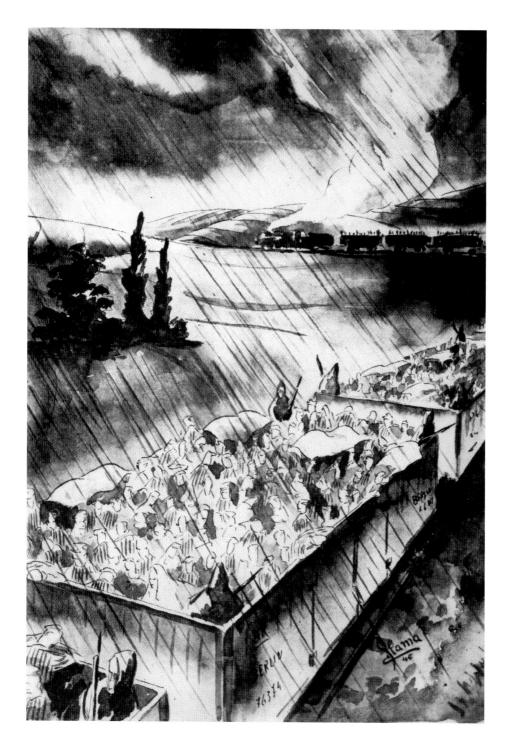

Carlo Slama, b. Italy, 1921
Hanging in the Hall, 1945
Dora Concentration Camp, Germany

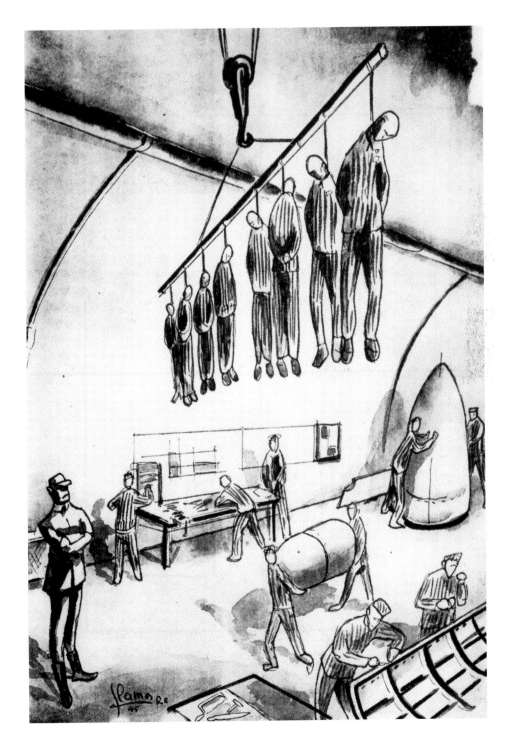

Gino Spalmach, b. Italy
Beyond the Fence, 1944
Wietzendorf Concentration Camp, Germany

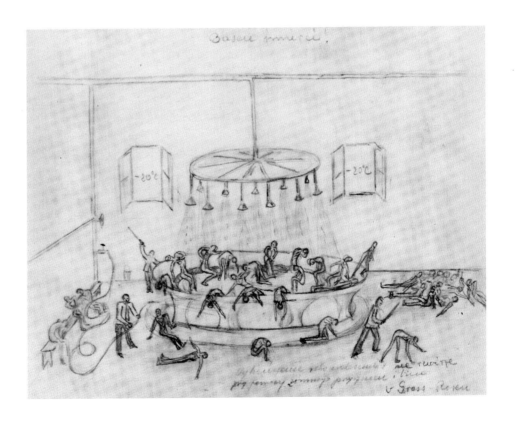

Karel Svolinski, b. Czechoslovakia, 1886
Sad Eyes, 1940
Terezín Concentration Camp, Czechoslovakia

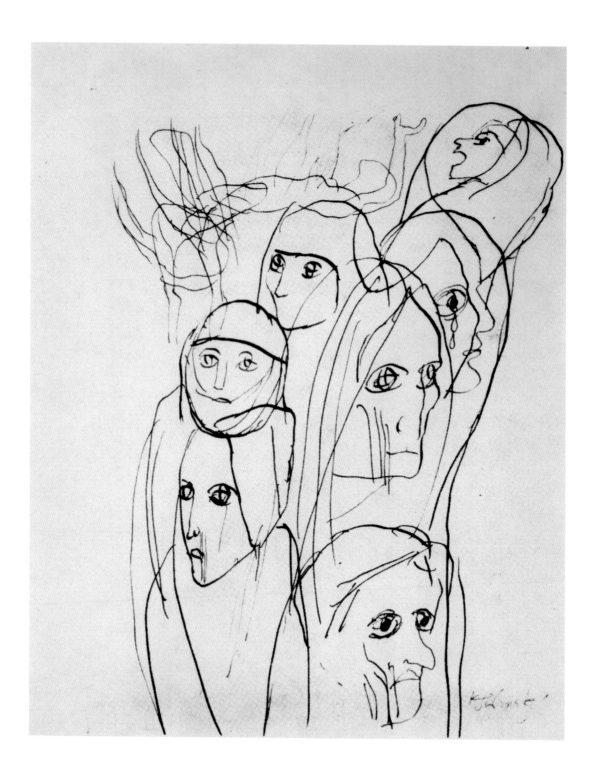

Jozef Szajna, b. Poland, 1922
Selected for the Firing Squad, 1943
Buchenwald Concentration Camp, Germany

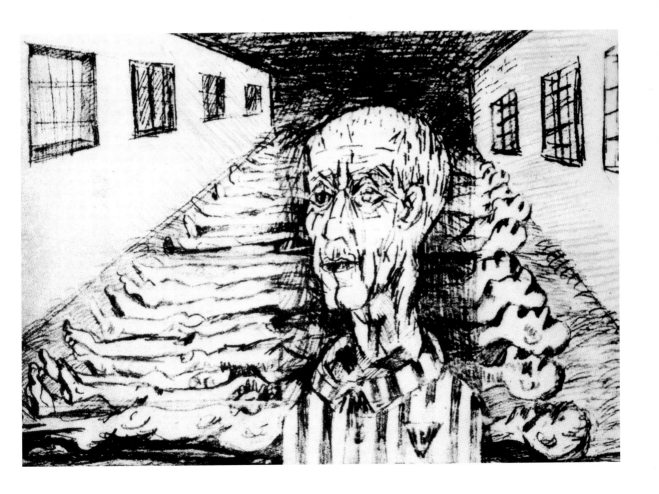

Jozef Szajna, b. Poland, 1922
Roll Call, 1944
Buchenwald Concentration Camp, Germany

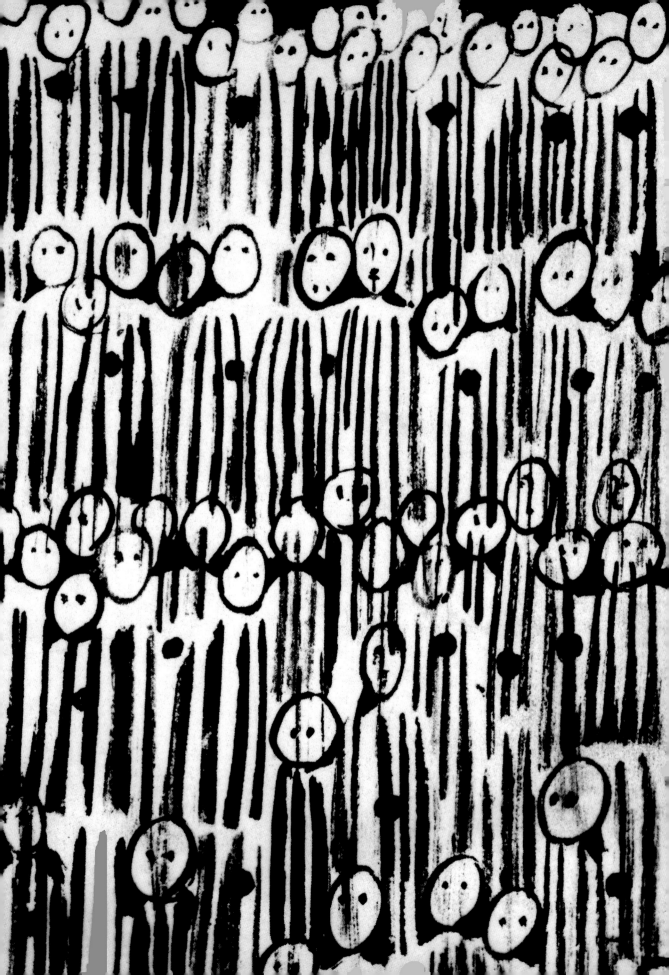

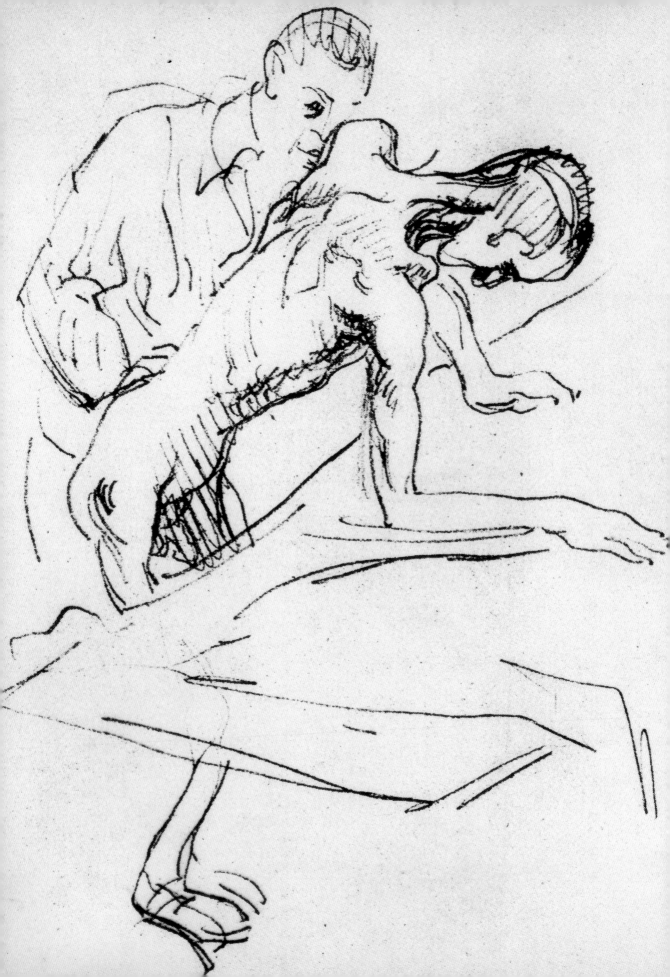

Boris Taslitzki, b. France, 1911
Medication, 1944
Buchenwald Concentration Camp, Germany

Boris Taslitzki, b. France, 1911
Professor Hakbwachs Receives Treatment a Few Days Before Dying, 1944
Buchenwald Concentration Camp, Germany

Boris Taslitzki, b. France, 1911
A Sick Man, 1944
Buchenwald Concentration Camp, Germany

Boris Taslitzki, b. France, 1911
Little Camp in February, 1945
Buchenwald Concentration Camp, Germany

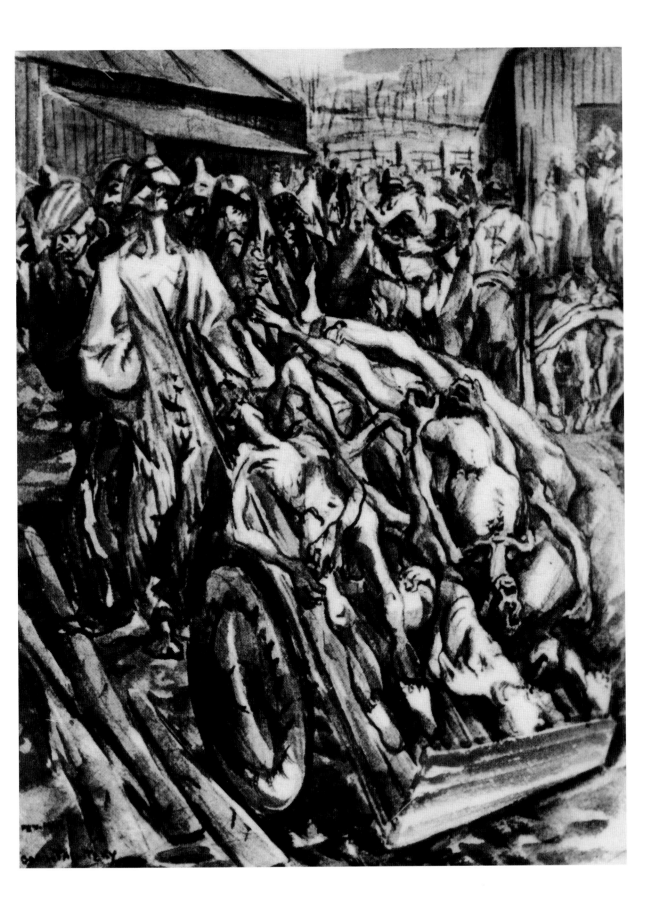

Eric Taylor, b. England, 1909
Living Skeleton at Belsen Camp, 1945
Belsen Concentration Camp, Germany

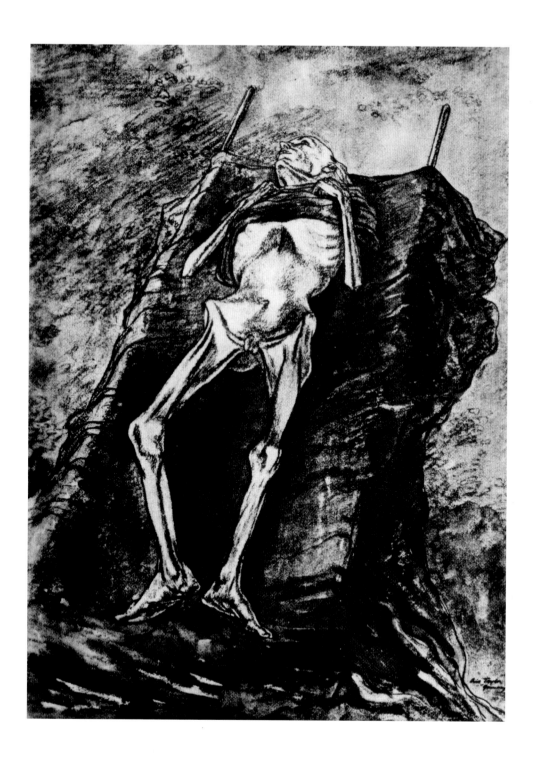

Eric Taylor, b. England, 1909
Bodies at Belsen Camp, 1945
Belsen Concentration Camp, Germany

Eric Taylor, b. England, 1909
Man Who Died from Hunger and Torture, 1945
Belsen Concentration Camp, Germany

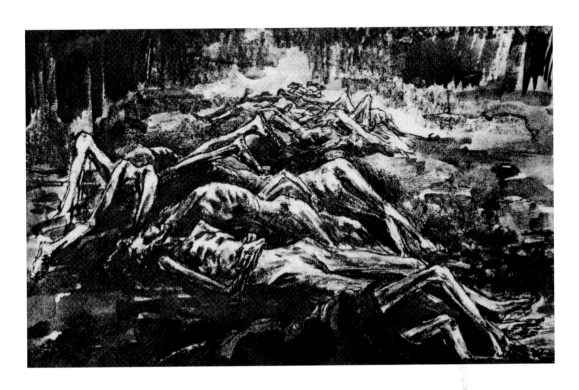

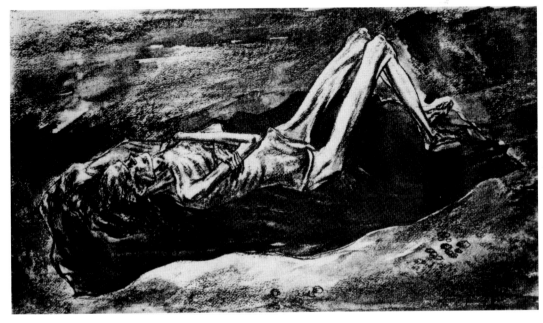

Janina Tolik, b. Poland, 1910
Water from the Puddle, 1950

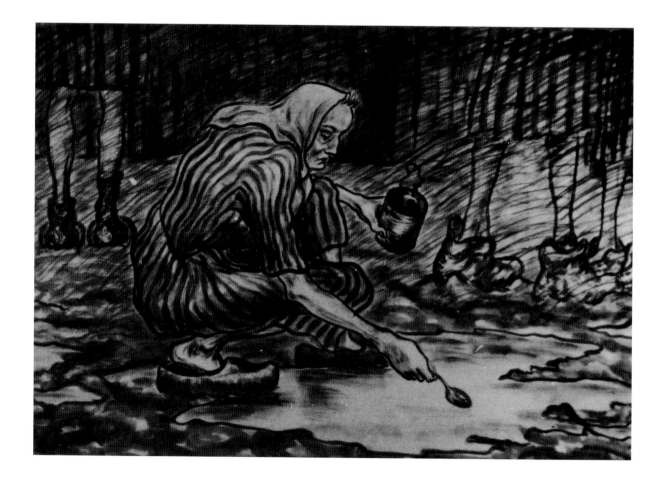

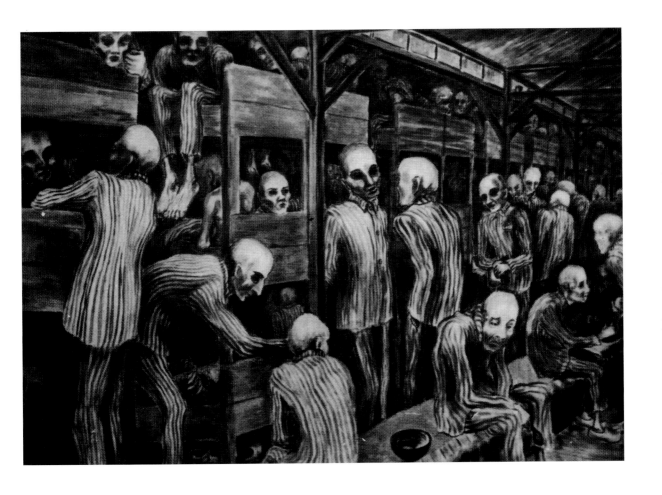

204

Sinowi Tolkacev, b. Russia, 1903
Protection, 1945
Oswiecim Concentration Camp, Poland

Sinowi Tolkacev, b. Russia, 1903
Mother and Child, 1945
Oswiecim Concentration Camp, Poland

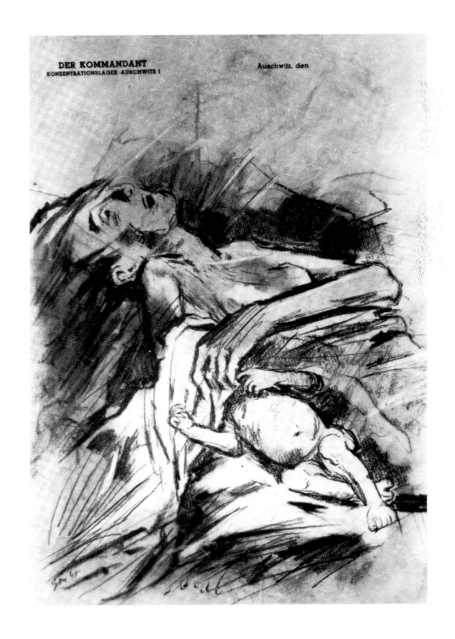

Sinowi Tolkacev, b. Russia, 1903
Affronted Beauty, 1945
Oswiecim Concentration Camp, Poland

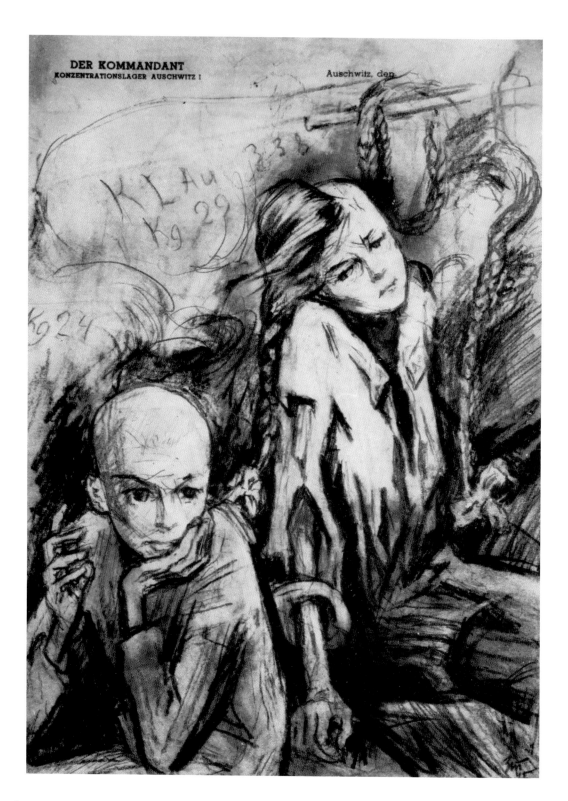

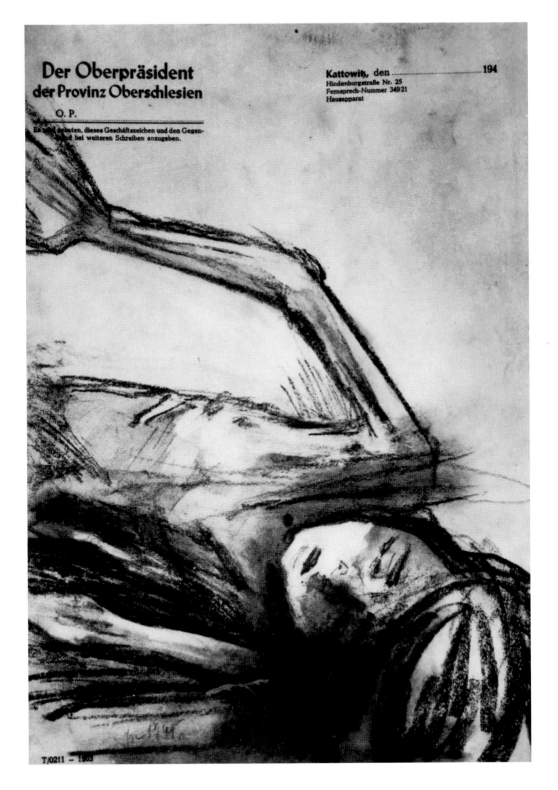

Sinowi Tolkacev, b. Russia, 1903
Without Words, 1945
Oswiecim Concentration Camp, Poland

Sinowi Tolkacev, b. Russia, 1903
At the Cremation Oven, 1945
Oswiecim Concentration Camp, Poland

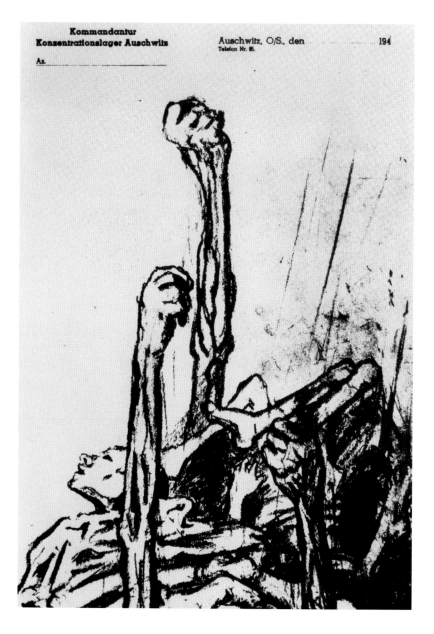

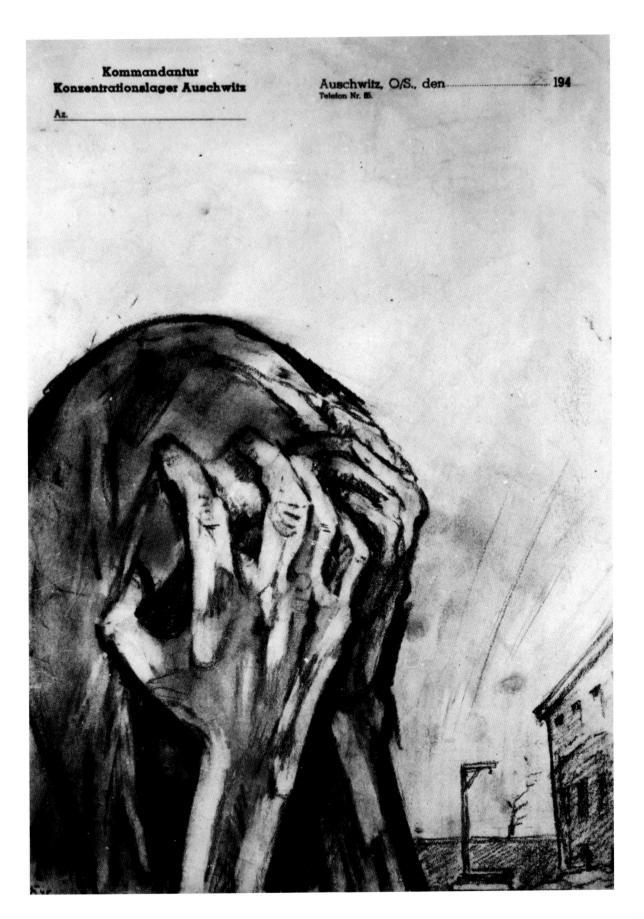

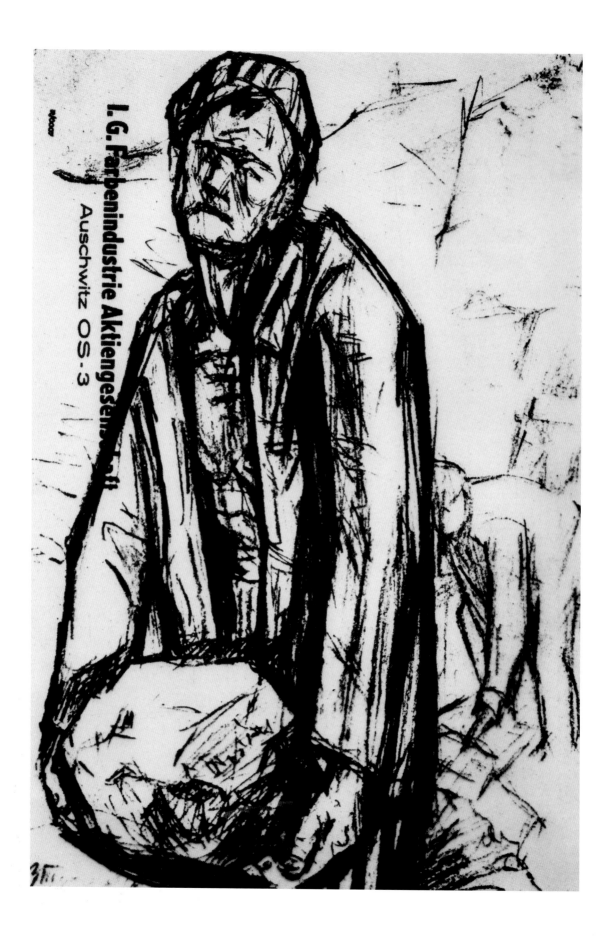

I.G. Farbenindustrie Aktiengesellschaft
Auschwitz OS-3

210

Sinowi Tolkacev, b. Russia, 1903
The Rock Quarry, 1945
Oswiecim Concentration Camp, Poland

Sinowi Tolkacev, b. Russia, 1903
Preparations for Action, 1945
Oswiecim Concentration Camp, Poland

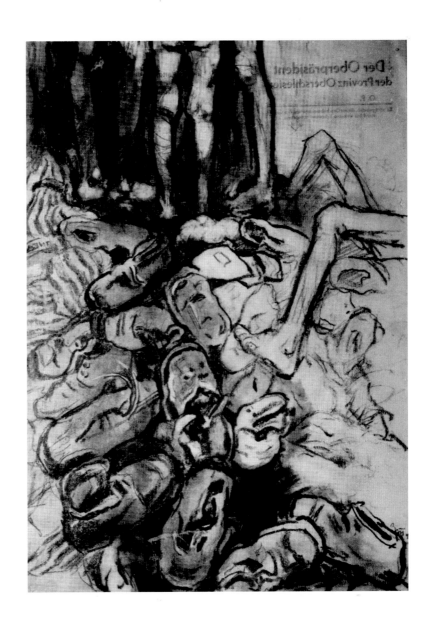

Sinowi Tolkacev, b. Russia, 1903
Silence, 1945
Oswiecim Concentration Camp, Poland

Sinowi Tolkacev, b. Russia, 1903
Burying the Victims, 1945
Oswiecim Concentration Camp, Poland

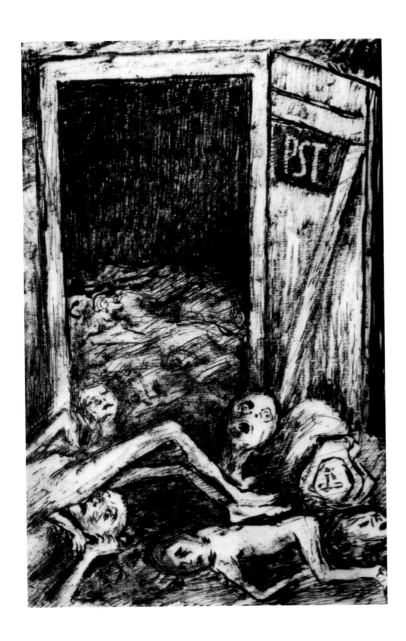

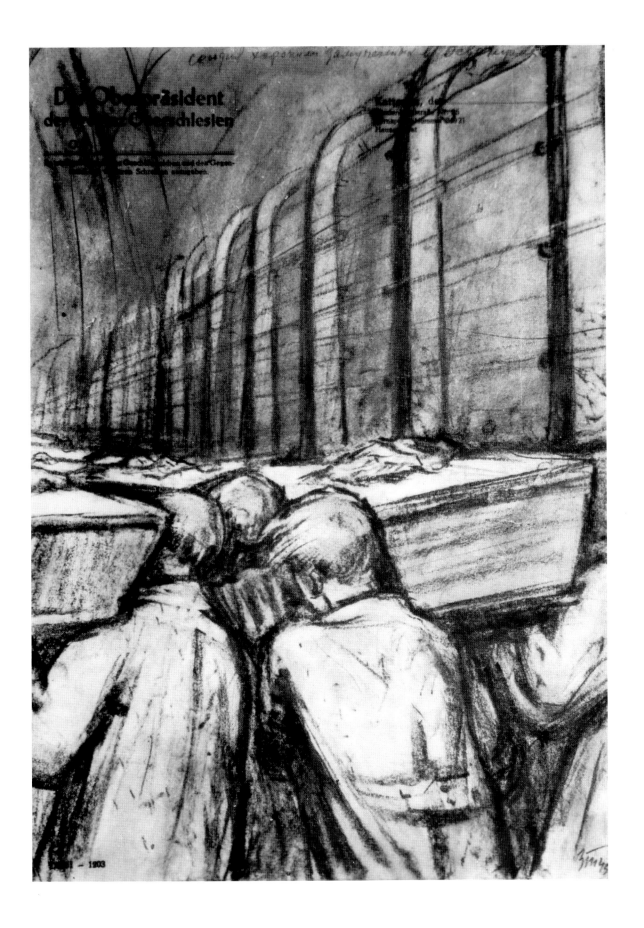

Marcello Tomadini, b. Italy
Search, 1944
Benjaminovo Camp, Poland

Marcello Tomadini, b. Italy
M Carts, 1944
Sandbostel Concentration Camp, Germany

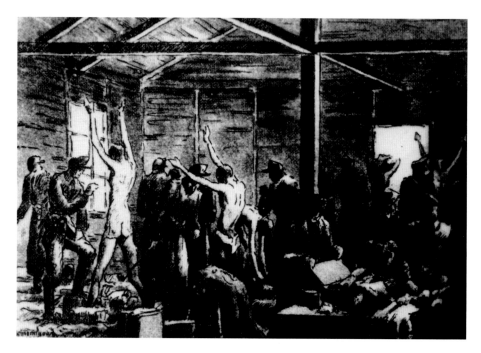

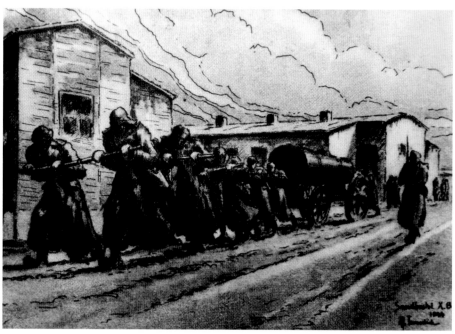

Marcello Tomadini, b. Italy
Flogging, 1945
Belsen Concentration Camp, Germany

Marcello Tomadini, b. Italy
Cremation Oven, 1945
Belsen Concentration Camp, Germany

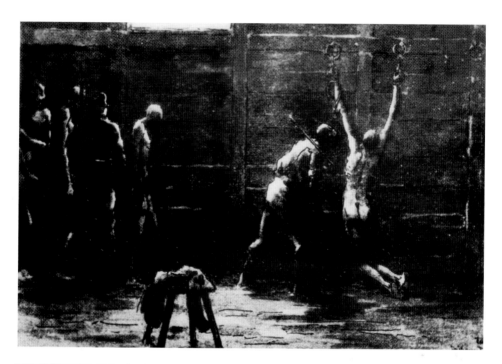

Feliks Topolski, b. Poland, 1907
Belsen Camp on the Day of Liberation, 1945
Belsen Concentration Camp, Germany

Feliks Topolski, b. Poland, 1907
Bodies Found at Belsen Camp on the Day of Liberation, 1945
Belsen Concentration Camp, Germany

Feliks Topolski, b. Poland, 1907
Polish Prisoners at Papenburg Disinfected after Liberation, 1945
Papenburg Concentration Camp, Germany

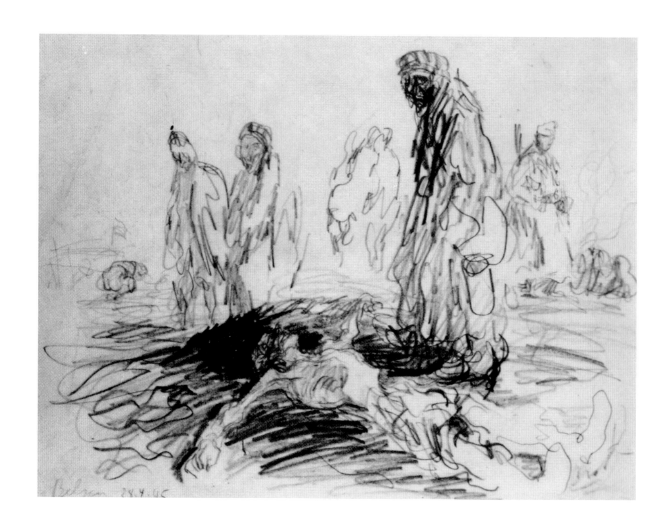

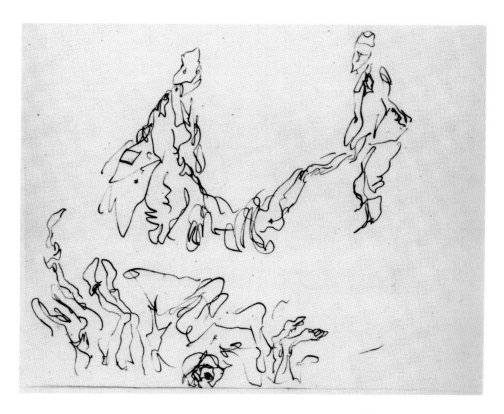

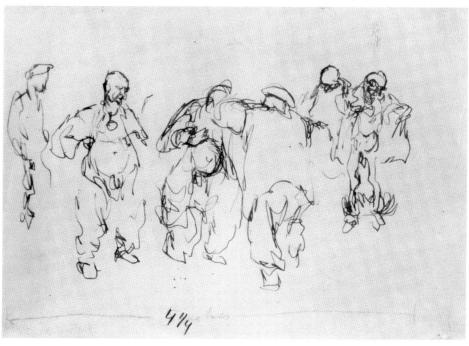

Feliks Topolski, b. Poland, 1907
*Papenburg Camp on the Day It Was Liberated
by the Polish Army,* 1945
Papenburg Concentration Camp, Germany

Feliks Topolski, b. Poland, 1907
*Interrogation of the German Commandant of the
Papenburg Camp by the Liberating Troops,* 1945
Papenburg Concentration Camp, Germany

Feliks Topolski, b. Poland, 1907
*German Soldiers Taken Prisoner after the Liberation
of Papenburg Concentration Camp,* 1945
Papenburg Concentration Camp, Germany

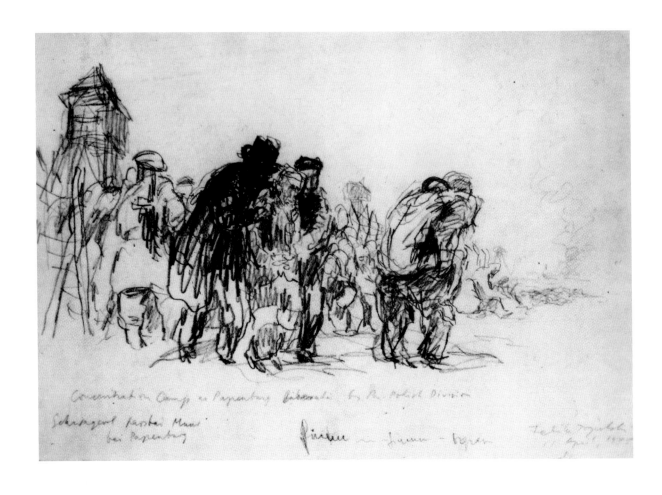

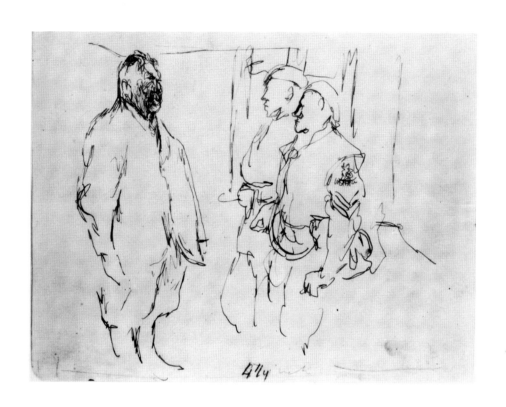

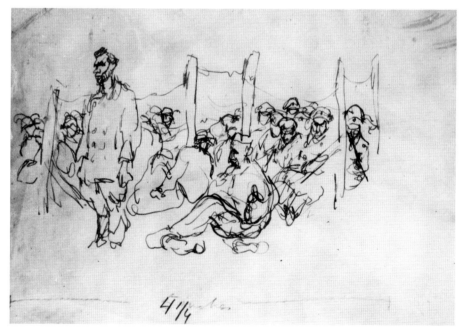

France Uršič, b. Yugoslavia, 1907
Bodies, 1945
Dachau Concentration Camp, Germany

Drago Vidmar, b. Yugoslavia, 1901
Young Internee, 1943
Renicci Concentration Camp, Italy

Bruno Vavpotić, b .Czechoslovakia, 1904
Cremation Oven, 1945
Dachau Concentration Camp, Germany

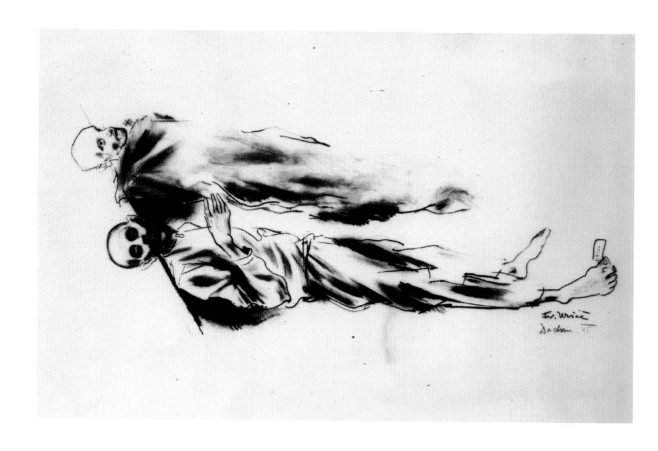

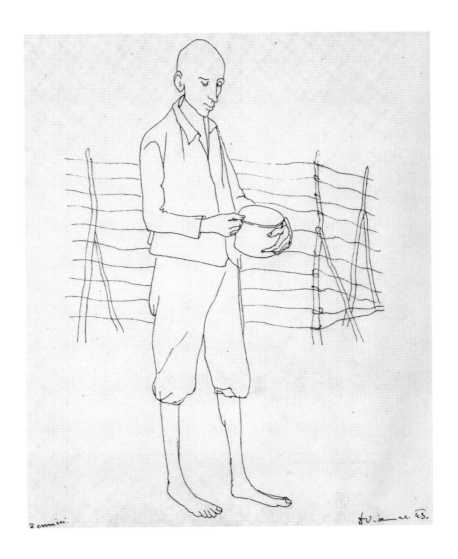

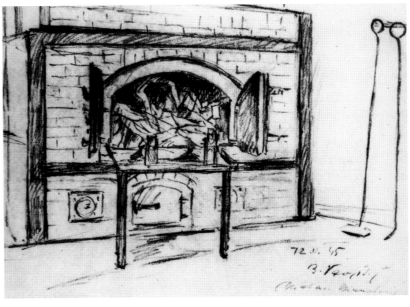

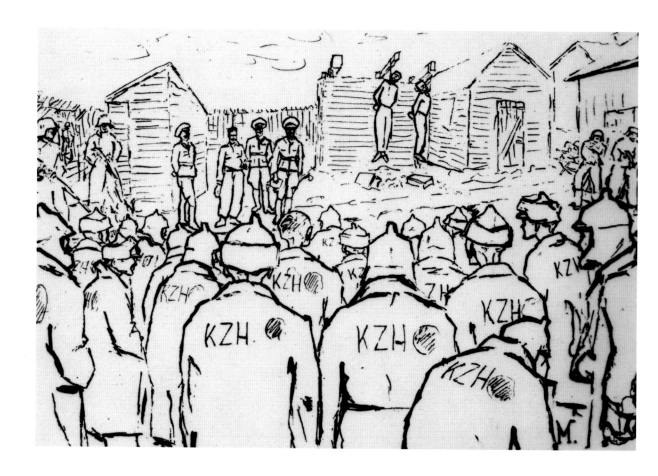

Arbeit Macht Frei

Transit to which
secret slaughters
signaled that accent over the entrance?
Could the lone birch hear
—oh so much in its tender mature
roots!—
the deceit entrusted to its leaves?
There was no illuded age, then.
In the air was certain end
spreading with gray swirls
smoke from a chimney.

Arturo Benvenuti
Oswiecim, June 1980

Stefan Wegner, b. Poland, 1901
Auschwitz
Poland, 1946

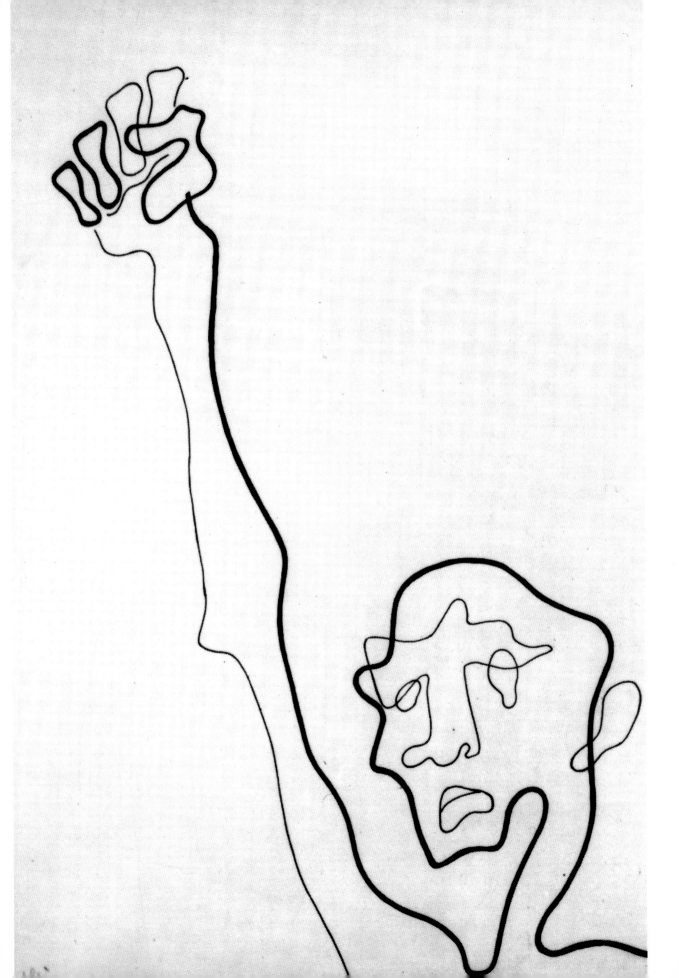

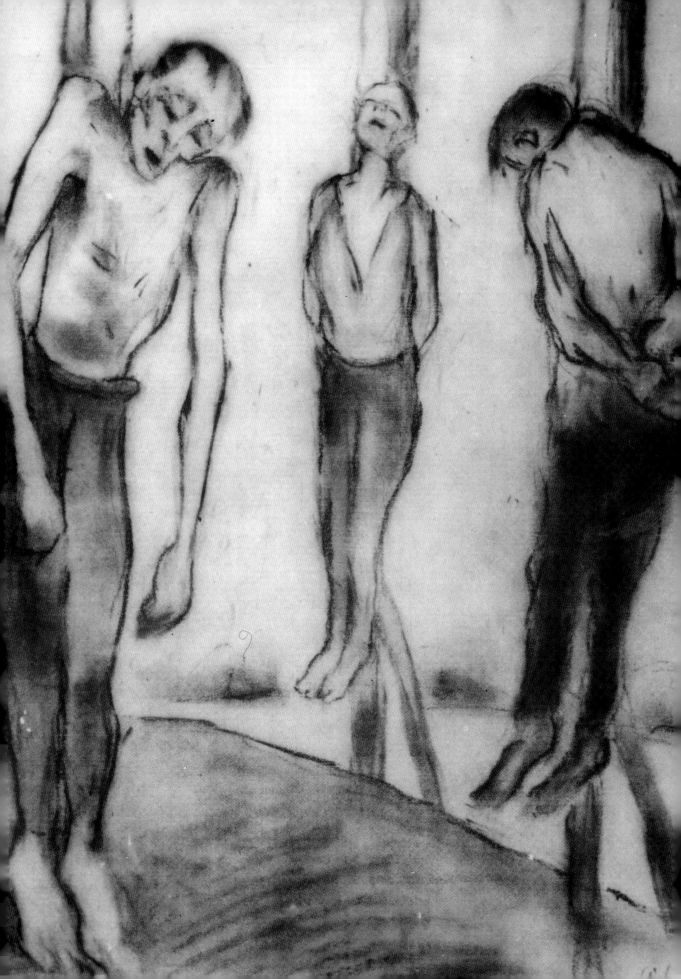

Adolf Weiler, b. Yugoslavia, 1895
Execution, 1944
Jasenovac Concentration Camp, Yugoslavia

Adolf Weiler, b. Y ugoslavia, 1895
Candidate for the Concentration Camp, 1942
Jasenovac Concentration Camp, Yugoslavia

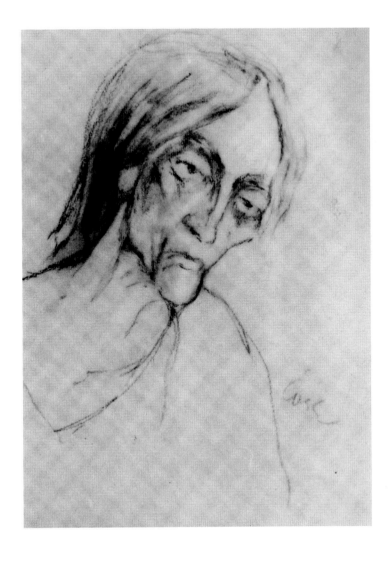

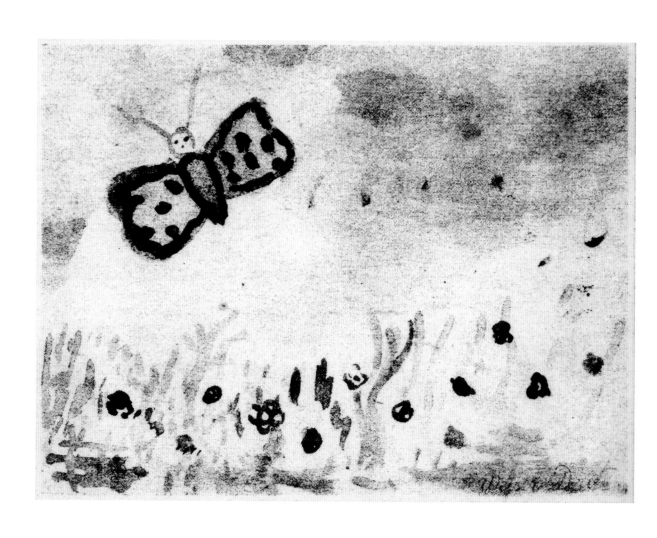

Doris Weiserová, b. Poland 1932
Untitled
Oswiecim Concentration Camp, Poland

The Children of Terezín

What smile did Theresa's city promise
your unripe flesh?
Cursed be her name
if the monster design generated
naught but gloomy stone.
Soft eyes dreamed
of soft absences in the place of dread;
in the guilty shadow
lurked the murderous cross.
Trembling wings
beat beneath sapphire skies
the butterflies of your innocence:
you kept them for us
in the meadow of a tiny sheet.
May my god not let them be lost
in man's muddy oblivion.

Arturo Benvenuti
Terezín, June 1980

[The "gloomy stone" refers to the stones of the fortress that
Austrian Emperor Joseph II dedicated to his mother, Maria
Theresa, which later became the concentration camp at Terezín.]

Franciszek Wieczorkowski, b. Poland, 1920
Work at the Road Roller, 1942
Auschwitz Concentration Camp, Poland

Marek Wlodarski, b. Poland, 1903
Bunks at Stutthof Camp, 1945
Stutthof Concentration Camp, Poland

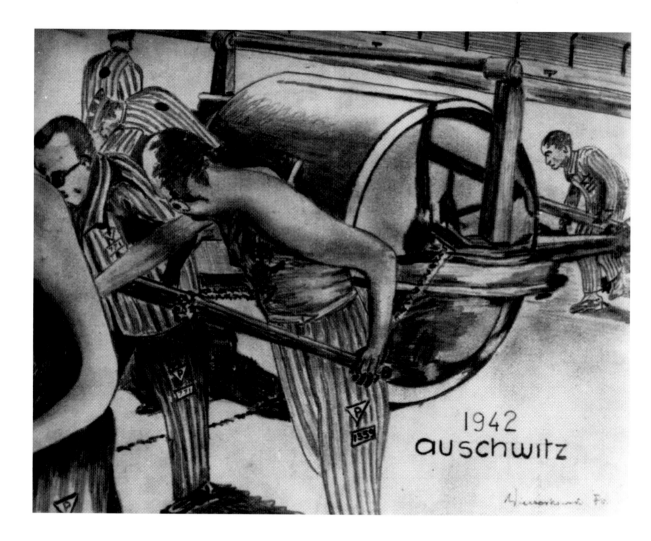

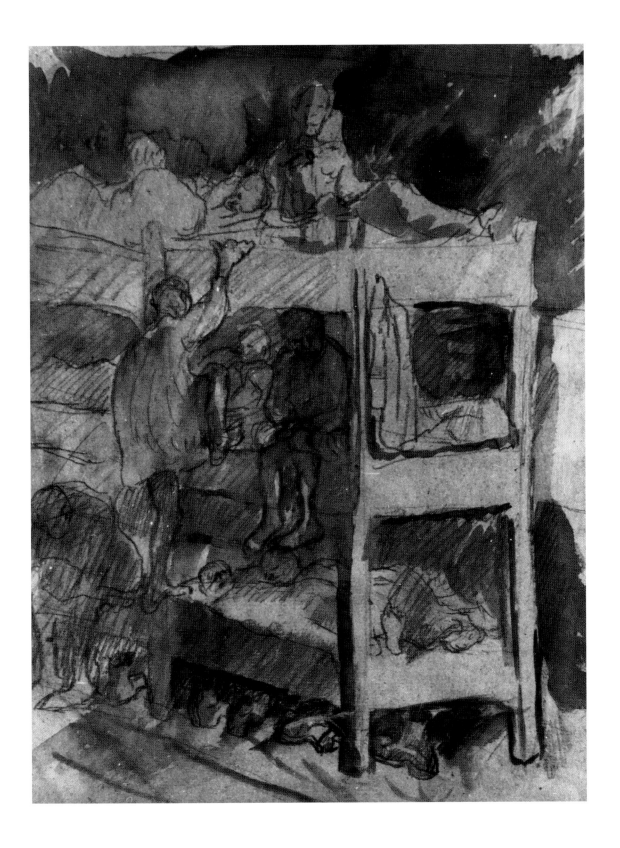

Karl Zahraddnik, b. Austria, 1909
Children in the Camp

Karl Zahraddnik, b. Austria, 1909
In the Ghetto

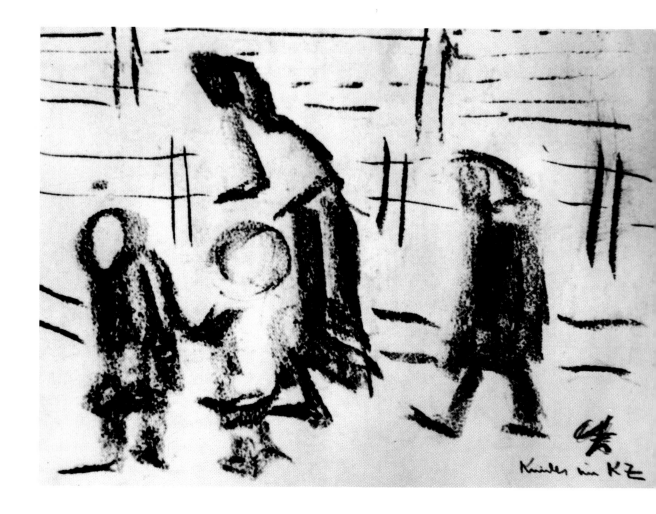

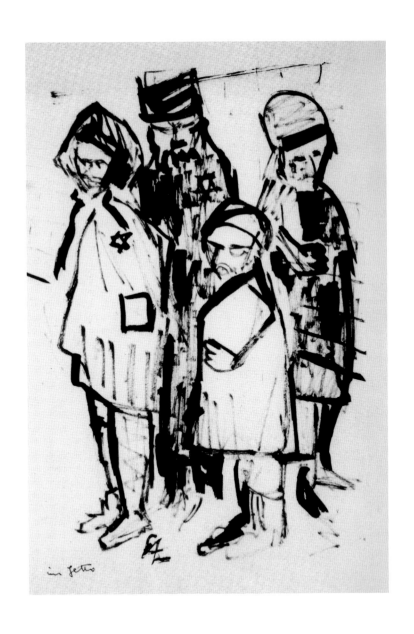

in getto

233

KZ: A Resounding Echo

Roberto Costella

> No one moulds us again out of earth and clay,
> no one conjures our dust.
> No one.
> Praised be your name, no one.
> For your sake we shall flower.
> Towards you.
> A nothing we were, are, shall remain, flowering:
> the nothing, the no one's rose.
> —Paul Celan, "Psalm" (Trans. Michael Hamburger)

After August 25, 1944—after Paris's liberation from the Nazi occupation—Pablo Picasso began painting *The Charnel House,* a complex work that is challenging to interpret, which rejects perspective references and spatial coordinates, intertwining bled and dismembered bodies, marked by dull grays and funereal whites—it is a tragic icon that metaphorically evokes the Spanish civil war, denounces the fierce slaughter (*feroz matanza*), incorporates the war currently in progress, indicating innocent victims, mutilated bodies, and broken limbs, as signs of an unhealthy and irreparable barbarism.

Painted after *Guernica* (1937) and before *Massacre in Korea* (1951), composed up to the first few months of 1945, and perhaps unfinished, *The Charnel House* depicts a massacre. In this same period, Picasso made the stark declaration that an artist is not "an imbecile who only has eyes [. . .] he is also a political being, constantly aware of the heartbreaking, passionate, or delightful things that happen in the world [. . .]. Painting is not done to decorate apartments. It is an instrument of war" (*Les Lettres Françaises*, March 24, 1945).

Another Spanish painter, Francisco Goya, had already expressed his clear civic intentions in 1814, with the paintings *The Third of May 1808* and the eighty-two etchings *The Disasters of War* (1810–20). To him, the desire for domination and aspirations to empire, producing nothing but violence, allowed for a handful of victors and many—too many—vanquished, almost always striking the defenseless. Truly, then as now, "the sleep of reason produces monsters," as well as unjustifiable, irreparable monstrosities.

If there exists no epic of war, nor does there exist an ethics that could justify treacherous armed interventions, and Honoré Daumier, in *Rue Transnonain* (1834), shows this in a lithograph depicting a family slaughtered in their sleep by Louis Philippe's militia. It is an image of a real event, a crime perpetrated to suppress

a popular rebellion. Charles Baudelaire said of that raw image that it was not a caricature, but "history, reality, both trivial and terrible."

Thus starting in the early nineteenth century, a civic consciousness emerged in some artists that resulted in taking a deliberate stance to denounce or protest, and this also happened, albeit less explicitly, with Théodore Gericault and later, occasionally, with Henri Rousseau and James Ensor. In the early twentieth century, the statements grew in number and intensity, especially in the German tradition: the *Die Brücke* expressionists systematically criticized Wilhelm's totalitarianism, while George Grosz, Otto Dix, and Max Beckmann documented (like soldier-photographers on many fronts) the violence of World War I and then showed the harsh living conditions in postwar Germany; John Heartfield, active since the first postwar period and the creator of cutting photomontages, even gave up and Anglicized his real name (Helmut Herzfeld), repudiating the militaristic, nationalist, and imperialist "pale mother Germany," and later attacking Hitler and the Third Reich.

Picasso was no less political. For nearly two decades, even in occupied Paris, he mobilized by appealing to the responsibilities of the democratic artist, signaling a political emergency and civil urgency, invoking historical awareness and social consciousness against all totalitarianisms. Through political commitment, expressed figuratively as well as verbally, the Spanish painter placed the problem of the intellectual in the face of violence, of art in the face of death, of civilization and freedom in the face of human brutality. Picasso was neither the first nor the only, but the echo of his stance was vast and virtually without equal, thanks to his prestige and its fame. *The Charnel House* took on high symbolic value, becoming the astonishing revelation of a massacre and the terrible emblem of the latest, devastating, thirty years' war.

Moreover, any historical assessment of the twentieth century cannot ignore the negative centrality of the element of war, which, creating serious socioeconomic implications and new geopolitical dimensions, irrevocably marked and altered the conditions of existence for contemporary humanity. Increasingly technological, violent, and global, war traversed the century with heightened frequency: conflicts caused by reasons ideological and economic, ethnic and religious, revealed an unprecedented capacity for destruction and murder, especially as regards civilian populations.

Thus, many citizens and people of culture felt a need to bear witness, to reject and condemn this violence. One of them was Arturo Benvenuti, who, with the utmost humility, driven purely by idealism, attempted to do something by retracing, first in his mind and then in person, the most painful trials of the twentieth century.

It wasn't easy, because Arturo Benvenuti, born in 1923 in the period of the racial laws and the second worldwide conflict, couldn't have known—too young

to understand and take action, but also too grown to remain indifferent and feel unrelated to it, and in the postwar era, too aware and sensitive not to begin some ideological reflection, not to think about political motives, ethical reasons, and life choices. As George Grosz, exiled in the United States, wrote in the 1930s: "At night I hear Europe, without a radio, from thousands of miles away, I hear screams of despair, I smell the scent of fire and of blood," so must Arturo Benvenuti have felt and thought, undoubtedly for years, about the drama of the camps and the latest "useless massacre." And if spatial distance wasn't able to mitigate Grosz's drama, temporal distance wasn't able to alleviate Benvenuti's malaise: a deep malaise, heightened by an unmotivated remorse, almost a sense of guilt, produced by the idea of not having been able to or known how to do enough.

In a poem he read in public, he berates himself, stating: "I did little. The life scattered / page after page like sand / blown over dry dunes / of deserted shores, / dead banks / where the sun bleaches / piles of gaping shells / and shorn claws / of crabs without marrow. / In vain the horizon reveals / pulsing sails / that will have me / a sailor no more; I gave in / to the blackmail of bread / in the course of spent swamps, / beneath a wrinkled sky / like the belly of old Megaera. / I'm surprised to find myself / with the bugbear of buried memories, / a tide that grows with the wind / the old dams crying out / the sums of giving and having. For a while I should fix / the sun on the edge / of its zenith, as if to frame, / in the fatigued autumn, an account that doesn't add up" ("Account," in *Masiere*, 1970).

An account that remains unresolved. And without any reason, realizing that Arturo Benvenuti—an impeccable accountant and banker for decades—devoted himself to producing culture with a strong ethical force: as a poet, he composed verses that were appreciated by Fulvio Tomizza and Biagio Marin and acknowledged by Samuel Beckett; he was an active painter supported critically by Giuseppe Marchiori; he engaged in archival research and aesthetic-historical analysis; he worked on photographing the social and natural environment of the Veneto region and the Istrian world of the Karst; he founded and was director of a museum, the Alberto Martini Art Gallery.

Hyper-critical and rarely satisfied, he even accused himself of insufficient social engagement, too little civil activism, stating that "letting do is the same as doing," and thus means being complicit and morally responsible. This is a weight—a burden— that long weighed on Benvenuti's conscience, but became the basis and the ideal push that gave led to the KZ project (the abbreviation and title of the Italian edition of the book, *KZ*, stands for *Konzentrationslager*, or concentration camp). It is evident that he struggled with it and took some time to work through these war traumas from deprivation and humiliation, fears and anxieties, displacement and deportation.

But an insistent, ineluctable inner need, slowly, led him back to that time, searching for the places, and ideally, the victims of the most tragic chapter of the

twentieth century. His aspiration was to understand better, to see for himself and verify in person, and then, perhaps, create a memory that wouldstate a historical truth, nurture new civic awareness. On the original cover of *Imprisoned*, dedicated "to the innocent victims of barbarism in all times," Benvenuti included George Santayana's admonition that "those who cannot remember the past are condemned to repeat it."

Thus in September 1979, at the age of fifty-six, in his camper with his wife Marucci, Arturo Benvenuti began crossing the Via Crucis of the twentieth century: a sort of reparatory journey, a secular pilgrimage, whose stations were Auschwitz, Terezín, Mauthausen, and Buchenwald, after stops in cities like Vienna and Paris, Amsterdam and Belgrade, Stockholm and Geneva, London and Munich, Budapest and Krakow, Weimar and Prague, Copenhagen and Stockholm. And there he found veterans, met survivors, visited local history museums, public archives, public libraries, searching for visual testimonies of the camps.

Out of this came *Imprisoned: Drawings from Nazi Concentration Camps* (originally titled *KZ*, subtitled *Drawings from the Nazi-Fascist Concentration Camps*), which was published in April 1983 with a preface by Primo Levi. The 276-page book, with as many black and white photographs, reproduces drawings, almost all of which were made in the camps, by the internees themselves. It is drawn, occasionally painted material collected over the course of four years, and then arranged by Benvenuti himself, who found a press at the Cassa di Risparmio della Marca Trivigiana. The Treviso credit institution, taking charge of the collection, created a not-for-profit edition, in adherence to the editor's specific request.

Benvenuti, an artist and intellectual, excluded every poetic, pictorial, and photographic text that had been created and signed during travel: he decided not to add anything more, so that the internees' drawings stood on their own. He avoided imposing himself, combining original visual texts that were expressions of a condition that had been experienced and painfully endured, with later interpretations produced by an idiosyncratic experience of exploration, however it had begun and progressed. The meaning, value, and degree of truth would be different. It was a necessary choice, because this way the victims—the creators of these documents—received the most visibility and greatest respect: after all, for many, it was their final testimony.

Primo Levi's very clear introduction was enough to explain, grasping the particularity and originality of the visual text, recognizing that "until now a book like this one has been missing" and if "in describing these horrors, words prove insufficient," the drawings of *Imprisoned*, in contrast, "say what the word is not able to."

Thus the poems inspired by those places and written in those places were left out: Benvenuti had composed five, then he printed them in a pamphlet he

distributed among his friends. We should recall, however, that in 2010, for the Holocaust Remembrance Day celebration in the City of Pordenone, the public library reprinted *KZ—Poems*, including Benvenuti's introduction that connects his writing to his "pilgrimages along the many paths of human suffering." They were "short compositions," i.e., essential and minimalist texts, with expressions of solidarity for the victims and admonitions to the perpetrators; there are poems written at Auschwitz, Terezín, and Mauthausen, and they constitute a statement of passage, an example of civic poetry, a testimony of mercy.

While he dedicates one lyric to the children of Terezín, his approach to the drama of the camps doesn't categorize, doesn't make distinctions or exclusions: all detainees, all victims deserve the same respect and are worthy of remembrance. To him, the extermination is a universal tragedy, and thus, without making distinctions of faith or ideology, origin or nationality, age or social status, he presents the images not according to theme, technique, or supposed artistic quality. And Benvenuti organized *Imprisoned* according to author (not subject or location), based on irreproachable alphabetical order (not national identity), in a choice that put ethics before aesthetics, perhaps creating a slightly unhomogeneous, even messy sequence. But unlike the tiles of a broken mosaic, this purposive disorder, by fully expressing, perfectly describing, makes the condition of life gone mad, without balance and security, into a possibility for relation and perspective. This was the only possible way to arrange the absurdity of a world dominated by homicidal madness, "absolute evil": essentially, this terrible collection of images, which without posture or logical continuity, presses on us, acts as a disturbing document and an unbearable charge against history.

The book that contains it would be full of life and rich with meaning if published in a new edition. Clearly it has been able to *mănēre* and *mŏnēre*—to resist and remind.

Over thirty years since its original publication, *Imprisoned* can aspire to greater diffusion—the time for it to be fully appreciated has come. Benvenuti, ever present and aware, has made his contribution and can finally observe, with the knowledge that he has saved images—and by extension, messages, experiences, people—that would have been otherwise destined to oblivion; he can be—must be—proud to have made a contribution of truth and civilization. As he wrote in his brief introductory note to *Imprisoned*, "Humanity continues to kill, to massacre, to persecute, with it has gone ruthlessness. [. . .] Behind the barbed wire of new concentration camps, it has gone on, humanity has gone on being suppressed. Most of all, this book aims to be—attempts to be—a contribution to the just 'revolt' on behalf of those who feel like they can't, in spite of everything, resign themselves to a monstrous, terrifying reality. Those who believe they must still and always 'resist.'"

Thus it is an ongoing commitment—struggle: the book documents and urges us to keep memory alive and consciousness alert, in the hope that "the memory of

the tragedy of the camps [may] serve the cause of peace, because the future of all peoples is no longer marked by contempt for human life and dignity," as Nilde Iotti, then president of the Chamber of Deputies, wrote in a February 2, 1984, telegram in reference to the original publication of *KZ*. And on occasion of Holocaust Remembrance Day in 2015, *K.Z., Disegni dai campi di concentramento nazifascisti*, returned to print by Edizioni BeccoGiallo in Padua. Yet this is not a new proposition of stale stories, an act of nostalgia, since today there are so many reasons to reflect on the issues raised by the book: how many rights have been denied, how many abuses committed against anyone who is other, different, or weaker? How many calls to violence become, individually or collectively, subjugation?

Imprisoned was also reissued for this reason, maintaining the form and content of the 1983 book, with the aim of preserving its original idealist charge. Technically, however, the text couldn't be reproduced exactly due to the limits of the material, as an older book in black and white that wouldn't meet today's standards of quality. All of the drawings, as well as the pictures in color, had been photographed in black and white; the layout is from 1983 and permits few alterations to improve definition, contrast, or tone, and most importantly, makes it impossible to recover the original polychrome.

This decision, which was obligatory nonetheless, besides imposing a hierarchy of images, led not so much to reproducing the drawings themselves but the photographs of the drawings Benvenuti took or acquired. But thirty years have passed since the first edition, and the need to *adapt* those prints actually enabled him to strengthen to the book, including the five poems from his eponymous collection, which he had composed at the same time (distinct but not distant), by including them with the drawings. It also allowed him to provide textual and visual documentation of the book's history after its release, mentioning the events and initiatives leading up to the new edition. And above all, it gave the author the opportunity to further explain his motivations, what the book meant at the beginning and what it means now. Yet it should be mentioned that visual section of the book is the same as in the 1983 edition.

This is the challenge of reprinting *Imprisoned*: Arturo Benvenuti and those who worked with him believed that a dated form would better preserve a period (a climate) and a history (individual and collective) that was connected to the original reality, and also, the documentation-restitution of that reality. There is also a strong belief that outmoded aesthetic and typographic conventions can't diminish content that continues to have extraordinary intensity and truth. Indeed, this makes Arturo Benvenuti's point of view appear even more evident, and valorizes an undertaking that demonstrates a keen and prescient understanding of the expressive potential of these historical graphic images, which, among other things, document the aberrant daily life of the camps, precluded from photographs and films taken after the fact by liberators.

So *Imprisoned* is also a book of testimony, the first of its kind, as Primo Levi said, that is to be read on a historical level and worked through on an ethical and existential one. And the work has received well-deserved acclaim and attention—it has been presented and supported by Primo Levi, promoted by Nilde Iotti, appreciated by Simon Wiesenthal. The images have been publicly exhibited on several occasions, while the book, along with the occurrences and motivations that created it, has been presented and discussed in public libraries and educational institutions in Veneto and Friuli-Venezia Giulia, especially for Remembrance Day. For Benvenuti, who always let some time pass between events, it was never about repetition or reciting a script, but rather every time reopening the pages of a painful diary that is difficult to reread and should be associated with other stories about the "banality of evil," or that claim "life is beautiful"—a diary always to be contemplated, impossible to share with those who, beyond any form of revisionism, go so far as denial.

The dead, like historical responsibility, remain, as does the evidence that attests to the extermination, and the methods and scope of the killings are known or can be reconstructed. Arturo Benvenuti is fully aware of this, just as he is aware of what the Soviet Gulags were and how many victims they created. He is fully aware of Goli Otok, the Croatian island where Tito imprisoned dissidents, which he commemorated in a painting cycle in 2000. Benvenuti, the painter and poet, and especially the public intellectual, has never hidden the truth or himself behind truth; he has never been afraid to seek it, even where he felt uneasy, misunderstood, at times on a mission, perhaps in the conviction that with *Imprisoned*, "We, the rescued, / We press your hand / We look into your eye— / But all that binds us together now is leave-taking. / The leave-taking in the dust / Binds us together with you" (Nelly Sachs, "Chorus of the Rescued").

Roberto Costella was born in Mansuè (Province of Treviso) in 1957. He earned a degree in Architecture in Venice in 1983, directed the Alberto Martini Gallery in Oderzo from 1994 to 1997, and set up the Oderzo Modern and Contemporary Art Gallery. He established the Tullio Vietri Museum at the Oderzo Public Library in 2001. In Friuli Venezia Giulia, from 1997 to 2003, he was on the committee for the contemporary art exhibition *Hicetnunc*. Since 1984, he has taught drawing and art history in high schools, and since 1988, has engaged in historical and artistic promotion, giving more than 250 lectures. Since 1990, he has curated and presented more than sixty contemporary art exhibitions. He has published monographs on Tullio Vietri and Armando Buso, and has edited the following works by Benvenuti: *Arturo Benvenuti. L'isola e micro/cosmi carsici*, Edizioni Cicero, Venice, 2011; *Arturo Benvenuti. Arcipelaghi*, Collana Segni e Disegni, Edizioni Biblioteca Civica di Pordenone, 2011; *Arturo Benvenuti. Uomo, scrittore, artista*, Fondazione OC, Oderzo, 2012.

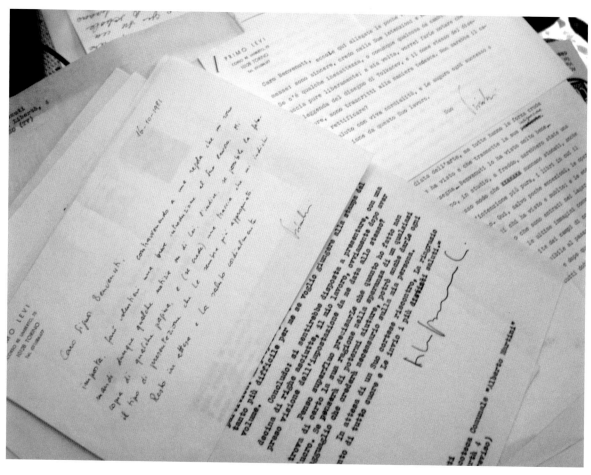

Correspondence between Primo Levi and Arturo Benvenuti.

KZ: To Future Memory

Giampietro Fattorello

1

"I finished my project some time ago, resulting in a collection of a few hundred photographs of drawings done by internees in the [. . .] concentration camps. My research extended virtually to all of Europe—but beyond as well—on several different trips. The aim, to publish a volume with my selection of drawings, leaving others the task of describing and condemning—this hasn't been done enough—the immense tragedy" (Letter from Arturo Benvenuti to Primo Levi, Oderzo, October 14, 1981).[1]

Arturo Benvenuti wrote these words on October 14, 1981, to Primo Levi, with whom he had begun an epistolary exchange in October 1979. Benvenuti informs Levi, who is from Turin, about the work he has done: the conclusion of his research and the collection, which he began in 1979, of drawings done by deportees in the concentration and extermination camps. Further on in that same letter, Benvenuti asks Levi whether he would be willing to introduce the work that he was preparing for publication.

With a celerity and courtesy that a great and renowned author rarely grants a fairly unknown correspondent, Levi replied two days later, on October 16: "going against my own rule, I would be happy to write a brief introduction to your work" (Letter from Primo Levi to Arturo Benvenuti, Turin, October 16, 1981).

The completed work would receive the endorsement of Primo Levi, writer and witness of the Shoah. A publisher had not yet been secured, but Levi's words provided validation for a human and cultural task whose roots went far back in Arturo Benvenuti's life.

1 This and the following citations from the correspondence between Arturo Benvenuti and Primo Levi are taken from the Arturo Benvenuti Archive.

Benvenuti's research, in fact, was meant to be a highly personal way of compensating for the memory of the victims of the deportation and extermination in the Nazi-Fascist camps and to resist his own feelings of guilt caused by the awareness of having done nothing to combat the massacre of innocents.

Indeed, in his October 22 reply to Levi, Benvenuti states: "although I was not imprisoned in the 'camps,' I suffered in my deepest self, in the most excruciating way, every stage of the monstrous operation carried out by degenerate, diabolical minds to bring about the moral and physical annihilation of millions of people" (Letter from Arturo Benvenuti to Primo Levi, Oderzo, October 22, 1981). Rejecting the fact that on too many occasions the extermination was remembered opportunistically, denounced and condemned for political, partisan, and ideological reasons, Benvenuti noted how internees' drawings had always been published without that European solidarity that Benvenuti had taken as his guiding criterion (Letter from Arturo Benvenuti to Primo Levi, Oderzo, October 22, 1981). Before that historical moment, testimonies had been strictly divided by country, each collecting the drawings of their own nationals to the exclusion of others. Art as testimony, on the other hand, even in the form of drawing, merited a common European perspective that would emphasize that there can be no distinctions in our memory of the tragedy.

Levi's nearly immediate reply: "I believe in your intentions and in your book" (Letter from Primo Levi to Arturo Benvenuti, Turin, October 27, 1981). Along with his message, Levi included his preface to Benvenuti's work, where he states "until now a book like this one has been missing in Italy."[2]

Before publication, Benvenuti's research led him to other difficulties besides the ones that had created obstacles for him in Italy. Someone even asked the president of the Cassa di Risparmio della Marca Trivigiana, Bruno Marton, if he was going to publish "a kilo of dead bodies," but Morton knew how to quell resistance, and in 1983, agreed to print *K. Z., Disegni dai campi di concentramento nazifascisti. Art as testimony*, which came out due to the very credit institution that, with indisputable cause, could boast a preface from the authoritative and incontestable pen of Primo Levi.

But who was Arturo Benvenuti? And how had he come up with the idea to travel, by camper, the roads of Europe in search of internees' drawings, along with his dear wife, Maria (Marucci) Poglianich?

Born in 1923 in Oderzo (province of Treviso), Benvenuti had cultivated a passion for drawing, painting, and literature since childhood and continued on this path despite the necessities of life that led him, after World War II, to an administrative

2 Benvenuti Archive (untitled note attached to Letter from Primo Levi to Arturo Benvenuti, Turin, October 27, 1981).

profession in the oil and then banking industries and to give up on developing his certificate in accounting into a degree in economics and commerce, as he had taken many of the courses already at the University of Venice and the University of Trieste. Bolstered by great tenacity and a keen ability to observe and understand himself and historical change, Benvenuti buried his need to give full expression to his way of being and seeing until the late 1960s, when he decided to go public with his art, which at that time consisted of painting and poetry. It was art that bubbled up from underground like a river in the karst, and indeed it was in that very geographical and cultural area that he found his privileged place and anchor in the native land of Marucci, the Kvarner Gulf island of Losinj. Losinj, the island that the couple had been going to since the early 1950s, staying with his wife's parents; the island that, along with Marucci herself, became the foundational and symbolic center of Benvenuti's pictorial and poetic art.

But Benvenuti, during the years of his research into the internee drawings and his correspondence with Levi, was also a tireless cultural promoter. With the blessing of Mary Petringa, widow of the painter and illustrator from Oderzo, Alberto Martini, and the support of illustrious art critic Giuseppe Marchiori, Benvenuti was able to critically reassess the artist in the late 1960s and he founded the Alberto Martini Art Gallery in Oderzo in 1970.

Having examined the volumes containing the inmates' drawings, the choice of this form of expression was necessary for someone like Benvenuti, someone who knew how to wield a pencil, paintbrush, and pen. He was disturbed by the image of those tortured bodies, but also by the absence of European unity that he lamented to Primo Levi. Above all, Benvenuti the man, before the artist and intellectual, was morally driven by the desire to bring about a more extensive unity through his meticulous research, to remember all those who Nazi brutality had relegated to the camps, and thus, alongside the Jews, the political prisoners, common criminals, homosexuals, gypsies, mentally ill. Because "they were all human flesh."[3]

The composition of *KZ, Disegni*, which coheres perfectly with the five poems from June 1980 published together as *KZ—Poems* (1983),[4] was therefore dictated by the desire to commemorate all those who had been victims and martyrs in the concentration camp system—the *Konzentrationszentrum*. But this way, Benvenuti

3 As Benvenuti said during an interview with me on October 31, 2014.
4 The poems in *KZ—Poesie* are: "Arbeit macht frei," "The Cremation Oven," "The Tunnel," "The Children of Terezín," "The Stone Steps;" they can be found in *Arturo Benvenuti, L'opera poetica*, ed. Giampietro Fattorello (Padua: BeccoGiallo, 2014).

was also able to come to terms with his conscience: what did I do then, while the massacre was going on?

This question is based on the fact that the then-twenty-year-old was able to perceive certain details that didn't take much for his vivid intelligence to figure out: in Oderzo, there was a group of Jews from Sarajevo who were confined in an Oderzo enclave and never deported, a sign that they had paid protection; from them he heard some things about the deportations that were taking place. Arturo also had a young Jewish friend, Bencko Urbach, with whom he fought in wrestling matches, and some news leaked from him. And in 1942 to 1943 at the train station of Treviso, a young Arturo would sometimes see the notorious sealed wagons passing through, indirect confirmation that the massacre was taking place: where could cars filled with men and women shoving their fingers through the slits of those sealed wagons be going?

Difficult times, in Benvenuti's memory. During the Nazi occupation it was wartime not just at the front proper, but also on the home front, where a true civil war had broken out and it was necessary to find refuge from the occupying Germans' roundups, even on the rooftops of the city.

An aware and alert conscience, Benvenuti's, since the days of World War II, when the young Arturo was tempted by the resistance movement. An uneasy conscience, sensitive to the times, a conscience that right after the war, hoped for a new, more just Italy, which over time had to be rethought. This is the same conscience that has animated Benvenuti's artistic and cultural activities as an adult and that have therefore translated into ongoing social commitment.

His search for these drawings, therefore, was not some sort of outlet for the macabre and sadistic impulses of a collector of funereal memorabilia but an opportunity, through testimonial art, to build memory outside of the official rituals and to come to terms with his own experience, to progress in his own existential and human growth.

A twinge of conscience thus became a moral obligation to create memory by attempting to "understand" the Shoah.

In 1987, at an event in memory of Primo Levi organized by the Russell Circle of Treviso, Benvenuti had this to say: "I felt this desire to understand as an imperative in my capacity as a citizen of a human society that defines itself as civil; that is, the need to respond in a way that was, if not completely definitive, at least sufficiently indicative" (Benvenuti, 1987). And in 1998, as part of an exhibition he curated called *The Shoah and Memory*, he reiterated: "The drive behind this project comes out of a need for moral order; perhaps I also mean a need to compensate, however late, for not having known, in that profound darkness, how to better combat the climate that led the world to such butchery" (Benvenuti, 1998).

The carnage that took place in the camps—whose proper name is the Shoah (extermination, destruction), not the Holocaust (ritual sacrifice)—notoriously manifested itself the night of the madness into which Europe and Western civilization fell under the Nazi swastika. The same night of dead stars and dead eyes mentioned by Elie Wiesel (Wiesel 2014, 18).

Europe and Western civilization saw their own sunset, like the Jew who, in Paul Celan's *Conversation in the Mountains*, goes out and sets off "one evening, when the sun had set and not only the sun" (Celan 2005, 149).

With the metaphor of the sunset and God, Celan expresses the loss of Western culture. Sinking into the concentration and extermination camps in fact plunged that civilization into barbarism. The decline of Western civilization became possible once man realized the degradation-destitution (*Entwürdigung*) of man that Primo Levi discusses in *The Drowned and the Saved*. A humiliation that went all the way to the loss of dignity, the stripping of personal identity and the desubjectification achieved through the biopolitical use of others' bodies. A systematic and industrial operation with which the prisoners reach "the bottom" (Levi 2015, 68), the lowest point of dehumanization, a point where language lacks the words to express the offense the internees have suffered.

In the face of the inexpressible that underlies the most barbaric dehumanization, one of the first unavoidable questions is, where was man? And second, where was God? The two questions actually form a single radical question: from whence this evil, an evil so inhuman and unjust that it tramples every human and divine foundation, the validity of all ethics and every divine principle? This is the question asked by Johann Baptist Metz, who says: " The theological question after Auschwitz is not only 'Where was God in Auschwitz?' It is also 'Where was humanity in Auschwitz?'" (Schuster 1999, 17).

So, where did this evil come from, why this evil without any justification, inconceivable and unacceptable? Where were man and God in the death camps?

Where was man in the camps, destitute places where executioner tortured victim and victim went against victim? Were there traces of humanity in that general degradation, with inhuman persecutors and dehumanized persecuted?

If there is a shred of humanity in the camps, according to Levi, it can only be attributed to those who managed to survive without sacrificing their moral system, "a very few superior individuals, made of the stuff of martyrs and saints" (Levi 2015, 137). There were very few who were truly saved, who saved not only their biological but also their human life. But human life could be saved and therefore also witness the presence of the human on every rare instance that human thoughts and feelings emerged, despite the strict surveillance and rigid dehumanization

within the industrial organization of the camps. In those extraordinary moments, humanity could surface, as when Primo Levi praises the "Canto of Ulysses" while going to get the soup with Jean, "Pikolo" from the Chemical Kommando.

The canto is not song but Levi's recitation of Canto XXVI of Dante's *Inferno* and his struggle to translate it into French. But it becomes music, because it demonstrates that even in a destitute place there can be glimpses of humanity and camaraderie, like the moment between Primo and Jean, where Primo is talking and Jean is begging him to say more. The Pikolo who is listening to Primo is good; good because he is perceiving and accepting Primo's sentiments. Jean-Pikolo is good, because "he is aware that [he] is doing me good" (Levi, 2015, 158), as Primo points out.

Theirs is "the canto of Ulysses," because like the one immortalized by Dante, theirs too is the "mad flight" (*Inferno* XXVI.125) of those who seek to avoid becoming brutes and not sacrifice the "high pass" (*Inferno* XXVI.132), to make the leap towards "virtue and knowledge" (*Inferno* XXVI.120). Thus "the Canto of Ulysses" can save *human* life even if it cannot save biological life. Thus "the Canto of Ulysses" is one of the saved among the downed on which the camp closes in like the sea that overtakes and swallows Ulysses and his companions (*Inferno* XXVI.139–142).

But where was God in Auschwitz?

The question of the absence of God from the sites of extermination. But also, a question that leads to the question of God's power: what could God have done? What can God do in the face of radical evil? A question that inevitably gives rise to the question of God's existence and his relationship to humanity.

This question recurs in Wiesel, who asks God: "Where were you when your children needed you most?" (Schuster 1999, 61). According to Johann Baptist Metz, this does not translate to a denial of God's existence, but rather the very despair caused by Auschwitz for Wiesel is a source that fosters "trust in God and human beings which lies not in forgetting the horror, but precisely in remembering it" (Schuster 1999, 61). Wiesel agrees, saying: "When I look around the world I see nothing but hopelessness. And yet I must, we all must, try to find a source for hope. We must believe in human beings, in spite of human beings" (Schuster 1999, 63). But we must believe in God, in spite of God, one might add, for as Wiesel says: "One of the most serious questions I have confronted over the years is whether one can still believe in God after Auschwitz. It is not easy to keep faith. Nevertheless, I can say that, despite all the difficulties and obstacles, I have never abandoned God. I had tremendous problems with God, and still do. Therefore I protest against God. Sometimes I bring God before the bench. Nevertheless, everything I do is done from within faith and not from outside. If one believes in God one can say anything to God" (Schuster 1999, 91).

In his Judaism, Wiesel can therefore be against God, never without Him. And then so he reconsiders the question: where was God and where is God? Wiesel replies, citing a great Hasidic teacher who said, "Where is God? Wherever one lets him in" (Schuster 1999, 92). Or perhaps God is hanging on the gallows in Auschwitz—he is one of the three hanged, two adults and one child, publicly executed: to the man who wondered where, on that occasion, God was, a voice in Elie replied: "Where is He? This is where—hanging here from this gallows" (Wiesel 1982, 78).

Wiesel's God is undeniable, in spite of radical evil, in spite of humanity, in spite of God himself. There is no perspective outside of God, even when you are against him. Except that, in this view, the question of the presence (or absence) of God from sites of evil, injustice, and pain is weakened to the point of emptiness: God is there no matter what, and "if God wanted he could bring the course of things to a halt and turn everything on its head. God could take away the murderer's strength and the victim's weakness. God does not do this, since God has God's reasons. We do not know. We have to live with the question of why God does not do it" (Schuster 1999, 97). But what sense is there in having to live with the question if the person to whom it is addressed has no obligation to respond? What sense is there in asking where God was or where he is if he is able to change the course of events for the better but does not? What are his inscrutable reasons in whose name he did not intervene, although he could have? How can God show his love if, although he could, he does not?

If, as Wiesel has it, the one called upon to respond evades the question, then inevitably the question loses its foundation and force. Is there any sense in continuing to ask and at the same time recognize my interlocutor's inscrutable reasons for the right to silence? How can one let God in so he is with us here and now, if he has already preemptively been assigned the role of the guest who is not required to respond? What does the questioner make of the mute guest to whom he can certainly ask for acknowledgment, while knowing that he will not answer because he is not required to do so?

Referring to the Jews, Wiesel says: "We do not believe in a weak God. God is the king of the universe, God is strong and omnipotent. God could do whatever God wants. But God does not. Should we feel compassion for God, not because God is weak, but because we abuse God's work. We destroy the world, God's creation. We break the trust that God placed in us" (Schuster 1999, 97).

Therefore, according to Wiesel, God remains omnipotent despite Auschwitz, and of course, cannot be reproached for anything—neither weakness nor impotence. If anything, one can merge an ecological sense and feelings of guilt and condemn human self-destruction as a distrust in God. For Wiesel, then, God is beyond reproach, if things are as we perceive and know them. God is absolved from the outset, for inscrutable reasons. A declaration for believing in God even when there

is no reason to except the psychological need for faith as the ultimate basis for continuing to give life meaning, even after Auschwitz.

This recalls the question in the Yiddish song that Celan quotes as an epigraph to "Benedicta": "Is it possible to go up into heaven / and ask God if things must be so?"

Absolute divine power—omnipotence—that in Wiesel is such even when God fails to utilize it for indecipherable and arcane reasons is what, on the other hand, Jewish thinker Hans Jonas not only challenges, but simply declares nonexistent— not only after Auschwitz, though even more so after Auschwitz.

The annihilation that the Jewish people faced in the camps—"the most monstrous inversion of election into curse" (Jonas 1996, 133)—what God could have allowed it? The Jewish God that the faithful have always deemed comprehensible (within human limits) and absolutely good must be rethought after the camps, and thus rethought, can no longer be regarded as the "Lord of history" (Jonas 1996, 25).

On the other hand, the divine impotence that was revealed at Auschwitz is only an overt demonstration of the original impotence of God the creator. In fact, according to Jonas, God the creator gave up his divine integrity—his omnipotence— before Auschwitz "to receive it back from the odyssey of time" (Jonas 1996, 134). In this Kabbalistic view—Isaac Luria's idea of "tzimtzum" according to which God, after creation, contracts and shrinks, retreating from creation and so revealing his weakness and impotence over that same creation. God has thus been powerless since creation, and all the more so after Auschwitz. This God abandons further action after the act of creation, because by giving up his own omnipotence he leaves humanity free to act and thus makes it responsible.

The act of creation was also necessitated by the divine power itself. Jonas is clear: his total and absolute power is not limited by anything, but that itself shows his impotence: without having an object to act upon, he remains powerless; for him to be able to act he must have an object upon which to demonstrate his omnipotence, but as long as there is none he remains powerless. To activate his omnipotence, God had to create the universe, entrust himself to it and to humanity, but by doing so, gave up this omnipotence and revealed himself to be powerless: his omnipotence coincides with his impotence—God is powerless as long as he does not create, or in other words, as long as he has no others over which to exercise his omnipotence. Yet he is impotent even in creating, because through the act of creation he is stripped of his own omnipotence.

Following Jonas's logic, God could not have been in Auschwitz nor can he act in favor of anyone, in history and in the world, who unfairly and unnecessarily suffers. Through creation, he created his own irresponsibility by delegating responsibility to humanity. This is the necessary outcome of Jonas's rethinking of God. Not being responsible, God cannot be subject to any accusation or blame. Therefore, we can

only come to the conclusion that, at Auschwitz, God could not have been there to offer any help, because he has withdrawn into himself, whereas humans were present, devoid of humanity, but responsible nonetheless.

On the other hand, as concerns the other two essential attributes of God (contemplability and absolute love), one can continue to contemplate and experience God, yet struggle to contemplate a God that is good but can't take care of his creatures, and this because his obligatory choice to create resulted in his self-withdrawal and not being able to show love for creation. How can one continue to believe in a loving God, however much one could think that he suffers not being able to offer his love when creation suffers unjustly?

How, then, does one pray to God? How, Primo Levi wonders, can old Kuhn pray and thank God for having escaped selection for the gas chamber? How can Kuhn pray and thank God, and heedless, "not see, in the bunk next to him, Beppo the Greek, who is twenty years old and is going to the gas chamber the day after tomorrow [. . .]?" (Levi 2015, 123–4). A God like that—or maybe God in general—cannot exist, cannot be the creator; no discussion can be made of his omnipotence nor of his impotence. Inexorable and peremptory, then, is Levi's judgment: "There is Auschwitz, and so there cannot be God" (Camon 1989, 68). In the face of Auschwitz, one can therefore refute the existence of God or, at least, doubt it. Addressing God in prayer itself means performing an act of faith, not in God but for God. This is why the little priest derided in Giorgio Caproni's poem prays "not, as it suits the world / to say, because God exists, / but, as I prefer to put it / to make God exist" (Caproni 2001, "Lament (or Boast) of the Mocked Little Priest," 258).

3

The question of whether God was at Auschwitz, therefore, can produce different results, to the point of doubting God's existence. But another question we can ask ourselves is: where, in Auschwitz, was Western culture? The concept and the reality of God were put to the test, but in the camps Western civilization also seems to have reached its sunset and sunk into the abyss of dehumanization, so that one may even doubt the essence and value of this civilization. Which has been done, famously, by Theodor Adorno, who called into question the very right to make art and poetry after Auschwitz, declaring: "to write poetry after Auschwitz is barbaric. And this corrodes even the knowledge of why it has become impossible to write poetry today" (Adorno 1981, 34). In other words, after the colossal tragedy of the Shoah, writing poetry is impossible because it is senseless; it is an impossibility—nonsense that condemns the creation of poetry to a solely aestheticizing practice, essentially vapid and empty when compared with the ashes from the crematories—an act as inhuman and barbaric as Auschwitz. Except one cannot help but wonder why the philosopher can make philosophy about Auschwitz yet imposes silence on

the poet. If all of Western civilization collapsed at Auschwitz, then it doesn't make sense to practice any philosophy (Adornian or no)—the West itself doesn't make sense.

It is thus opportune to examine whether Adorno's famous proclamation can be appealed, challenged, and at least reformed.

The statement is well known, as is the reaction from Celan, whose poetry is fully intertwined with the extermination of the camps. In one of his notes for *Atemwende* (*Breathturn*), Celan writes: "No poem after Auschwitz (Adorno): what sort of an idea of a 'poem' is being implied here? The arrogance of the man who hypothetically and speculatively has the audacity to observe or report on Auschwitz from the perspective of nightingales and song thrushes" (Jäger 2004, 187). Thus the poetry unacceptable after the camps is only that which is produced in melodious, harmonious verse, oblivious to the suffering of the concentration universe—certainly not the poetry of someone who, like Celan, faces and internalizes the internee's onus of pain. Peter Szondi, a friend of Celan's with a deep knowledge of his poetry, devotes an essay to the poem "Engführung" ("Straitening") where he states, "the actualization of the extermination camp is not only the end of Celan's poetry, but at the same time was the condition for it. 'Engführung,' in the strict sense, is a rejection of Adorno's proclamation" (Adorno-Celan 2011, 19).

If poetry about Auschwitz is not, then, simply an aesthetic practice, but a taking on of Auschwitz—experiencing Auschwitz "poetically"—then poetry is possible even after Auschwitz, "*anus mundi*" (Levi 2015, 592). It is possible and has meaning even after the catastrophe of Western civilization, even after "that which was," as Celan referred to the genocide. In fact, according to Ilana Shmueli, when Celan spoke of the Shoah, he would always only say "that which was" (Lyon 2006, 65).

And if poetry becomes a form of "compensation" offered to the drowned and the saved, then poetry cannot be an act of barbarism, but rather an act of restitution of that humanity that Auschwitz took away. In this way, poetry, with its simple means—simple in comparison to the means of the apparatuses of politics, technology, finance—can make its contribution to the reconstruction of not only Western civilization, but simply human civilization.

If poetry after Auschwitz is an act of barbarism, then what about the words of someone who some still (unjustly) consider the greatest thinker of the twentieth century, Martin Heidegger, who places agriculture, understood as the mechanized food industry, on the same level as the manufacturing of corpses in the gas chambers? A gem that one cannot but share: "Agriculture is now a mechanized food industry, in essence the same as the production of corpses in the gas chambers and extermination camps, the same as the blockading and starving of countries, the same as the production of hydrogen bombs" (Heidegger 2012, 27). Everything is the same, no differences, everything is leveled and homogenized by manufacturing;

in the world of technology everything is equivalent and has the same meaning: death on an industrial scale in the camps is a manifestation of the same industrial production to be found in agriculture, in the starving of entire peoples and the construction of hydrogen bombs. In the eyes of the great philosopher who looks from up high and dominates from the perspective of being and from there the truth of the world below is revealed, it can't but all appear the same.

Indeed, it is not all the same for the "Wizard of Messkirch," because it's one thing to pass away, another to be killed. Indeed, "Hundreds of thousands die in masses. Do they die? They perish. They are put down. Do they die? They become pieces of inventory of a standing reserve for the fabrication of corpses. Do they die? They are unobtrusively liquidated in annihilation camps" (Heidegger 2012, 53). It is one thing to perish "unobtrusively" in the camps, another thing to die, to know how to die. Indeed, "the human is first and only capable of death when being itself from the truth of its essence brings the essence of the human into the ownership of the essence of being" (Heidegger 2012, 53). That the human capable of death in being—the true mortal—is the Nazi, ascertained that the internee is limited to perishing "unobtrusively"?

It is this man, who looks at the poetry of Auschwitz, this man—the man who suffers without reason—to whom poetry sparks memory and "sings." After Auschwitz, but also before and during, i.e., "in Auschwitz." Indeed, as poet Andrea Zanzotto states, approaching Celan's verse "is shocking. He represents the achievement of what didn't seem possible: not only writing poetry after Auschwitz but writing 'inside' these ashes, reaching another poetry by defeating this absolute annihilation while remaining in some sense within that annihilation" (Zanzotto 2003, 1332). Words of extraordinary poetic and critical acumen.

And the fact that in the camps poetry was possible—or art or simply being human—is demonstrated by the drawings patiently collected by Arturo Benvenuti. It is demonstrated by a painter who was at Dachau, Anton Zoran Music, whose drawings appear in Benvenuti's work.

"In that crazy world I was happy to have something to draw" (Vallora 2011, 23), says Music, adding: "It was as if I was overtaken by a fever to express everything I was seeing" (Vallora 2011, 23). Music doesn't deny the fascination of the deathly landscape of the camp: "I daren't, I shouldn't say, but for a painter it had an incredible beauty. Maybe that shouldn't be said, but . . ." (Vallora 2011, 22). Even as art realizes the horror, it cannot renounce its aesthetic function, as remarks Giuseppe Bevilacqua (Bevilacqua 2012, XXXVI), a childhood friend of Benvenuti's.

Yet Music links aesthetic function to the duty to bear witness: "A painter can't stop, even if I ran the terrible danger of being discovered; he can't not, I say, bear witness, not at all! But it was an absolute need, a need to . . . I don't know how to put it . . . To reproduce, to represent, to show, to preserve it for later" (Vallora 2011, 25).

A need to save oneself by saving one's own humanity. So Music asserts: "Timidly, I begin drawing. Maybe that's how I'll save myself. In danger, maybe I'll have a reason to resist. [. . .] Drawing is the site of my meditation, my solitude. By drawing, I am unconsciously writing my memoirs, my personal diary" (Respi 2011, 37).

Music's drawings, as well as the drawings of all those who, secretly and at risk of death, expressed their desire to create art and with art give testimony to the horror, are thus also the manifestation that art and poetry were also in Auschwitz—and precisely that inside Auschwitz a testimony of humanity and civilization was possible. The humanity and civilization that Nazi barbarism murdered and yet rose again each time a glimmer of light made its way through that night of ideological and racial madness.

Adorno's statement, so unilateral, can thus not stand. On the other hand, Adorno himself was eventually compelled to reconsider his position, saying: "While the present situation no longer has room for art—that was the point of the sentence about the impossibility of poems after Auschwitz—it nevertheless has need for it" (Adorno, "Art and the Arts," 387). It is precisely because the historical-political reality is opposed to art that art must rise against "the situation" that seeks to suppress it. Primo Levi has clear ideas on this: "I'm a man who doesn't much believe in poetry and yet I write it. [. . .] Adorno wrote that after Auschwitz there can be no poetry, but my experience is the opposite. At the time (1945–46) it seemed to me that poetry was more suitable than prose to express what weighed inside me. When I say poetry, I'm not thinking of lyric poetry. In those years, if anything, I would have reformulated Adorno's words: after Auschwitz there can be poetry only about Auschwitz" (qtd. in Levi 2015, l).

Thus it is also especially that which is negative and nefarious in reality that poetry must grapple with; the poetic does not emerge through the antipoetic, poetry must first pass through antipoetry to reach itself. Taking on the negativity of the "situation" is the first step that poetry makes. Celan understands this fully, when he says: "He speaks truly who speaks the shade" (Celan, "Speak, You Also"). And also according to Celan, it is the later, more scattered part of God, that we have to deal with.

The antipoetic is what poetry cannot ignore and in fact must appropriate, just as the artists drawing the camps appropriate the horror committed against the bodies and minds of the inmates to say that all this happened and it must not happen again.

How can we expect poetry to silence barbarism, when in the face of ferocity and there is necessarily "a strong inclination towards falling silent" (Celan 2005, 180) and a tendency to surrender to the ineffable? Like asking poetry to be silent when "the situation," however harrowing or unbearable, demands testimony and

"singing" the pain of the martyrs? How, then, to make do without art, when it is the art of testimony?

Paul Celan, who confesses to Ruth Lackner, "only in one's mother tongue can one express one's own truth. In a foreign language the poet lies" (qtd. in Felman and Laub, 26), wrote the majority of his poetry in the German language, *die Muttersprache* (mother tongue), "the soft, the German, the painful rhyme" (Celan, "Near the Graves")—the same one spoken by the murderers of his mother and father. He couldn't help but express the atrocity of the extermination in his own language, the same as the executioner's; he felt and he knew that he had no means other than the German tongue: the language of the assassins (with double-ss), almost as if only in the language of your assassins can you speak of the nonsense of their murder; as if only in the language of your assassin can you attempt the possibility of finding sense and recognize yourself in your fate; as if only in the language of the murderers can you say that the language is not murderous: and so you save it, save yourself. And, in fact, only in his German mother tongue: "Through / the sluice I had to go, / to salvage the word back into / and out of and across the salt flood: / *Yizkor*" (Celan, "The Sluice," 2001, 151).

Celan challenged, in human terms, the unspeakability of the events, and through poetry in the German language, the very inability to speak about inhumanity. As Adorno himself recognized, "Celan's poems want to speak of the most extreme horror through silence" (Adorno 2013, 405); they want to be the possibility of forcing and opening the unspeakable, because those responsible for radical evil aren't hiding behind the unspeakable—they don't have the cover or benefit of the ineffable that, left to its own inexpressibility, protects the merciless perpetrators and prevents witnesses from being credible and their heirs from sharing their testimonies.

Celan had been right about the fact that the witnesses of the atrocities of the camps were not believed, saying succinctly / curtly: "No one / bears witness / for the witness" (Celan 2005, 105). Of course, despite deniers and revisionists, there is an enormous amount of evidence of the Shoah that is consistent and irreproachable, and above all, supports the reliability of the witnesses. And yet what happened was so unprecedented that it is hard to find it credible and the witness himself is afraid of not being believed. Primo Levi's words attest to this: "Almost all the survivors, either orally or in written memoirs, recall a dream that recurred frequently during their imprisonment, varying in its details but unchanging in its substance: to miraculously return home, to relate with emotion and relief their past sufferings to a loved one, and not to be believed. More than that, not even to be listened to" (Levi 2015, 737) .

And on the other hand, how can we silence the "irritation" of the listener, even the most receptive, who, when confronted with a testimony of the horror and extermination is led to acknowledge the guest—death—that lives inside us and that we are constantly trying to dispel?

Yet although Nietzsche made us realize once and for all that remembering is painful and that you forget pain in order to survive, an imperious no, an ethical command, a moral commandment breaks into our consciousness: how can you forget "that which was"? How can you justify that it happened in the name of the alleged superiority of a supposed Aryan race? How can you not see from the point of view of the suffering prisoner? How can you not ask yourself, what if now, tomorrow, a madman were to appear, a maniac or fanatic who in the name of his aberrant ideas of superiority called for my exclusion and my elimination?

The commandment to give testimony is the commandment to remember so that "that which was" will not be repeated. And "that which was," for having been *horrendum dictu et nefandum factu*—horrendous and heinous to the point of annihilating all dignity and therefore unjustifiable—demands, imposes, commands: it is a commandment. A commandment to remember and a commandment to bear witness, a commandment that surges forth even where a mere shred of conscience can be found, a commandment not commanded.

Only the witness has the right to command, having urged us to consider "if this is a man, / Who toils in the mud / Who knows no peace / Who fights for half a loaf / Who dies according to a yes or a no" and "if this is a woman, / With no hair and no name / With no strength to remember / With empty eyes and a womb as cold / As a frog in winter" (Levi 2015, 21). But when the witness can no longer give testimony, you must gather his word and give testimony for him. Conscience demands it: take the witness's testimony, be a co-witness to justice and preserve the witness's truth. This is the witness's command: that the memory of Auschwitz is an imperative to create memory and remember clearly, on the premises of good itself.

The witness's testimony should thus set into motion a virtuous cycle: generating stories and listening, making memory for the listener who in turn helps to build memory of the unforgettable atrocity—"that which was"; a memory-making that translates into a commandment to safeguard memory—the witness's testimony that urges telling and that telling listening so that memory is retained in the listener, a new generator of memory.

Making memory is the only antidote not only against the disease of what happened but also against anything similar ever happening again; in the words of Primo Levi, "It happened once and it can happen again" (Levi 2015, 704).

Making memory is therefore not simply remembering, but making a treasury of "that which was" for future memory, for an unfailing commitment for this to

never be again. Even more than the past, making memory looks to the present and the future. And this precious collection of drawings by the internees gathered by Arturo Benvenuti fits precisely into the prospect of making memory in order to restore dignity to the drowned and the saved—to all without distinction—and to inspire not mere indignation or ritual commemoration but memory that saves, memory that becomes ethical and idealist, even utopian, commitment.

Of this Benvenuti is certain, as "it is by virtue of utopia, a certain utopia, that man can, when he can, get away from the cave" (Benvenuti 1987). His is the utopia of those who believe that even the images in *Imprisoned* can help to distance us from the condition of bestiality; it is utopia and the hope of those who implore that "a hand, even one hand, the mind turning for even a infinitesimal fraction of a second to one of them, would no longer find the strength to pull the trigger at the temple of a innocent" (Benvenuti 1987) .

It is a utopian aspiration, which would be fully realized when the agony of the internees on their way to the gas chambers is internalized by those who have taken in the testimony of the drowned and the saved. Addressing the internees who crossed the tunnel in Terezín that led them to the site of their death, Benvenuti says: "Full will be our lives / when the right measure / of your lucid agony / will be able to grow inside us" (Benvenuti, "The Tunnel," 2014, 264).

BIBLIOGRAPHY

ADORNO, THEODOR. *Aesthetic Theory*. London: Bloomsbury Academic, 2013.

ADORNO, THEODOR. "Art and the Arts." *Can One Live after Auschwitz: A Philosophical Reader*. Ed. Rolf Tiedemann. Stanford, Calif. : Stanford University Press, 2003.

ADORNO, THEODOR. *Prisms*. Trans. Samuel and Shierry Weber. Cambridge: MIT Press, 1981.

BENVENUTI, ARTURO. "Un ricordo di Primo Levi attraverso un libro di Arturo Benvenuti: K. Z. Immagini dai campi di concentramento nazifascisti. " Palazzo Onigo, Treviso, Italy. 27 June 1987. Benvenuti Archive.

BENVENUTI, ARTURO. "Lecture for the exhibit 'Shoah and Memory. '" Liceo Classico Concetto Marchesi di Conegliano, Oderzo, Italy. 29 April 1998. Benvenuti Archive.

BENVENUTI, ARTURO. *L'opera poetica*. Ed. Giampietro Fattorello. Padua: BeccoGiallo, 2014.

BEVILACQUA, GIUSEPPE. "Eros-Nostos-Thanatos: la parabola di Paul Celan." *Paul Celan, Poesie*. Ed. and Intro. Giuseppe Bevilacqua. Milan: Mondadori, 2012.

CAMON, FERDINANDO. *Conversations with Primo Levi*, Marlboro, Vt. : Marlboro Press, 1989.

CAPRONI, GIORGIO. *L'opera in versi*. Ed. Luca Zuliani. Milan: Mondadori, 2014.

CELAN, PAUL. *Selections*. Ed. and Trans. Pierre Joris. Berkeley and Los Angeles: University of California Press, 2005.

CELAN, PAUL. *Selected Poems and Prose of Paul Celan*. Trans. John Felstiner. New York: W. W. Norton, 2001.

FELMAN, SHOSHANA, AND DORI LAUB. *Testimony: Crises of Witnessing in Literature, Psychoanalysis, and History*. New York: Routledge, 1991.

HEIDEGGER, MARTIN. *Bremen and Freiburg Lectures: Insight into That Which Is and Basic Principles of Thinking*. Trans. Andrew J. Mitchell. Bloomington: Indiana University Press, 2012.

JÄGER, LORENZ. *Adorno: A Political Biography*. New Haven, Conn.: Yale University Press, 2004.

JONAS, HANS. "The Concept of God after Auschwitz: A Jewish Voice. " *Mortality and Morality: A Search for Good After Auschwitz*. 1996.

LEVI, PRIMO. *The Complete Works of Primo Levi*. Ed. Ann Goldstein. New York: Liveright Publishing Corporation, 2015.

LYON, JAMES K. *Paul Celan and Martin Heidegger: An Unresolved Conversation, 1951-1970*. Baltimore: Johns Hopkins University Press, 2006.

RESPI, LORENZO. "Matricola 128231: Zoran Music. " *Zoran Music. Se questo è un uomo*. Ed. Flavio Arensi. Turin: Allemandi & C. , 2011.

SACHS, NELLY. *Art from the Ashes: A Holocaust Anthology*. Ed. Lawrence L. Langer. New York, Oxford: Oxford University Press, 1995.

SCHUSTER, EKKEHARD, JOHANN B. Metz, Elie Wiesel, and Reinhold Boschert-Kimmig. *Hope against Hope: Johann Baptist Metz and Elie Wiesel Speak Out on the Holocaust.* New York: Paulist Press, 1999.

VALLORA, MARCO. "I non-occhi degli automi di Dachau. Zoran Music e Jean Clair. " *Zoran Music. Se questo è un uomo.* Ed. Flavio Arensi. Turin: Allemandi & C. , 2011.

WIESEL, ELIE. *Night.* Trans. Stella Rodway. New York: Bantam Books, 1982.

ZANZOTTO, ANDREA. "Per Paul Celan." *Le poesie e prose scelte.* Ed. Stefano Dal Bianco and Gian Mario Villalta. Milan: Mondadori, 2003.

Giampietro Fattorello was born in 1962 in Ponte di Piave (Treviso), where he currently resides. A graduate in philosophy from the University of Padua in 1987 (with a thesis on knowledge of principle in the thought of Marino Gentile), he teaches literary subjects at a scientific high school. Interested in the intersection between philosophy and poetry, he has mainly dedicated himself to "clandestine" literary activity. For *Arturo Benvenuti. Uomo, scrittore, artista* (2012), he wrote the essay, "Lošinj and the Seagull: The Poetry of Persuasion in Arturo Benvenuti." For the Goffredo Parise Cultural Center of Ponte di Piave, he curated two events taken from *I movimenti remoti* and *Arsenio*, staged at the writer's house along the river. In 2013, he curated, along with Roberto Costella, the exhibit *Islands: The Painting and Poetry of Arthur Benvenuti* at the Public Library of Ponte di Piave. In 2014, he edited the publication, *Arturo Benvenuti. L'opera poetica* for Edizioni BeccoGiallo, which included the essay "Benvenuti, The Ashes of Life and Poetry."

Timeline

1983—In April, Benvenuti completed and published *K.Z., Disegni dai campi di concentramento nazifascisti,* a book that is the fruit of multiple trips and epistolary exchanges in Italy and beyond starting in September 1979. The monograph is about the tragedy of the concentration camps, with drawings by internees of many nationalities found in museums, documentation centers, and archives throughout Western and Eastern Europe. The work was edited by Benvenuti, who had envisioned a text of images alone, and earned a preface by Primo Levi, praise from Nilde Iotti, then president of the Chamber of Deputies, as well as the appreciation of Simon Wiesenthal. The volume was produced by the printing department of the Cassa di Risparmio della Marca Trivigiana, the book's sponsoring bank and distributor, managed by Bruno Marton. The book consisted of 276 pages with as many black and white images, in a printing of 1,500 copies (officially 1,300) in a free, non-profit edition.

1984—March 3, the book *K.Z.* was presented at the Alberto Martini Gallery to the residents of Oderzo. The event was introduced by Guido Sinopoli, a former internee in concentration camps in Germany and Poland, who presented the text alongside the author.

On June 27, the Treviso section of the Bertrand Russell Cultural Circle organized the commemorative meeting "A Remembrance of Primo Levi in Arturo Benvenuti's *K. Z. Immagini dai campi di concentramento nazifascisti.*" Malcolm Sylvers and Benvenuti himself were speakers.

1997—From November 3 to 22, the Library of Verona dedicated an exhibition to drawings from the extermination camps from the Benvenuti archive as part of the initiative "Gertrud Kolmar, Lina Arianna Jenna, Primo Levi, Witnesses."

1998—From April 23 to May 6, the Concetto Marchesi Classical High School in Oderzo hosted a photography exhibit devoted to the Holocaust titled "The Shoah and Memory" with material from the Arturo Benvenuti archive. On April 29, Benvenuti himself spoke on the subject of extermination in the Nazi-Fascist camps.

2003—On January 27, Benvenuti was invited to the State High School XXV Aprile in Portogruaro to celebrate Remembrance Day. He spoke on the question of revisionism and the reasons that led him to create the book *K.Z.*

2005—After meeting Simon Wiesenthal in Vienna on June 14, 1983, Benvenuti commemorated their visit in the article "Simon Wiesenthal: A Man for a Just Justice," published in *Il Dialogo*, Oderzo, November 2005, in observance of his passing.

2006—On February 3, Benvenuti was invited to celebrate Remembrance Day at the Antonio Scarpa State Scholastic Institute in Motta di Livenza. He gave a talk on the subject of the Holocaust, referring to his experience with *K.Z.*, projecting and commenting on the images and also addressing the question of revisionism and denial.

2010—The City and the Public Library of Pordenone invited Benvenuti to celebrate Remembrance Day on January 29 by relating his experience with *K.Z.* Roberto Costella also participated, presenting the book and introducing Benvenuti. *KZ— Poesie*, which had already been distributed as a self-printed booklet of five poems written in June 1980 in Auschwitz, Mauthausen, and Terezín, was newly reprinted for the occasion.

2012—From September 22 to October 28, Palazzo Foscolo in Oderzo hosted the comprehensive exhibition, "Arturo Benvenuti, Writer, Artist," curated by Roberto Costella. The last room in the exhibition, called "Arturo Benvenuti, Witness and Public Intellectual," was devoted to "K.Z., Drawings and KZ - Poems," which were displayed in various versions and editions, along with supplementary materials and documents from the author on related topics, primarily related to the repression of dissent and the recent history of Yugoslavia. The catalogue includes essays by the curator and Giampietro Fattorello that document the experience of *K.Z.* and the related poems.

2014—November marked the publication of *Arturo Benvenuti. L'opera poetica* (Arturo Benvenuti: Poetic Works), edited by Giampietro Fattorello, with a preface by Roberto Costella, for BeccoGiallo, which also contains the collection *KZ—Poems*.

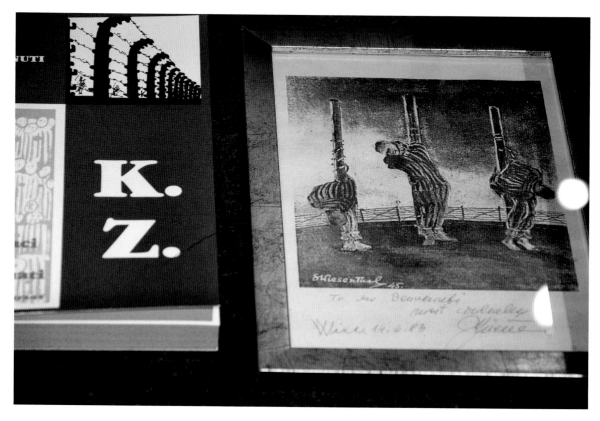

Drawing and dedication to Arturo
Benvenuti by Simon Wiesenthal.

KZ, Abbreviation and Initialism

The initialism "KZ" is derived from Yiddish (the Germanic language spoken by the Jews from Eastern Europe) and stands for "Konzentration Zenter" (concentration camp), yet seems to be a little-known and thus little-used derivation, with the preferred form being *Konzentrationslager*, the correct German equivalent. In fact, KZ refers to "Ka-Tzetnik," or "concentration camp prisoner," indicating a detainee rather than a site or type of detention. Ka-Tzetnik, along with their number, was what prisoners were usually called in the camps, and the word comes from the initials "KZ" pronounced in German, as in "Ka" (K) + "Tzet + nik" (Z), a Slavic suffix indicating a person (for example, the lists of prisoners were sequences like KZ 787987, KZ 898789, KZ 687454, and so on).

Yehiel De-Nur, a survivor of the Shoah and witness at the Eichmann trial, wrote several memoirs under the name Ka-Tzetnik 135633, and it is mostly from his story that Ka-Tzetnik and the abbreviation KZ became symbolic words for depersonalization in the camps. In a drawing by Vitorović Mileta, "KZH" is printed all over on the backs of the jackets of the internees, while "Kommandantur Konzentrationslager Auschwitz" is printed on the letterhead used for Tolkacev Sinowi's drawings. It therefore seems possible to make a distinction, insofar as the initialism KZ, for Konzentration Zenter, connects the reality of the camps to the Jewish sphere and therefore to the Shoah, whereas KZ as the abbreviation for Konzentrationslager expresses a more general meaning, a place of universal punishment designed for detention, the exploitation of labor, and extermination by Hitler's National Socialism.

Acknowledgements

It isn't important to detail the difficulties encountered in compiling the images collected here. Still, it's fair to mention that I encountered eager receptivity, and sometimes even touchingly generous contributions, as well as negativity, rivalry, and worse, indifference. Aside from the more extreme responses, I had the bitter disappointment of encountering the greatest obstacles at home, where not infrequently, despite repeated appeals and requests, even a civil response was lacking. I would therefore like to thank everyone who, in one way or another, substantially helped me by granting the materials in their possession and by providing me with useful tips and moral support.

Special thanks to:

Czechoslovak Academy of Sciences–Institute of Theory and Art History–Prague, Italian Embassy in Bonn, Tamari Graphic Arts–Bologna, French Association of Buchenwald-Dora and Kommandos–Paris, National Association of Former Internees (A.N.E.I)–Rome–Padua–Treviso–Trento, Atelier Fuhrherr–Vienna, Agostino Barbieri, Giuseppe Bellese, Jaroslava Bezděkovà, Eulalia Bogusz, Jerzy Adam Brandhuber, Eugenio Bucciol, Giannino Buccio, Giovanna Carpi De Rosmini, Center of Contemporary Jewish Documentation–Paris, Center of Contemporary Jewish Documentation (C.D.E.C)–Milan, Center for Italian Language Instruction–Fiume, Teresa Ceglowska, Ewa Cholodzínska, Civic Arts Collection–Drawing Archive–Sforzesco Castle–Milan, Arturo Coppola, Mario Cordaro, Stefan Danyluk, Documentation Centre of Austrian Resistance–Vienna, Istok Duriava, István Eckhart, Aniello Eco, Béla Esti, Dorota Folga, Cagli Foundation–Florence, Fulvio Giudici, W. Herbst, Maurycy Horn, Imperial War Museum–London, Historical Museum of Serbia–Belgrade, Dolores Ivanuśa, Janina Jaworska, Miroslav Jaroš, Yoza Jaroslav, Aleksandra Kodurowa, Ljiliana Kostantinović, Nada Kraigher, J. Krása, Bogdan Lasić, Primo Levi, Fortunato Lorenzon, Museum of the Hungarian Labour Movement–Budapest, Zivko Mali, Renzo Margonari, Daniele Martin, Pierre De Mijolla, Michael D. Moody, Stane Mrvić, Muroran Institute of Tecnology–Sapporo (Hokkaido)–Japan, Civic Museum of Turin–Gallery of Modern Art–Turin, Art Museum of the Socialist Republic of Romania–Bucharest, Ghetto Fighters' House Museum-Kibbutz Lohamei Hagetaot–Israel, Risiera di San Sabba Museum–Trieste, Museum of German History–Berlin (DDR), Anton Zoran Music, Museum of the People's

Revolution–Ljubljana, Museum of the Yugoslav National Revolution– Belgrade, Museum of the Croatian Revolution–Zaghreb, Museum of the Vojvodina Socialist Revolution–Novi Sad, Xawery Dunikowski Museum–Warsaw, National Museum, Warsaw–Warsaw, Francesco Muzzi, National Buchenwald Memorial– Weimar/ Buchenwald (DDR), National Memorial–Ravensbrück, Václav Novák, Miriam Novitch, Terezín Memorial–Terezín, Auschwitz-Birkenau State Museum–Oswiecim, Pinuccia Papadia, Paride Piasenti, Institute of Art of the Polish Academy of Sciences–Warsaw, Andrzej Rottermund, Hachiro Sakanishi, Bruno Serafin, Sergio Sini, Carlo Slama, Jaroslav Slavík, Kazimierz Smolén, Les Belles Lettres–Paris, Luigi Spacal, Jewish Museum in Prague–Prague, Blanka Stehlíková, Jozef Szajna, Amel Tolkačeva, Klaus Trostorff, Benko Urbah, Yad Vashem-Martyrs' and Heroes' Remembrance Authority–Museum Department-Jerusalem, Karl Zahraddnik, Jewish Historical Institute–Warsaw.

To my wife, the most heartfelt gratitude for following and helping me with serene patience on my many "peregrinations" across Europe in search of the documents that in large part are reproduced here.

A.B.

The visual materials in this volume were generously provided by:

French Association of Buchenwald-Dora and Kommandos—Paris
National Association of Former Internees (A.N.E.I)—Rome
Atelier Fuhrherr—Vienna
Eulalia Bogusz (photo Polska Akademia-Warsaw)
Giovanna Carpi De Resmini
Czech Academy of Sciences—Prague
Civic Arts Collection—Drawing Archive –Sforzesco Castle—Milan
ArturoCoppola
Documentation Centre of Austrian Resistance—Vienna
Aniello Eco
Editrice S.A.T.—Vicenza
Imperial War Museum—London
Nada Kraigher
Museum of the Hungarian Labour Movement– Budapest
Museum of Modern Art—Ljubljana
Museum of Walloon Art—Liège
Civic Museum of Turin—Gallery of Modern Art—Turin
Yad Vashem-Martyrs' and Heroes' Remembrance Authority—Jerusalem
Ghetto Fighters' House Museum-Kibbutz Lohamei Hagetaot—Israel
Anton Zoran Music
Museum of the Yugoslav National Revolution– Belgrade
Museum of the People's Revolution—Ljubljana
Museum of the Croatian Revolution—Zaghreb
Museum of the Vojvodina Socialist Revolution—Novi Sad

Art Museum of the Socialist Republic of Romania—Bucharest

Xawery Dunikowski Museum—Warsaw

Francesco Muzzi (Studio Cagli)—Rome

National Buchenwald Memorial—Weimar/ Buchenwald (DDR)

National Memorial—Ravensbrück

Waldemar Nowakowski (from Janina Jaworska)

Terezín Memorial—Terezín

Auschwitz-Birkenau State Museum—Oswiecim

Bruno Serafin

Carlo Slama

Les Belles Lettres—Paris

Jewish Museum in Prague– Prague

Józef Szajna

Amel Tolkačeva

Karl Zahraddnik

ARTURO BENVENUTI

Arturo Benvenuti is a scholar, writer, and artist, born in Oderzo (Province of Treviso) in 1923. The founding director of the Alberto Martini Art Gallery of Oderzo (1970), he has fostered museum programs and cultural events throughout the area, often in Trieste and the Karst region, Istria and Dalmatia. Since the 1960s, he has worked in literary and visual production, alternating poetic language and visual exploration, using painting, drawing, and photographic techniques. He has written several essays on Alberto Martini as well as the poetry collections *25+15 bozzetti giuliani* (Rebellato, 1969), *Masiere* (1970), *Adriatiche rive. Poesie* (1973), *A meno che* (Rebellato, 1977), *Još* (Altrarea, 1978), *Non ve ne andate gabbiani* (Altrarea, 1979), *KZ—Poesie* (1983), and compiled and edited the present book, originally titled *K.Z., Disegni dai campi di concentramento nazifascisti* (1983). In 2014, his poems were collected in *Arturo Benvenuti. L'opera poetica*, edited by Giampietro Fattorello with a preface by Roberto Costella (BeccoGiallo).

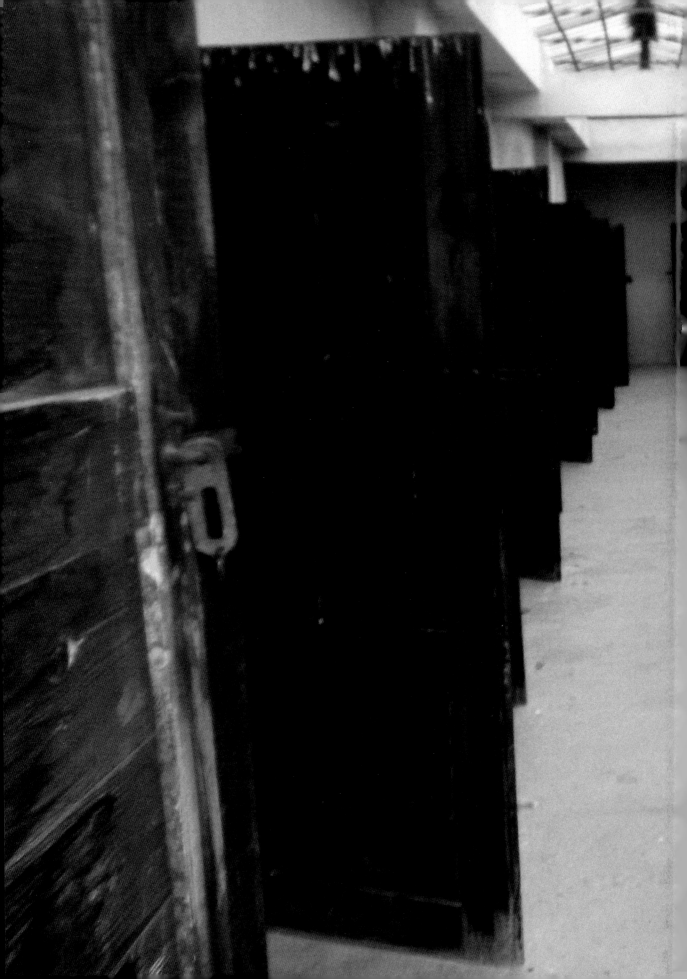

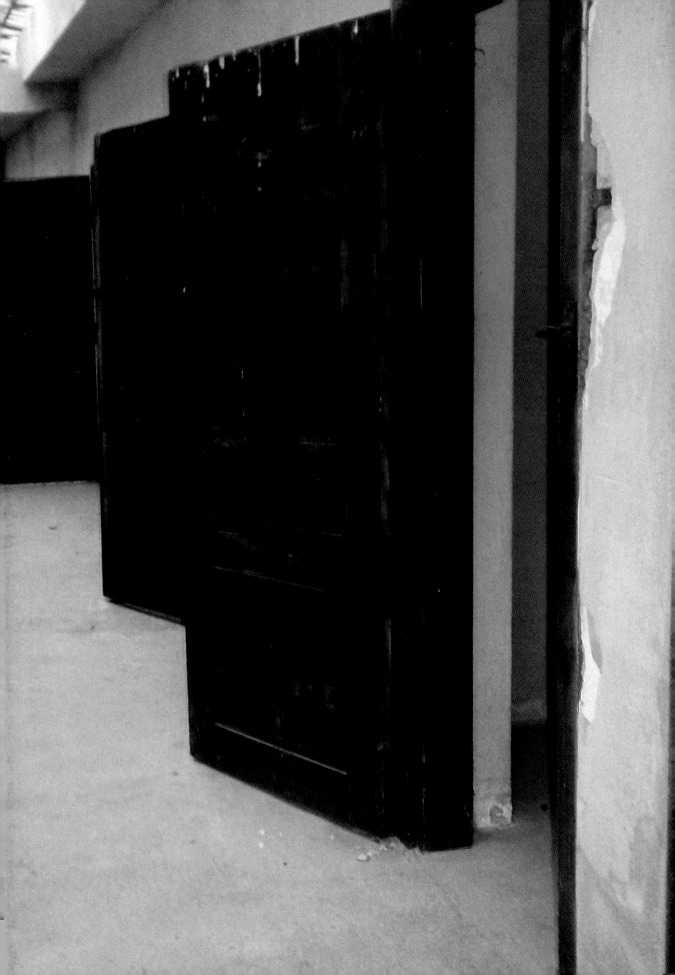

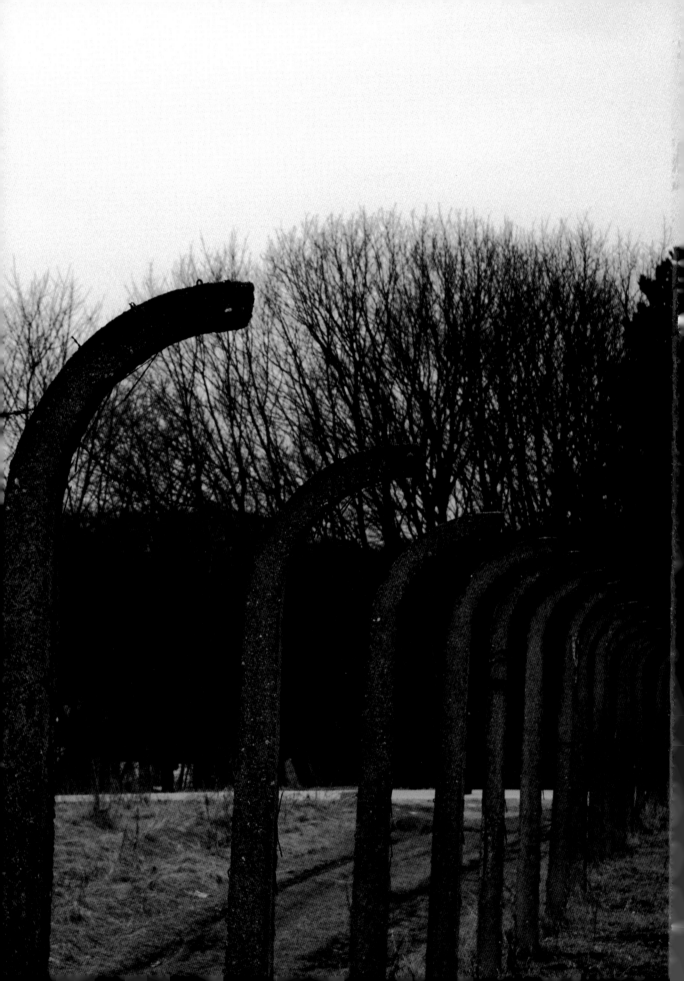